"You don't make a photograph just with a camera, you bring to the act of photography all the pictures you have seen, the books you have read, the music you have heard, the people you have lived."

Ansel Adams

"David, what musical instrument do you play?"
"I play the Hasselblad!"

Ben Webster: London studio, 1973

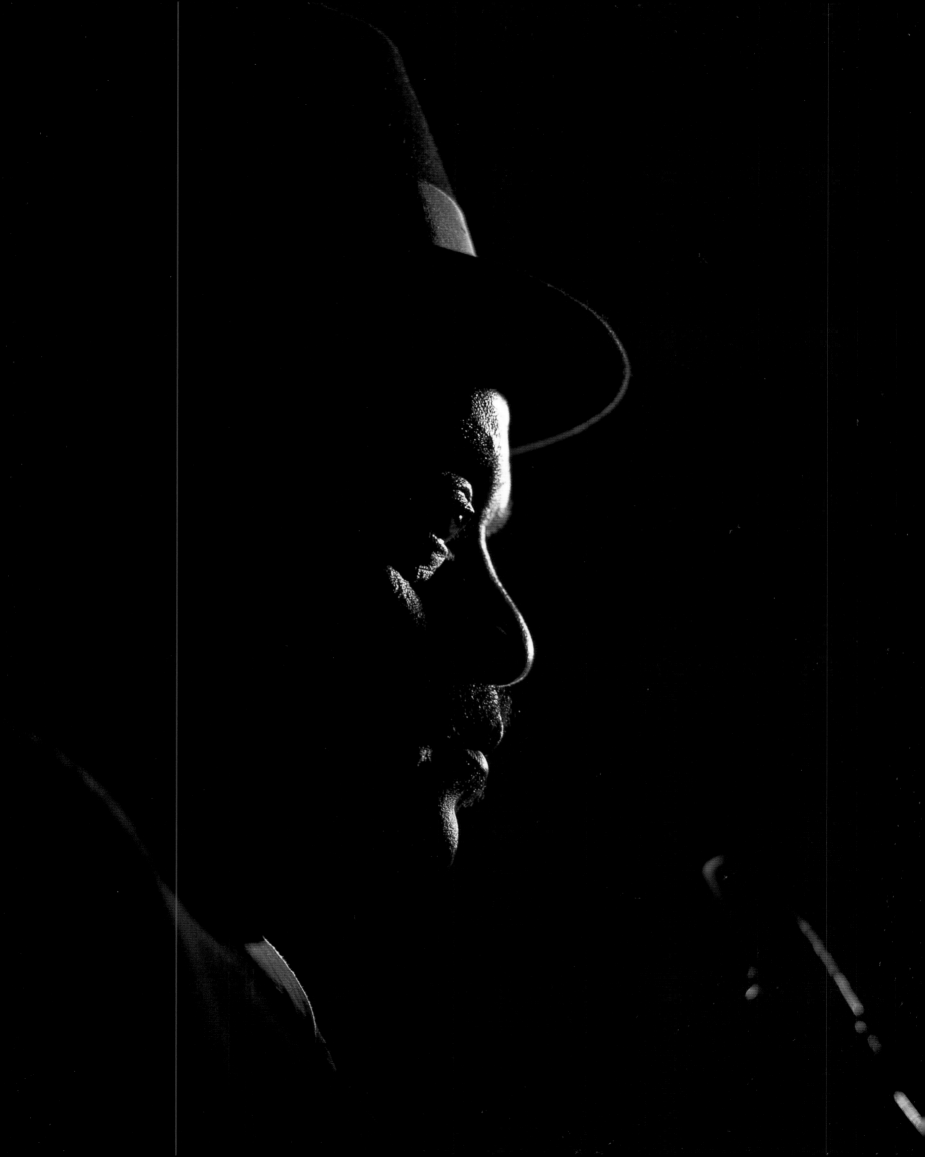

the unclosed eye

{the music photography of David Redfern}

DAVID REDFERN

THE UNCLOSED EYE
The Music Photography Of David Redfern

First published 1999 by Sanctuary Publishing Limited
This expanded edition published 2005 by David Redfern
The Apartment, 7 Bramley Road, London W10 6SZ

Design: Peter Curzon and Storm Thorgerson
Editor: Paul Redfern

Text and photographs: Copyright David Redfern, 2005
www.redferns.com

ISBN 0-9550718-0-1

Printed in China by Compass Press Ltd

FOREWORD • • • • • It is perhaps appropriate that we first became aware of David Redfern's existence in an extremely photogenic setting. Our early appearance at the Beaulieu Jazz Festival, in the middle of the famous Abbey and stately home, was a perfect backdrop for photographers and performers alike, and it attracted David, then at the beginning of his career. Our manager, Don Read, allowed him under the ropes to shoot us from privileged positions; this was perhaps the first time in his career that such a favour had been bestowed on him.

Since that time, David has been omnipresent throughout our career, his easily spotted countenance beaming at us from various distances – sometimes a lone figure, sometimes one of dozens of others. It is possible that many pictures of us finished up on his cutting room floor, as the events were sometimes gala evenings at which there were far more important faces to be covered than ours. Nevertheless, there are some examples of his work featuring one or other of us that remain classic examples of the photographer's art.

We admire him for his patience and seemingly unflappable nature. We respect him for his long service record to his art, and we love him particularly for the instances when his skill and imagination have documented our careers appropriately and effectively. We feel that David Redfern has every prospect of a career at least as long as our own, and we look forward – as we enjoy the pages herein – to the inevitable updates of the work of this remarkable artist in the years to come.

Dame Cleo Laine John Dankworth CBE

CONTENTS

PREFACE • • • • •

During the last four and a half decades or so I have been taking pictures of – and living in – the world of popular music.

In this book I have collected together some of those pictures, and recounted some of my experiences.

The book offers views of the music world from two sources.

One source is my photographer's eye: through-the-lens.

The second is my other – **unclosed** – eye, which is kept open to report on what's happening back and front of stage. (A third eye monitors the trials and tribulations of running a business.)

The title also refers to the professional trick I learnt early on of keeping the non-focusing eye open to avoid eye-strain.

I've loved taking the photographs: I trust you'll enjoy seeing them.

David Redfern,
London, June 2005

To Dede, without whom this book would never have happened, and to my children:- Simon, Bridget, and Mark, for allowing me to be myself.

chapter one {the beginning}

THE BEGINNING

opposite:

Humphrey Lyttleton:

Manchester, 1962

David Redfern: Aged 2

David Redfern: Aged 18

There is one question I'm asked more than any other: "How did you start in this business?" They always want to know which came first – the camera, or the music.

I believe that photographers are born and not made. My inherited interest was sparked into life at an early age. My first memory is of my father putting a piece of photographic paper behind a negative in a frame and leaving it in the window for about half an hour. This was then "fixed" and – amazingly – a contact print was produced.

Some years later the camera my father had used – a Kodak folding Brownie – was resurrected and found to have a hole in the bellows. This was fixed by the local camera shop for the princely sum of 19/6 (ninety-five pence) – a lot of money in the late Forties. My school in Burton-on-Trent had a camera club...of a sort. In reality it was a vehicle for the master in charge to get cheap labour from the members. We produced mass prints for his school group photographs which were taken on a 10x8 plate camera and then contact printed. This was an important lesson in how to make money out of something I enjoyed doing – it set me up for life! My first published picture was in the school magazine (no fee, of course). It was taken on a field biology trip in South Wales. The picture also appeared on the school notice board. This was my first taste of glory from a photograph.

My early musical education came from having to sing songs like 'Nymphs And Shepherds' ("shrimps and leopards", to us) and listen to incessant classical music (Beethoven – "bake-oven") both at school and at home. On Sunday evenings silence had to be observed while the evening concert on the radio was listened to with mute reverence, which was very apt as I'm the son of a preacher man. My rebellion against this type of music was swift and complete in those early years and I concur with drummer Max Roach in his dislike of eighteenth century European music.

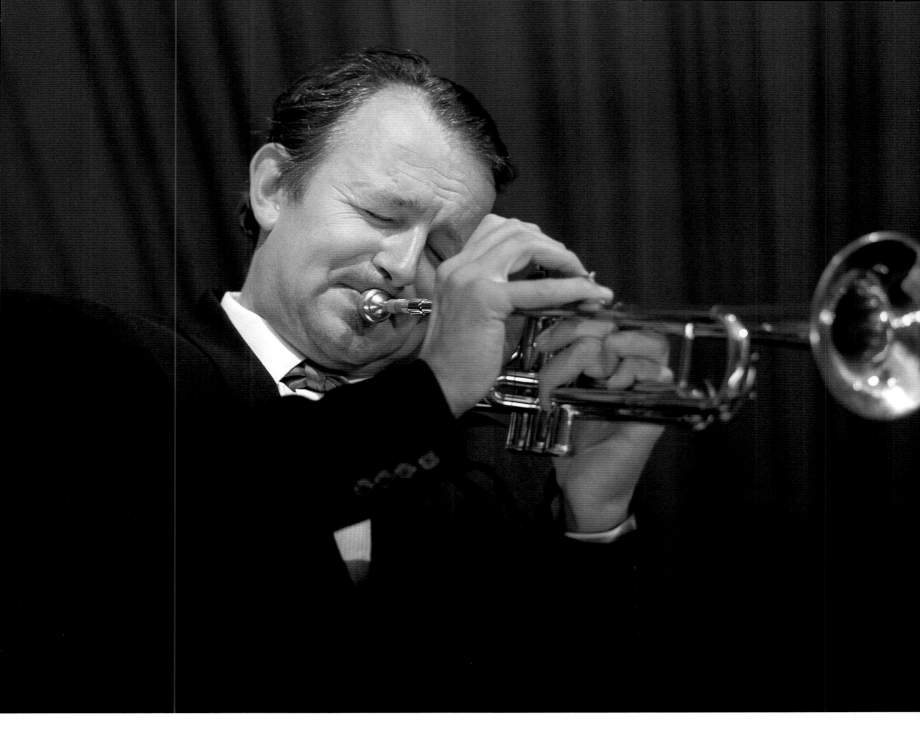

The first record • • • • • It didn't take long for me to discover my own taste. The BBC Light Programme on the wireless gave Humphrey Lyttleton an hour show each week, and Jack Jackson had his *Record Round Up*. These programmes became compulsive listening: the first record I bought was Lyttleton's 'Bad Penny Blues', quickly followed by Harry Roy's 'Leicester Square Rag'. At the same time as buying these seventy-eights I used to purchase the sheet music of the more jazzy popular songs and persuade my mother to play them on the vicarage piano with me and my brothers banging anything we could lay our hands on in accompaniment. I guess we made a terrible noise – but what an antidote to the establishment's classical music.

The first camera • • • • • Since the age of eleven I'd always wanted to work on the land. At school (Burton-on-Trent Technical High School) there was little vocational training for such a career. The best they could do was put me and a few like-minded types in the Domestic Science class (ratio – five boys to nineteen girls). While the fairer sex learnt about cooking and needlework, we were digging on near-by allotments. My forlorn hope was to go to the Royal Agricultural College in Cirencester. That was not to be, so at the age of sixteen I found myself farming in Surrey for a couple of years, but I continued to take an avid interest in photography. I bought my first "proper" camera, a Voigtlander Bessa 66 (120) from a friend. The only sounds I can remember hearing then were the milk-maids singing in the dairy or the pigs that I was looking after screaming for their food – and the occasional live band at the Young Farmers' Ball. I guess the fact that I had to be at work at 7am precluded me from listening to any late night radio.

I was conscripted into Her Majesty's Army for National Service for two years. At the time it seemed like a life sentence. But luck was on my side. Like an idiot I had applied to go into the Guards (peer pressure – "you're so tall...", etc). Fortunately my feet didn't pass the medical. So suddenly I was in the Signals, learning the Morse code (twenty words a minute) and how to operate a radio. After basic training I was posted to Scarborough, a great place to be in the spring as the barracks were more or less just above the beach, but for me the jewel was the Spa ballroom where a lot of the Big Name Big Bands used to appear. Ted Heath and the Ken McIntosh bands were among those that I remember fondly.

The first studio • • • • • Six months later I was helping to run the telephone exchange at Hadrian's Camp in Carlisle, which turned out to be a good opportunity to pursue my interest in photography. I transformed the telephone exchange into a makeshift studio, with the help of a regulation grey army blanket for a background, and a couple of clip-on photoflood lamps. I soon found that soldiers loved having their pictures taken – and would even pay for the privilege! The local chemist employed a pretty young lady who always dressed in black – therefore nicknamed "Midnight" – who took care of the processing.

The musical offerings in Carlisle were limited to the weekly dance at the County Ballroom, usually visited after many pints of the local beer, where I listened to the dance music of Charlie Shadwell and his orchestra and waited in the mostly vain hope of getting a dance with Midnight (achieved once, I think).

Ted Heath:

Marquee Club, London, 1959 | **Gerald Sawyer:**

Carlisle, 1955

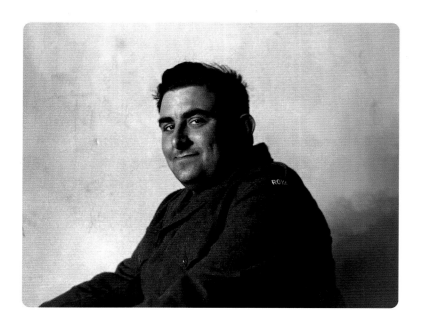

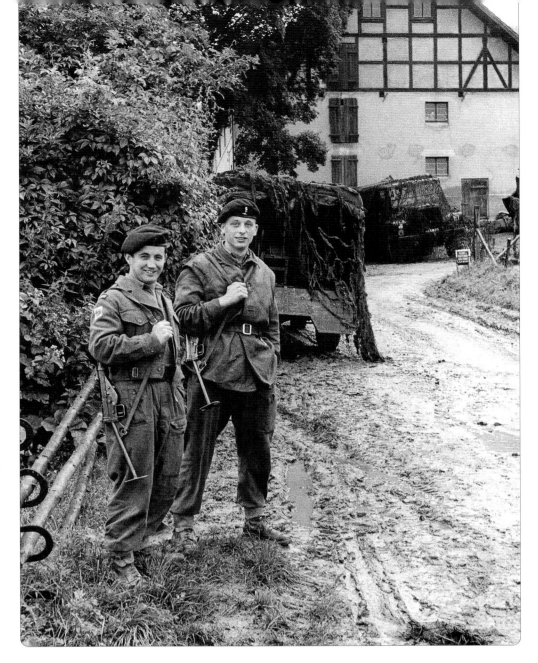

Army manoeuvres:
Germany, 1956

The first flash gun · · · · · Germany was calling – and in the winter of 1955 I was stationed in Luneburg near Hamburg. Barrack photography continued apace. I bought my first flash gun, a Braun Hobby 55, and, more importantly, my first 35mm camera. The Voigtlander Vitessa had a very fast film wind-on mechanism operated by a plunger. All this equipment was financed by an HP agreement with the local camera shop, Foto Tegla, who did all my processing. The agreement worked very well – considering the enormous distrust and dislike the local people had for the occupying forces only eleven years after the war. We used to go to the local dances: you scored well in the evening if you managed to get one dance. During that time "Darf ich bitten?" was a much used phrase, "Nein, danke" the usual reply.

Hooked on jazz · · · · · The undoubted musical highlight of those National Service years was a Jazz At The Philharmonic concert in Hamburg with a fabulous array of talent: Ella Fitzgerald, Dizzy Gillespie, Oscar Peterson, Ray Brown, Louie Bellson, Roy Eldridge, Flip Phillips and Herb Ellis. That was a marvellous concert – little did I know that I would get to photograph all these greats in the next decade or so. And from that day on I was totally hooked on jazz.

Demobbed and free at last in the summer of 1956 all I had was a few pounds, a badly-fitting suit, and no career prospects. I loved the country, but somehow I knew that farming was not for me. I had no qualifications, and there was no family farm to eventually come my way. Two years away from home working deep in cow and pig shit had made its mark; all I could do was try my luck in the big city. At the time I was living in Brighton with my mother, where work was non-existent at the end of the season. So I was to be found developing X-rays at St George's Hospital, Hyde Park Corner (now the Lansborough Hotel), using my school interest and experience to get the job.

As the pay was all of five pounds a week, and as I was commuting from Brighton with a weekly rail fare of three pounds, it's not difficult to work out that the job didn't last very long (six months). The experience didn't exactly lure me in to becoming a medical photographer. The only things I missed were the pretty radiographers. Brighton didn't have too much going for it, either, as far as I was concerned. The only live music I heard was at the Aquarium Ballroom where the dance bands used to play. The only good thing about being on the South Coast seemed to me that radio reception was excellent. I used to listen to the Voice of America *Jazz Hour* most nights. The DJ was Willis Conover whom I met many years later. As I've said, work was very thin on the ground, so the move to London was inevitable.

My first job in London was working for Joe Lyons feeding oranges into a machine to make Sunfresh juice. Not much photography there, but I did the odd "portrait" for friends or acquaintances. After the three-month orange season was over unemployment stared me in the face, but on the grapevine I was told that the Kodak factory were looking for workers. Photography was the draw, of course, but I ended up working in the film finishing department running machines that punched the holes in 35mm film. All the work was either under a safe light or in total darkness, and I was on shift-work, one week 7am-3pm, the next 3pm-11pm. Not very good for the social life, perhaps, but the pay was better at an average of thirteen pounds a week depending how many holes you punched. And I did learn two valuable lessons:

| **David Redfern:** New Orleans, 2005

(Photo by Leon Morris)

Seeing is believing • • • • • The first thing I was taught was how to avoid eye strain. You should never try and see in the dark immediately because the eye naturally adjusts to the conditions, and you should wait for ten minutes or so. And you should not squint when looking through a viewfinder: I learnt to keep my left eye open while using the right one for the camera viewfinder. I still do it: hence the title of this book! Somehow my brain has been trained to ignore the message from the left eye. Using a Rolleiflex- or Hasselblad-style horizontal viewfinder made the adaptation easy. These days I use a Hasselblad with a vertical prism finder, and I have found that sticking a bit of black card on the left-hand side works very well.

Listening is helpful • • • • • The second lesson was how important industrial relations are. In the late Fifties and early Sixties, Kodak were supposed to be a model company with its worker councils and so on. I remember thinking that if this was the best practice in top British companies, then heaven help the rest. I'm sure I was being very idealistic in those days of multiple strikes (not Kodak), but it did teach me how important it is to communicate to colleagues and employees alike.

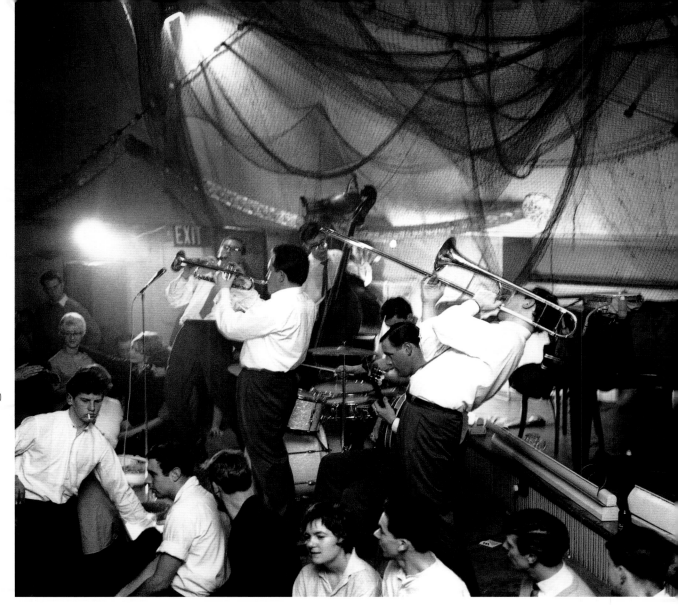

| Terry Lightfoot: Chatham, 1960

Colour in the dark • • • • At that time I was
sharing a flat in the Harrow Road with guitarist Arthur Golding
which my brother Paul had found for me. Arthur introduced me to
Melody Maker which in those days was the bible of the music
business, and always carried equal amounts of jazz and pop
stories. It quickly became mandatory weekly reading. But Arthur
wanted the place to himself (and his lady friends), and the only way
he could get rid of me was to find me somewhere else. This was the
top floor of a house in Abbey Gardens, St Johns Wood. One of the
two rooms was very small and immediately became a darkroom,
with a convenient bathroom next door, so I was able to process my
own negatives and prints. I even experimented with processing my
own colour – E2, I think.

The flat at 15 Abbey Gardens became a very important residence
for me: on the ground floor was Pat Pretty, press officer for Pye
Records at the time; Cleo Laine had just left one of the flats, and
another was occupied by three guys, song plugger Lenny Black,
composer Les Williams and Don Read. Don had previously worked
with John Dankworth for six years as band manager and was now
managing Terry Lightfoot's band. This was the start of the trad scene
and I was very soon getting involved in the world of British jazz.

Up to speed in Beaulieu • • • • • I think the first time that I crossed the line from being an amateur to a professional was at the Beaulieu Jazz Festival in 1959. I had hitch-hiked there with a tent and my new Rolleiflex 2.8E. These cameras were in very short supply as only a few were allowed in every year and you needed an import licence from the Board of Trade. I had to convince them I couldn't use a British equivalent, the Microcord. Lens speed was one of the qualities I quoted in my successful bid for an import licence.

So, having pitched my tent I was ushered to the other side of the barrier – right in front of John Dankworth's big band – by my one-time neighbour, Don Read. I felt very privileged to be so close to this fantastic band, and to be able to take pictures uninterrupted. This feeling has stayed with me to this day. Photographers are between the artist and the audience as a privilege, not a right. Sometimes I despair of today's photographers, who seem unable to learn this simple lesson.

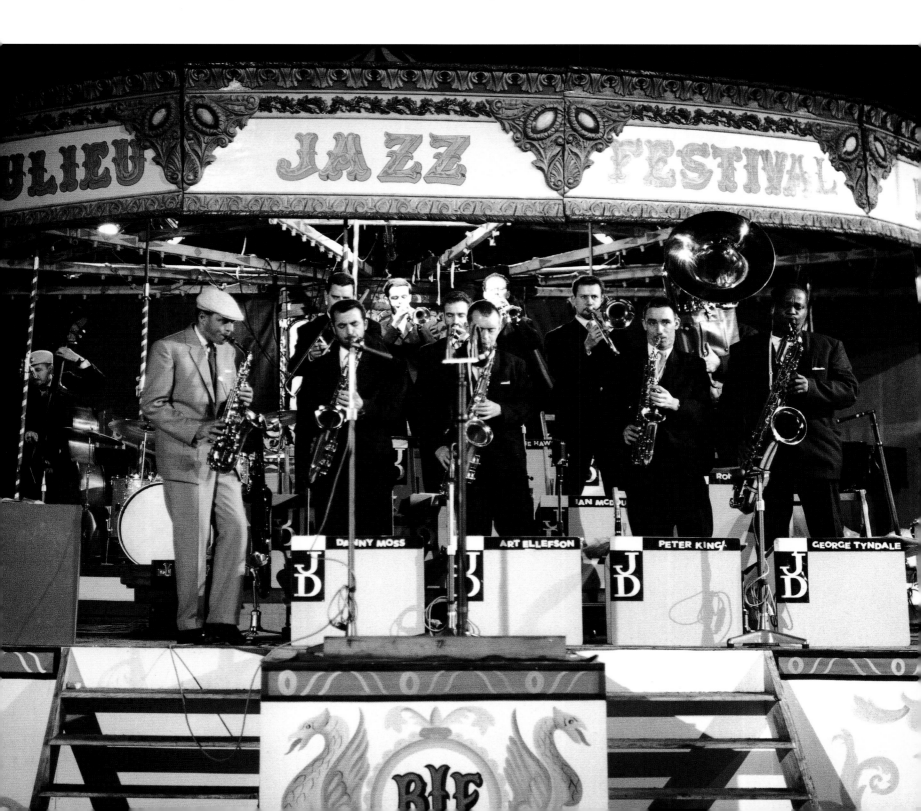

Stills means "stay still" • • • • • I covered all the Beaulieu Jazz Festivals until they were finally closed down after a mini-riot. The previous year the magnificent Anita O'Day sang with the John Dankworth Big Band, fresh from her triumph in the newly released movie of the 1958 Newport Jazz Festival, *Jazz On A Summer's Day*. The film made a lasting impression on me and in a strange sort of way influenced me more than the work of my peers. That it was made by a stills photographer, Bert Stern, had a lot to do with it. He was quite content to let the camera stay in one position and allow the artist to come in and out of frame. I think I have subconsciously used this technique myself ever since. I could never see the point of charging around in front of the stage like a buzzing bee. It wears you out, and upsets both audience and artists.

That penultimate Beaulieu festival was the first time I photographed an American jazz musician/singer. It was also my first experience with colour slides on a 6x6 format, and I liked the results.

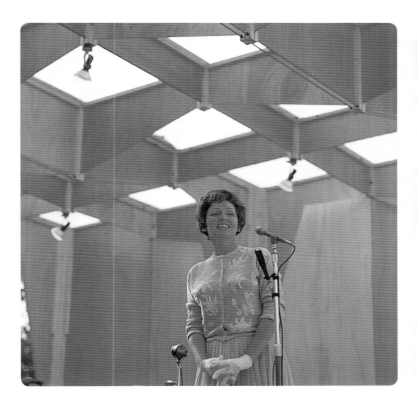

Anita O'Day:
Beaulieu Jazz Festival, 1961 | Beaulieu Jazz Festival, 1960

opposite:
John Dankworth Big Band:
Beaulieu Jazz Festival, 1959

Express to Germany • • • • • When the festival riot happened I was one of the few photographers present. None of the Fleet Street boys appeared until the next day – after the action. I knew little of the workings of Fleet Street, although my father's twin brother, John Redfern, was one of the star reporters on the *Daily Express*. He introduced me to Ian Macintosh, who ran London Express News and Features Services, and after I returned to London I gave Ian some pictures to sell. One was published in *Neue Revue* in Germany – my first foreign sale. Ian tried very hard to make me into a photo-journalist, but to no avail as I had already decided it was not for me. I was going to stick strictly to music, but *all* music.

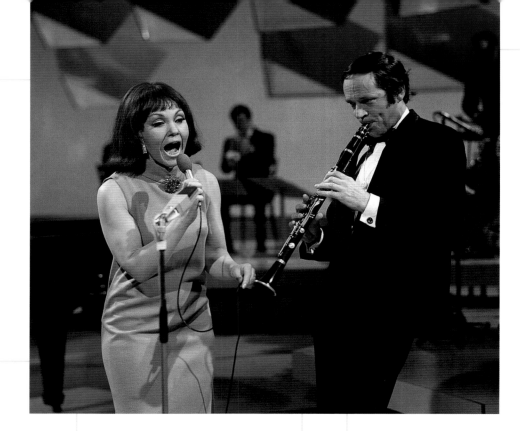

Cleo Laine, John Dankworth:
BBC TV, 1963

100 – and other clubs • • • • • The 100 Club in Oxford Street, London, was the place to be, as it provided a perfect training ground for a would-be music photographer. I still had only a Rolleiflex, with no interchangeable lenses, and zooms hadn't been invented. So a close-up on a band member meant pushing through the crowd to get to the front, and if you wanted a wide shot, push to the back. It was always very hot and sweaty, but lots of fun. The crowds were always very friendly, and a couple of pints in the Blue Posts before or after helped replenish all that lost liquid.

Another regular haunt of mine in Oxford Street was the Marquee Club for the John Dankworth Sunday night sessions, at that time underneath the old Academy cinema. Great music and, sometimes, the added bonus of a lot of laughs with Dudley Moore on piano.

Rock in the Channel • • • • • This was also the era of the river boat shuffles. Rent a pleasure boat, put a couple of trad bands aboard, and go up and down the Thames. The sound systems may have left something to be desired, but with lots of beer and a little sunshine nobody seemed to care.

Once I ended up on a boat which went a little further. *Rock Across The Channel* sailed from Brighton to Calais. Thankfully the sea was calm as there were no stabilisers in those days. I didn't know much about rock 'n' roll then, but my first taste of photographing it was a good one, a concert on Calais Harbour featuring Gene Vincent dressed in black leather, supported by British band Sounds Incorporated.

Gene Vincent:
Calais Harbour, 1959

opposite:
Sounds Incorporated:
Calais Harbour, 1959

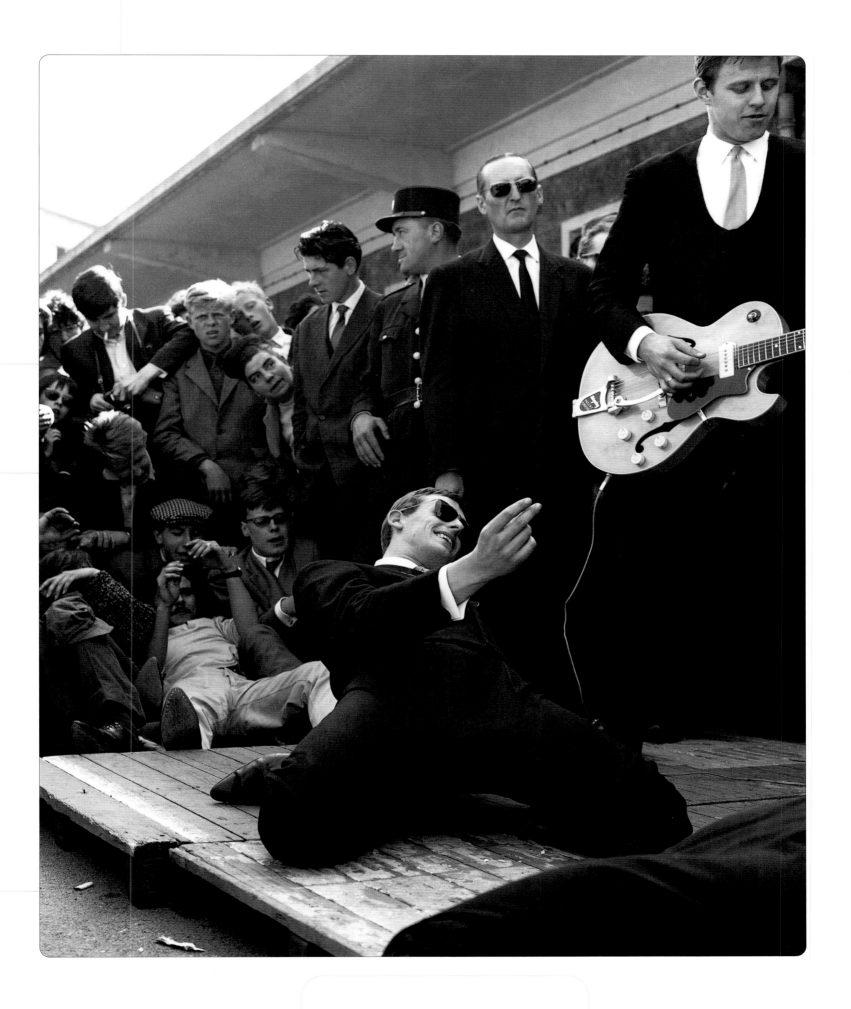

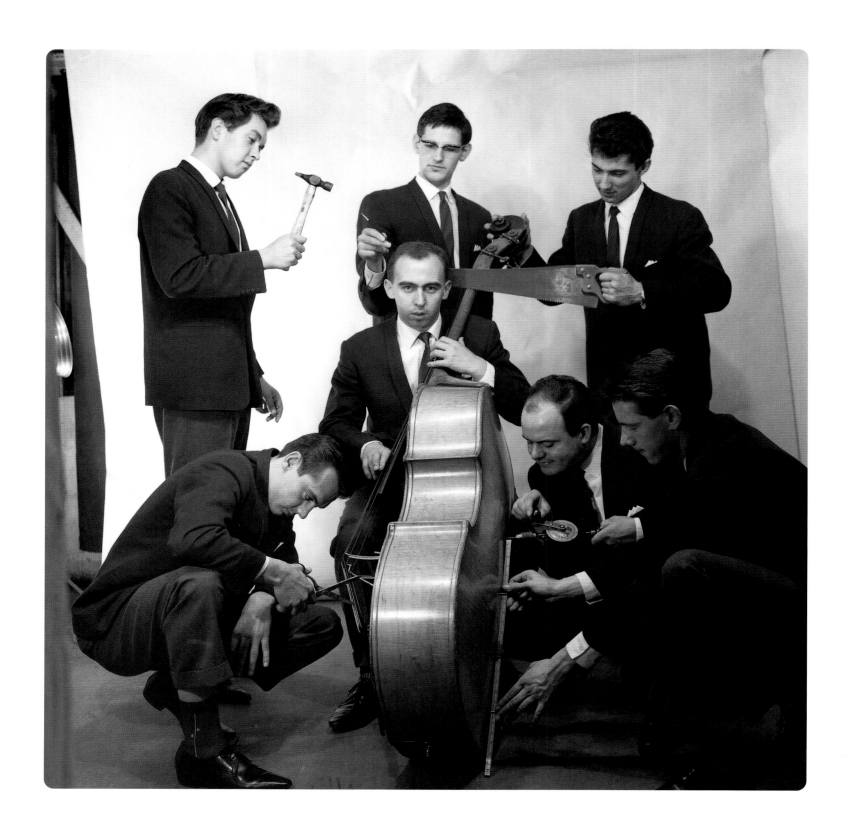

| **Ed Currie s Jazz Band:** London, 1963

chapter two {**the sixties**}

below:

Chris Barber:
Marquee Club, 1962

Jazz Wedding:
Sandra Smith-Graham Stewart:
Croydon, 1962

THE SIXTIES

Swing in London • • • • • I guess I was in the right place at the right time: swinging London at the start of the Sixties. The British trad jazz phenomenon of the late Fifties was followed by the British rock and pop explosion – and Kodak fired me. This was to be the last proper job I held, as the sudden loss of all the securities of proper employment forced me into action. I didn't know anything

photography. "You can play," they would say, "with your music photography when you make some money." Bad advice – as it turned out.

To supplement my income, I did a few days printing for fashion photographer Chris Moore (hasn't he done well – you can rarely turn a fashion page without seeing some of his pictures). I

about business, but I did know how to take a picture. And I had come to like, even relish, the music photography lifestyle with a passion I'd never felt before.

I guess it was then that I decided my two equal loves – music and photography – would permanently come together. Of course, the sixty-four thousand dollar question was: could I make a living at it? But there was no question that that was what I was going to try to do.

And what else was there? I was definitely not up for snapping weddings and parties.

In life, I knew, you have to start as you mean to go on. Okay, so I was encouraged by the well-meaning to take up wedding and PR

remember he advised me to stick to what you want to do and let the rest take care of itself. Good words.

Clubbing – and sleeping in • • • • • So I spent my time going to clubs, usually the 100 Club or the Marquee, sleeping late in the mornings, and processing my black-and-white films in a make-shift darkroom – which always caused trouble with landlords who, it seems, don't like windows permanently blacked out.

In the afternoon I would venture out, and maybe visit the odd magazine to try to sell a picture. At the time *Jazz News* was

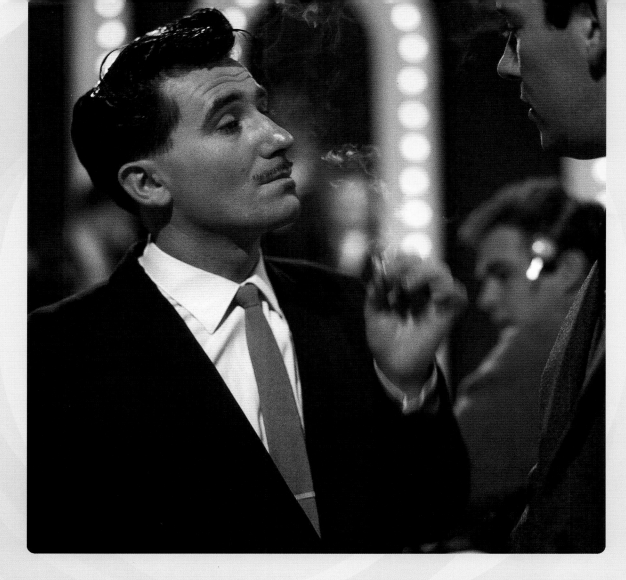

Kenny Ball:

Thank Your Lucky Stars

edited by Peter Clayton, and there were Fleetway publications like *Roxy* or *Marilyn*.

Jazz News used to pay the princely sum of one pound a picture published – and *Melody Maker* would pay three times this. *Marilyn*, though, paid a magnificent fiver for their trad pin-up on the back page, so I spent a lot of time running around trying to get group shots or portraits of the bands run by Acker Bilk, Kenny Ball, Chris Barber and many others. It wasn't easy to get a decent shot in the clubs. So when the music shows started to appear on TV, it turned out to be my salvation.

Coloured minstrels? • • • • • In the early Sixties television was still being broadcast in good old black and white. TV cameras were nowhere near as sensitive as they are today. This meant bright lighting for all programmes, and, although colour film was comparatively slow, I was able to get good colour shots of bands in action. The film at first was Super Anscochrome-T, rated at 100 ASA. The film could be pushed during processing to 200 ASA, but it had to be sent to a Colour Centre lab at Farnham Royal in Berkshire. If the pictures were needed in a hurry, the film could be sent by train from Paddington station and returned later that same day if necessary. This was the forerunner of the Red Star service – but they never lost a film for me.

Lucky stars • • • • • I originally went to Birmingham to photograph trad bands, like Kenny Ball's. The first record cover I sold was for *Kenny Ball's Golden Hits*, which I shot on the set. It sold a million copies, as I remember it, and I think I was paid twenty-five pounds for the picture.

One of the most important shows for me was *Thank Your Lucky Stars*, which was recorded on Sunday evenings between 1961 and 1966 at Aston Studios in Birmingham. I didn't have a car, so I went by train every Sunday morning for rehearsals starting around lunchtime. The show was recorded in front of a live audience in the evening: that's if you can call singing to backing tracks – or miming – live recording!

The press officer for *Lucky Stars* was Jimmy Bake who was always extremely helpful – often beyond the call of duty. Jimmy liked a pint, so it was always a toss-up whether to catch the last train at 8pm with dinner on board, or have a few with the Brum boys and catch the milk train. This would take about four-and-a-half hours going round the countryside arriving at Paddington at 4am.

Although I started by covering the trad-jazz elements of these shows, I was soon photographing all the popular bands of the day: just about everyone on the British scene; and some notable Americans like John Lee Hooker, Bo Diddley, Roy Orbison and The Everly Brothers.

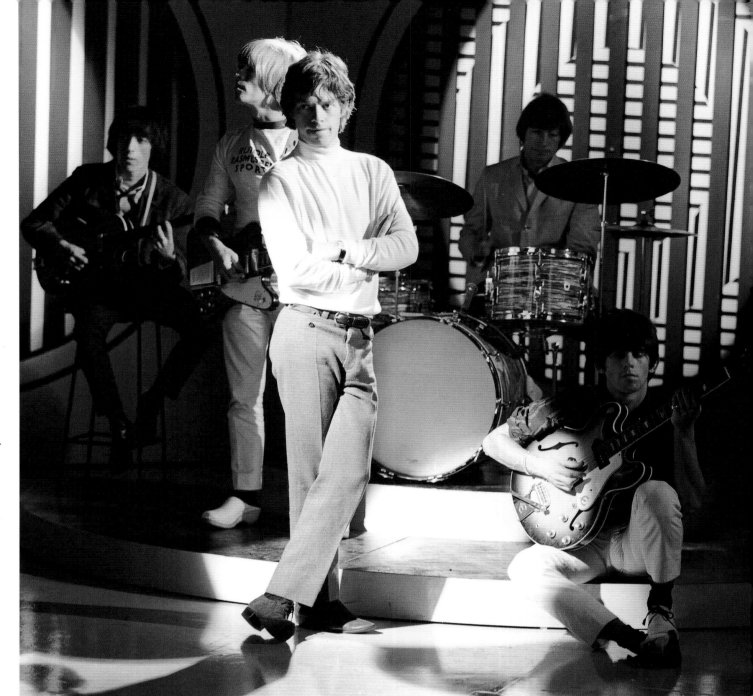

The Rolling Stones:

Thank Your Lucky Stars

Marianne Faithfull:

Thank Your Lucky Stars

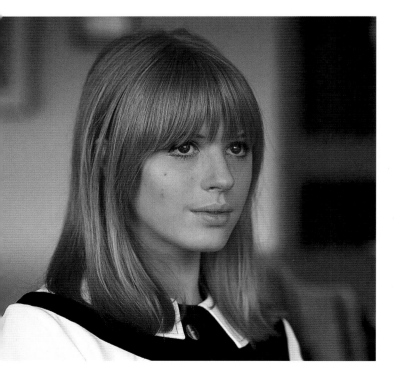

opposite:

John Lee Hooker: | **The Beatles:**

Thank Your Lucky Stars | *Thank Your Lucky Stars*

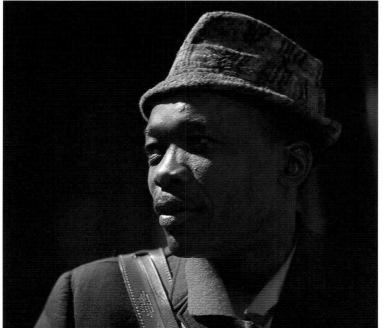

Rolling stones gather no beetles • • • • • I had found a steady market with record companies, selling them good colour pictures from the TV shows for the EPs (forty-fives) of bands like The Searchers and The Merseybeats. And then there were The Rolling Stones and The Beatles. Whenever they turned up there was always a thrilling atmosphere.

I was there for The Beatles' first appearance on the show. They were already sensations, and drew large crowds. There was a police cordon protecting the entrance to the studios, and the plate glass windows on the front of the building had been boarded up. I'd already photographed the rehearsals, been out for a beer, and decided to catch the milk train, so I was outside, waiting for the lads to arrive back. The next minute I found myself between the Fab Four slipping into the building behind me and hundreds of screaming teenage girls rushing towards me through the police cordon: not a pleasant experience.

Once inside, all was calm. The floor manager was a very co-operative Scottish guy. I heard him say to the band, "Right, lads, I want you down five minutes early for stills." Magic: the Fab Four posed for me round the drum kit. That shot has certainly made a bob or two for me over the years, although I still ask myself, why did I shoot only black and white? In retrospect, I suppose, it suits the medium very well. In 1996 The Beatles' management company, Apple Corporation, tried to buy the picture outright. My answer was, of course, no, so they had to pay a large fee for using it in The Beatles' *Anthology*.

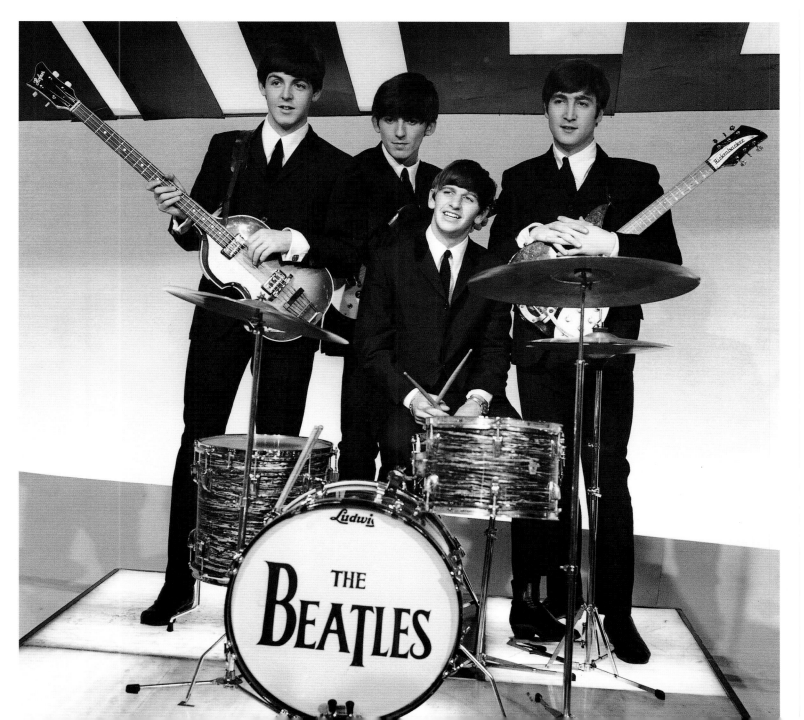

Faithless in Brum • • • • • Few photographers travelled up from London – or were allowed into the studio – so it was never very crowded on the floor, usually only the TV company's stills man, and one or two others. The canteen on the first floor was blessed with lots of daylight through roof lights. I took some of my most candid portraits here. Marianne Faithfull let me do a couple, but told me that, as David Bailey shot all her album covers, my sales possibilities were limited. I felt it was poetic justice, many years later, when I was booked to photograph her in my studio for a record company. Apparently David Bailey had done an earlier session they didn't like.

Sometimes I'd get a lift back to London in the car provided for the stars by the TV company – if the artist agreed. Sandie Shaw gave me the best trip. She posed for me on the bridge crossing the M1 motorway at one of those dreadful service stations. On the other hand I also had to endure artists who insisted on listening to Radio Luxembourg all the way in case their song was played.

Bill Haley was another artist who made it to *Lucky Stars*. There was no trouble in Birmingham, but a few months later at the Odeon Hammersmith I was caught in a mini-riot at one of his concerts. The place was in uproar, with seats being torn out and chucked around. I just managed to throw my camera and myself under the fire curtain as it came down.

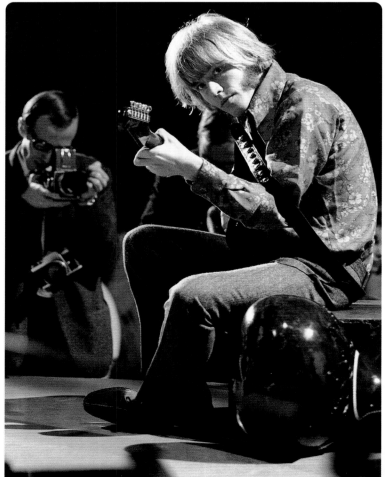

Ketty Lester:

Thank Your Lucky Stars

Screaming reels • • • • • Around that time there were occasional events I found strange. I was asked to go to Leicester to photograph a singer called Darrel Quist who was trying to make it in the pop world. Larry Parnes, his manager, decided it would be a good idea to have Darrel pulled off the stage by screaming girls. The Leicester venue had been chosen because the stage was low so it was easy for these girls to rush up and drag him off. I was taken there with two other photographers in a chauffeur-driven car. The two young girls hired to do the deed did their number according to plan, and we rushed back to London with the film. I took my pictures to the *Daily Express*, where the picture editor told me he thought it looked like a stunt: "But it's a good picture – I'll run it." The next day it was on the front page.

Darrel Quist:

Leicester

Marianne Faithfull:

Thank Your Lucky Stars

| **Adam Faith:** *Thank Your Lucky Stars*

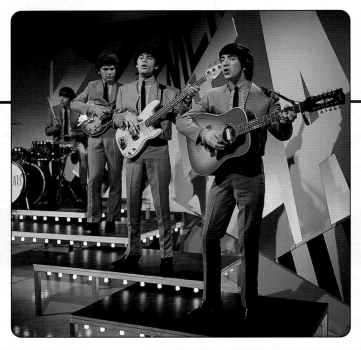

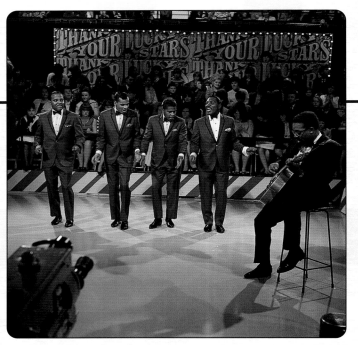

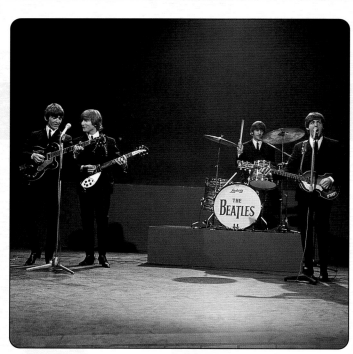

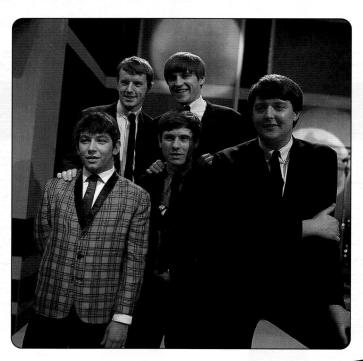

SUITS YOU

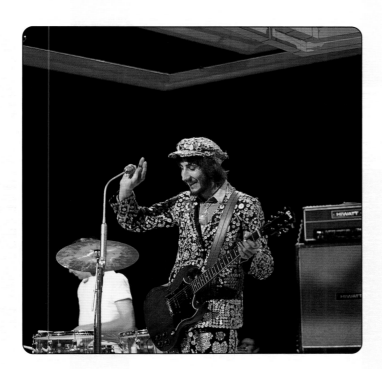

this page:

Pete Townshend

———————

The Rubettes

No self-respecting band in the Sixties would
be without their matching suits, the band uniform.
In fact many West End tailors made their fame – and,
I suspect, fortune – by designing and supplying suits
for these bands.

opposite:

The Merseybeats	**The Drifters**
The Kinks	**The Searchers**
The Beatles	**The Animals**

Hassled by Jenny • • • • • My luck did change in one respect. I had coveted for many years that ultimate in cameras, the superb Hasselblad. To my amazement, shock and delight Jenny Edmonds, a well-off friend of my mother's, said she really liked my work and asked me what camera I would really like, what would five hundred pounds buy? Being desperately short of cash, I asked if I could buy a Hasselblad professional outfit with a 150mm lens for three hundred and fifty pounds, and, if I could, I'd like to take the rest in cash to repay some bills and buy more film. Jenny was offering me a no-interest loan, to be paid whenever it was possible. In the end I paid it to my mother many years later.

Pocket full of cash, I walked in to my usual camera store where, normally, I could raise only enough cash for a couple of rolls of film. So it was a great thrill, but they took some convincing that I indeed had the money to spend.

I still kept the Rolleiflex for some time, but eventually traded it in for an 80mm lens for the Hasselblad. Not before the Hasselblad had found its way into the pawn shop on several occasions, though (well, the rent had to be paid somehow), but I was very careful not to over-stretch my resources and borrowed only for my immediate needs.

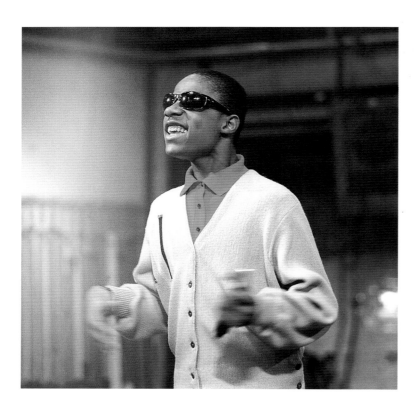

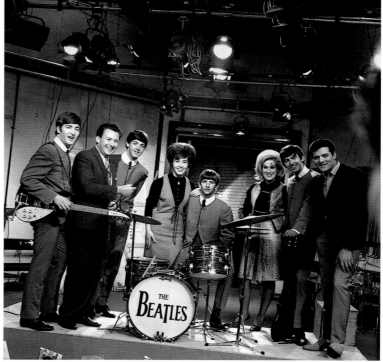

Stevie Wonder: | **Mersey groups:**

Ready, Steady, Go | *Ready, Steady, Go*

Springing into action for Dusty • • • • • "The weekend starts here" was the slogan for *Ready, Steady, Go*, which went out live on air every Friday night at around 6pm from August 1963 to December 1966. The programme originally came from the Rediffusion studios at the bottom of Kingsway in London. Space was very tight and, as they always had a live – and lively – audience, it was chaotic, but very exciting. The lighting was good, but the backgrounds were messy. I found the 150mm lens on the Hasselblad invaluable in enabling me to take some nice head shots.

opposite: | **Dusty Springfield:** *Ready, Steady, Go*

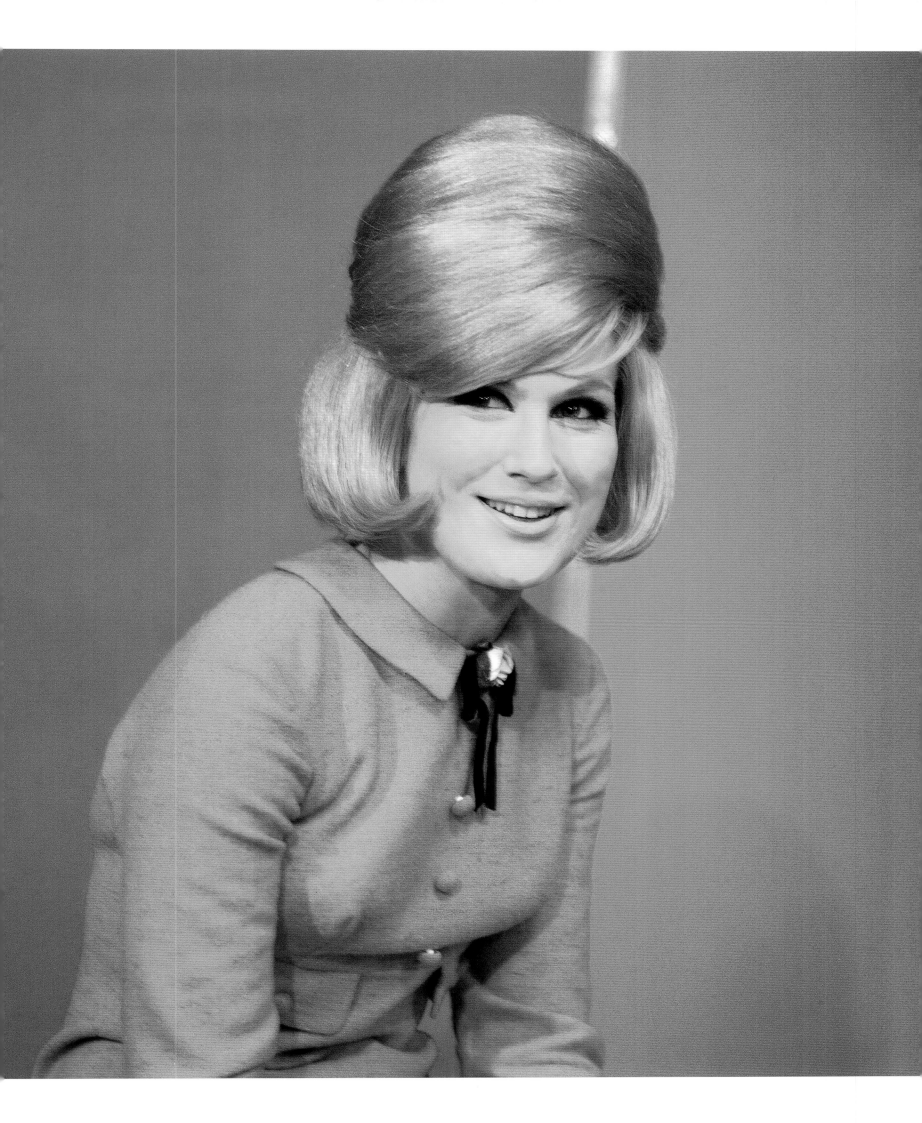

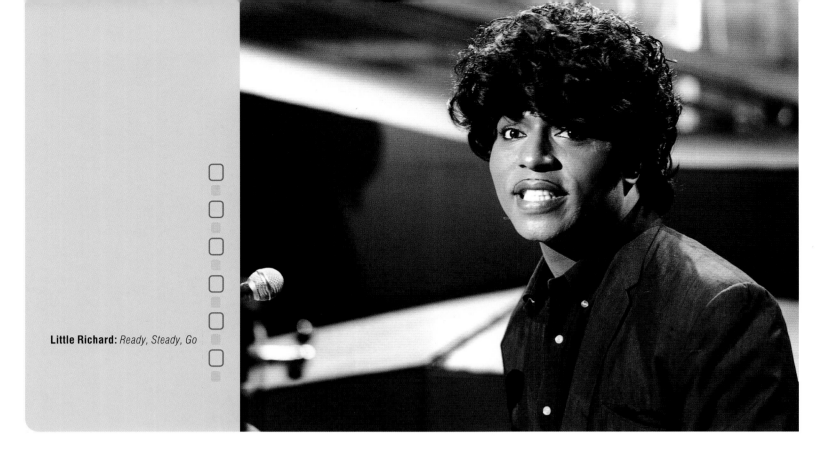

Little Richard: *Ready, Steady, Go*

Eventually the show moved to Wembley Studios. It lost a little of the vibrancy, but with artists such as Little Richard, Sonny And Cher, James Brown and The Ike And Tina Turner Revue, there were some golden picture moments.

I had taken a couple of excellent portraits of Dusty Springfield on *Ready, Steady, Go* but we had a curious love/hate relationship. She would warn people about me – "Watch him, he's an evil one – he always gets his pictures" – but she was smiling when she said it...

This started when I went down to Bristol to photograph The Springfields on a TV show at the behest of the record company, Philips. When I arrived I was told, "Sorry, no pictures." I appealed, "I'm doing it for the record company, and I have come all this way, no pictures – no pay for me."

After many phone calls back and forth to London, there was still a stalemate. Suddenly Dusty said, "Oh, take your fucking pictures!" Which I did. And thought no more about it – until the next morning when all the papers carried the story that The Springfields were breaking up. I'd photographed their final appearance.

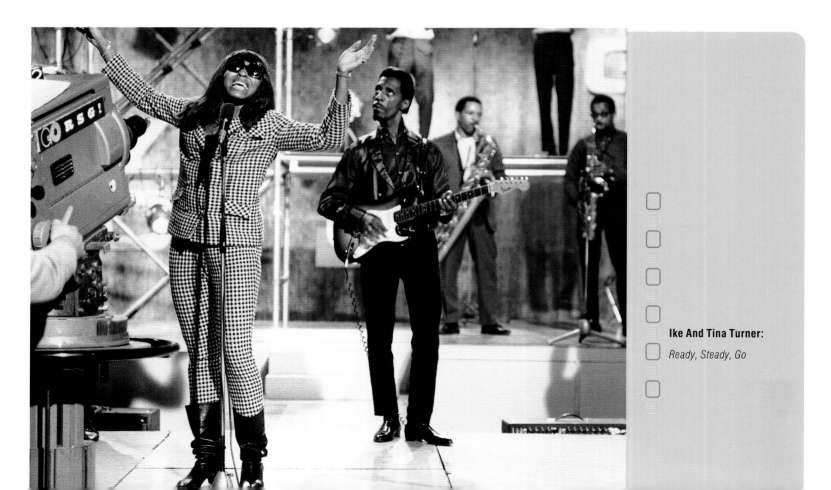

Ike And Tina Turner:
Ready, Steady, Go

Museum crypt • • • • • The heady Sixties continued and I moved into my first studio, a small, damp basement in Museum Street, Bloomsbury which I shared with another photographer, Ron Boardman. We each paid three pounds a week rent.

Sometimes promoters and agents wanted publicity shots posed in a studio. I managed to get many trad bands down to my studio for these sessions, which helped to pay the rent (just about) although studio shots were never my forte. To supplement my income I started a repro service churning out black-and-white 10x8s for record companies' publicity give-aways. My first wife, Kate, was working as a legal secretary at the time. She would come down after work and help to wash, dry and spot the prints.

One could live quite cheaply in the early Sixties (which was just as well). I remember finding it worthwhile to take a bus to the bank to pay in a cheque for two guineas (bus fare – three pence). Two or three times a week I would be invited to a record company's press reception, where there was always enough good food to keep me going until the next one. As long as I had enough money to buy film nothing else mattered too much – as several landlords and utility suppliers will testify!

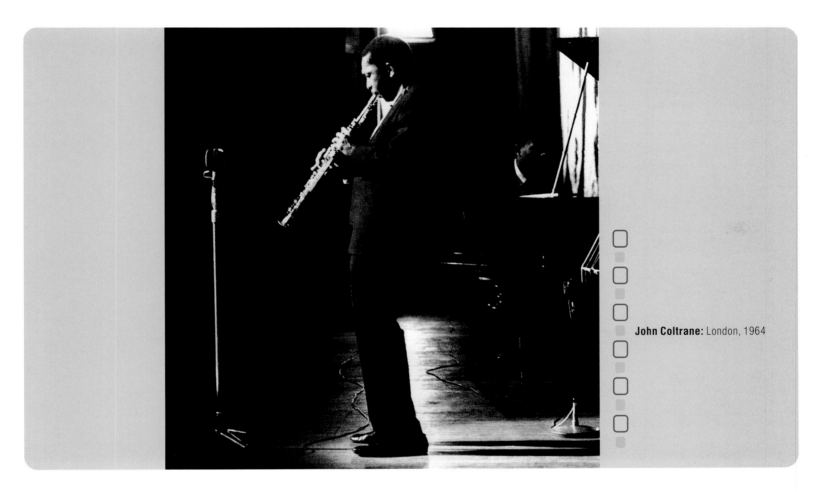

John Coltrane: London, 1964

At the riverside with my Rollei • • • • • I was still trying to photograph concerts with the Rolleiflex, although not always successfully. I did a whole series for Riverside Records when they first launched in England, but some of the live stuff with the likes of Thelonious Monk was not so good. I'll always remember Riverside's Jack Lewerke (sadly no longer with us) saying to me, "Dave, if you only spend your time photographing three things – jazz, chicks and motor racing – you won't go far wrong." The first two, as you may have gathered by now, I have done. Motor racing – my sporting passion then as now – has yet to be graced by my camera (I think I'll leave that to the experts), but it does give me a lot of armchair excitement.

One or two concerts with the Rollei did work well: I'm thinking of Miles Davis at the Odeon Hammersmith, and Art Blakey and John Coltrane at the Gaumont State Kilburn, both in London. The Coltrane shots were touch-and-go, as the negs were very thin black-and-white. I had them intensified, the only time I've ever done that, and ended up with just one usable picture. I didn't see him again, so that shot has been used on countless occasions.

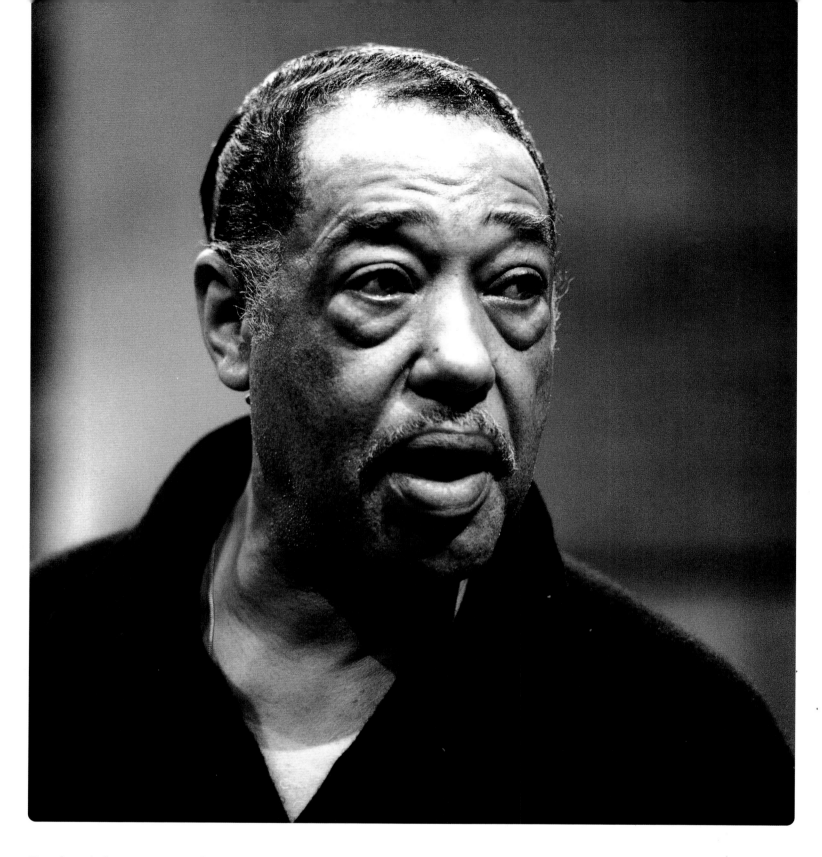

Reciprocity across the pond • • • • • Bristol has always been a good place to get pictures. I went to the Colston Hall so often that the chief bouncer (head of security!) would ask me if I was coming down for such-and-such a band. If I said I didn't have a photo pass he'd say in his lovely West Country brogue, "Don't worry about that, boy, we will always get you in."

The hall was a very popular venue for all the American bands that had started to tour the UK in the early Sixties. Until that time there was a union ban on British musicians playing in the USA and Americans playing over here, unless they slipped in under the "variety" cloak. The Sixties pop revolution changed all that, so an exchange deal was set up between governments and unions whereby every musician that played over here had to have a British one playing there. For example, The Beatles and a couple of other groups would go to America with the Duke Ellington Orchestra coming here in exchange. These exchanges were rarely culturally matched, but in their own corrupt way they seemed to work. In any event I was personally delighted with all these exchanges, and one of the first major bands I became involved with was Duke Ellington and his orchestra.

Duke Ellington: | **Miles Davis:**

Coventry Cathedral, 1966 | London, 1960

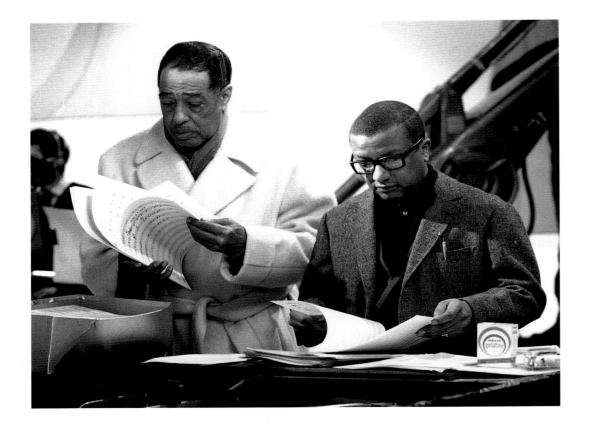

| **Duke Ellington, Billy Strayhorn:** London, 1964

Put up your dukes • • • • • In 1964 the Duke was touring here and spent a couple of days at Chelsea Studios recording a TV show. In those days every camera shot was carefully plotted in advance. During the long periods when nothing was happening, apart from moving the cameras, I would get to know the musicians and take a number of candid photos.

So much has been written about the Duke and his music that it would be foolish of me to try to add to it. It's enough to say that I went to see him with my pictures after much prodding from friends. For me it was like an audience with royalty. I need not have worried: he loved the pictures – and gave me a very large print order. I continued to photograph the Duke at every possible opportunity: even in Westminster Abbey where I hid in the crypt behind the altar so that I could shoot the show unseen through the gilt altar-work. Incidentally, the security people thought I was with the band…surely the wrong colour!

Later I caught the Duke in Newport in the States – and then Hollywood. It was here I photographed him for the last time.

We had met on the plane going over. I could tell he looked tired and ill, which wasn't surprising considering the gruelling schedule that he had just finished. The Hollywood show was called *Love You Madly* and consisted of an all-star band made up from the ranks of the Ellington and Basie orchestras and guests including Ray Charles, Sammy Davis Junior, Peggy Lee, Aretha Franklin, Roberta Flack, Sarah Vaughan, Joe Williams and many more. Quincy Jones was master of ceremonies, supervising all the different arrangers – and their arrangements. They were all working to impossible deadlines. Rehearsals took place at the old Chaplin studios. The show itself was taped before an invited audience at Century City. The only trouble was that what turned out to be the final show was running hours late and didn't start until three in the morning, when even jazz musicians will be tired – having been in rehearsal since nine the previous morning. I didn't see that show and those rehearsals were the last time I saw the Duke. He died shortly after, but my photographs and his music will live on for ever.

Give me five – no, 625 • • • • • Now a galaxy of jazz talent started arriving on our shores. The newly opened television channel, BBC2, started recording them in April 1964. The first series of programmes was called *Jazz 625* – appropriately for our first channel with 625 lines. It ran for two years and was filmed at the new White City Television Centre, directed by Terry Heneberry. He was ably assisted on the floor by Vernon Lawrence and Jimmy Moir, who are now such luminaries in the broadcasting world. I was always allowed to photograph the rehearsals, and quite often the show. Stills photographers working in television require a lot of trust from the director's point of view. The director needs to know that you're not going to get in front of the camera, or, just as importantly, make any noise. Over the years one becomes quite adept at pressing the shutter on the down beat. Mind you, a friend of mine in New York, Chuck Fishman, used to photograph even in very quiet concert situations with a Leica – but he would always cough when he pressed the shutter. I bet he never tried that at a Keith Jarrett concert.

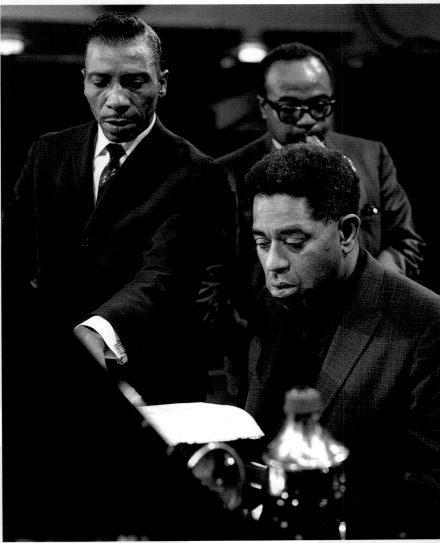

| **T-Bone Walker, Dizzy Gillespie, James Moody:** BBC TV, London, 1964

| **Peggy Lee, Sarah Vaughan, Roberta Flack, Aretha Franklin:**
Hollywood, 1974

In concert, *in camera* • • • • It was very easy working at the BBC. Amazing though it seems now, the press office actually had one woman, Pam Pyer, whose sole job was to arrange photo passes for photographers, and look after us when we were on the premises. What with the jazz shows,

Top Of The Pops (*TOTP*), the *In Concert* series, and all those light entertainment specials with artists like Petula Clark, Shirley Bassey and Val Doonican, I spent a great deal of time, either at TV Centre or at the TV Theatre on Shepherd's Bush Green. I always figured in those early years that it would have been easy to set up a little office hidden somewhere in the depths of Television Centre, but I never put it to the test.

It was at these shows that I began to develop and cement lasting relationships with many of the jazz greats: Woody Herman, Ben Webster, Oscar Peterson, Dizzy Gillespie, Dave Brubeck, Erroll Garner and Jimmy Smith to name but a few.

The second BBC2 jazz series was *Jazz Goes To College*. As the name implied the whole series was shot on location at colleges and universities around the country. Shows that stuck in the mind were those with Dave Brubeck at Norwich, and Art Blakey and Sonny Rollins at Reading. The most interesting location was the Oxford Students Union with Earl Hines and an all-star band.

Jazz At The Maltings was the third BBC2 series at Aldeburgh in deepest Suffolk. It was a great location – once you arrived. That was the main complaint of the musicians: it took nearly as long to get there by coach from Heathrow as the transatlantic flight itself. When, later, the building burnt down, there were many sick jokes in the business that somehow Buddy Rich had organised it. He was certainly very vocal about the journey. The travel story that takes a lot of beating was that of Earl Hines who appeared at the Maltings one day, Milan the following day – and the day after that back in Norwich, just a few miles from the Maltings.

For me those shows meant a great week out of London. The musicians came through daily, and the roll-call tells you how great the music was: Gerry Mulligan, Muddy Waters, the Dizzy Gillespie Big Band – and a fabulous session with just four drummers on stage. Max Roach, Elvin Jones, Art Blakey and Sonny Murray were all playing together...well, three of them were, Sonny Murray was kind of left at the starting post. The non-musical highlight was mingling back-stage with Count Basie and the guys in the band when Princess Margaret looked in – a photographer's dream.

Count Basie, Princess Margaret:
Aldeburgh, 1968

opposite:
Bill Evans: BBC TV, London, 1965

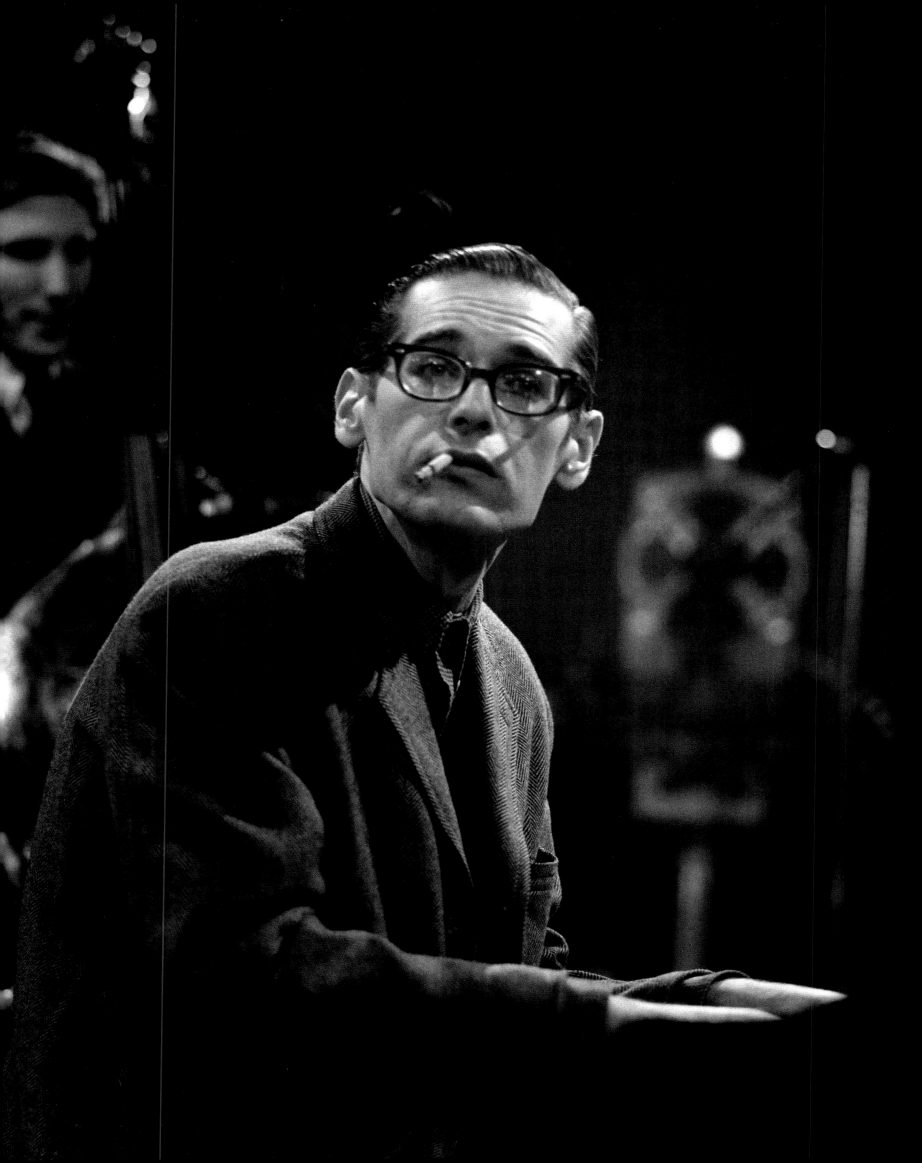

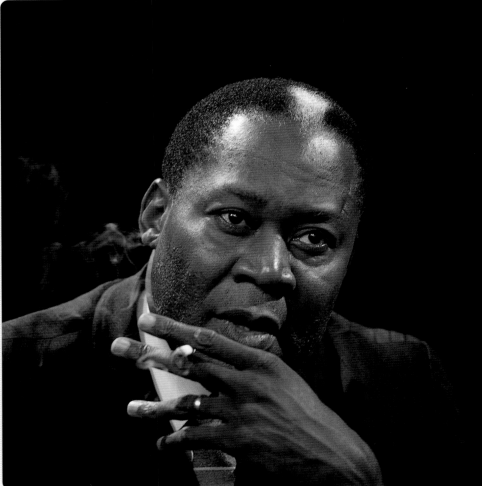

Memphis Slim:
BBC TV, circa 1966

Petula Clark:
BBC TV, 1966

T-Bone Walker:
BBC TV, 1964

Son House:

London, 1969

Nancy Wilson:

Talk Of The Town, London, circa 1966

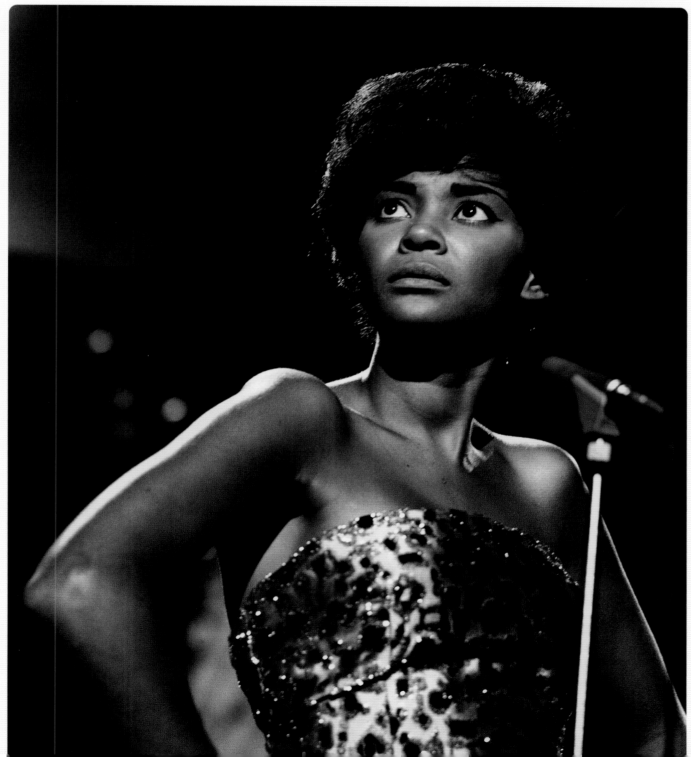

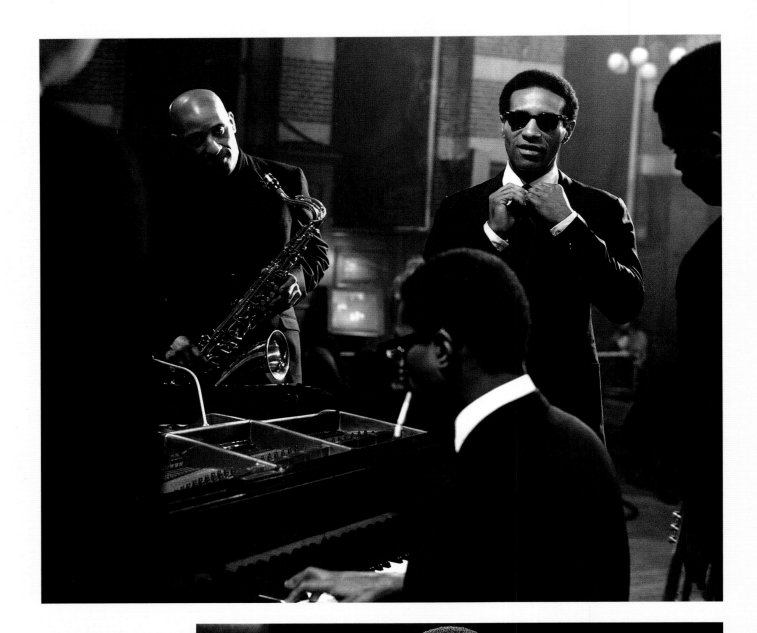

Sonny Rollins,
Ron Mathews,
Max Roach,
Freddie Hubbard:
Reading, 1967

Jimmy Smith:
London, 1965

opposite:
Sonny Rollins:
Reading, 1967

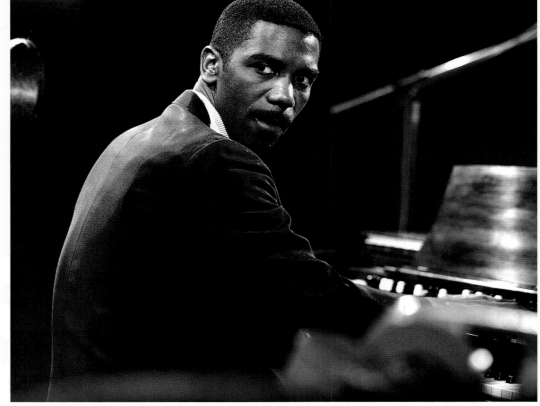

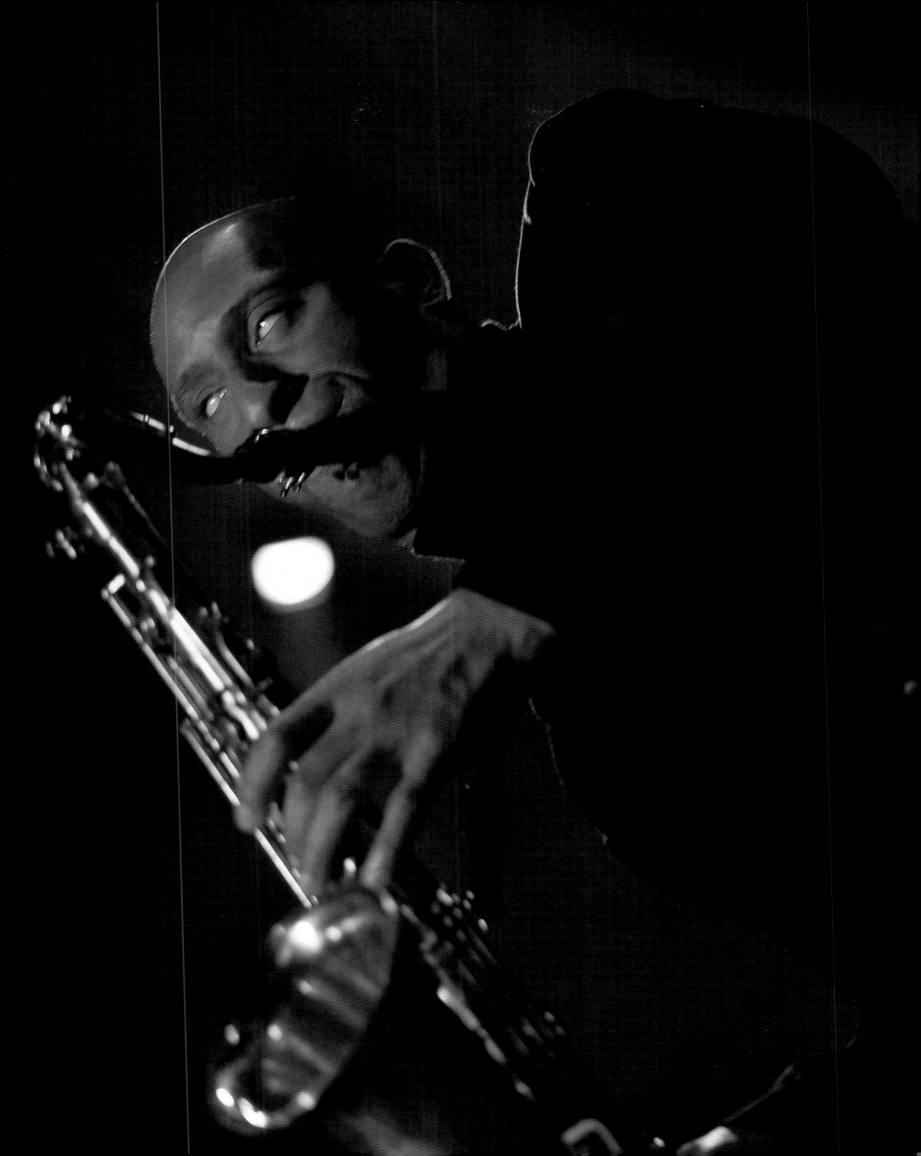

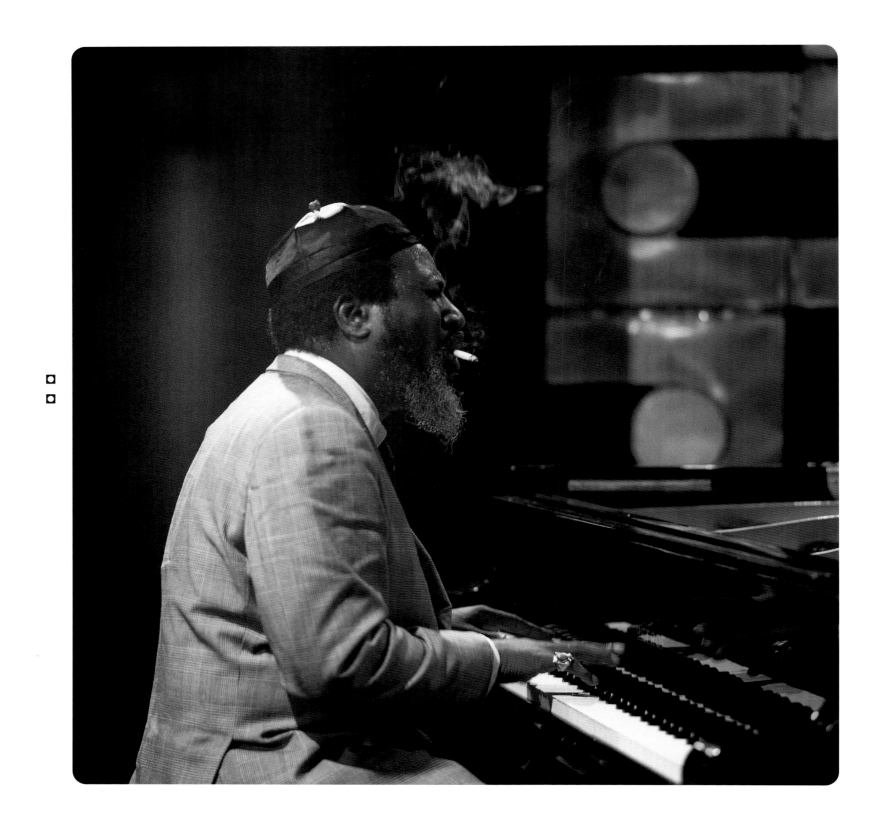

| **Thelonious Monk:** Ronnie Scott s, London, 1969

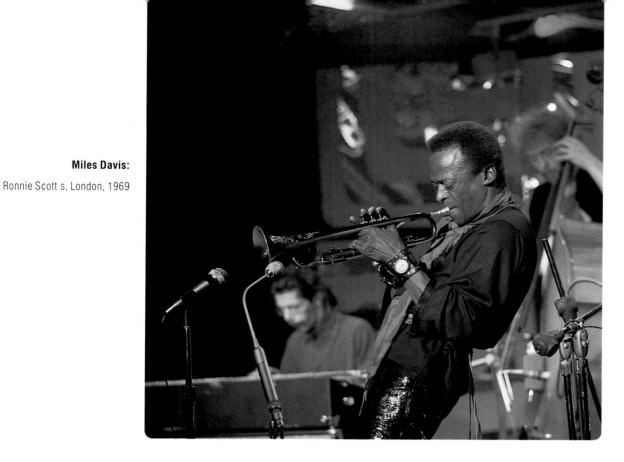

Miles Davis:
Ronnie Scott s, London, 1969

Even the flies resisted • • • • • But the *pièce de résistance* of all those series was filmed during ten days at Ronnie Scott's famous club in 1969. The series was called *The Jazz Scene At Ronnie Scott's*, and they got sixteen programmes out of those ten days. I had already built up a good relationship with the club, so I could do what I wanted (I still can). Jazz for me is at its best in a small club. This may not be good for the finances, but it's great for atmosphere. That wonderful wall of sound that hits you close up from a big band is about as exciting as it gets.

By this time television lighting could be very good. Those programmes gave me golden opportunities to photograph a club atmosphere in good light and in colour. Yet another list will remind the older ones among my readers – and inform the younger ones: among those appearing were Oscar Peterson, Lionel Hampton, Gary Burton and the Clark Boland Big Band.

On one occasion Miles Davis didn't turn up for the rehearsal. They were about to have heart attacks when he walked in ten minutes before the show was due to start.

Thelonious Monk looked fabulous with that trademark furry hat. I had, of course, no idea that some twenty-eight years later one of those shots would appear on a US postage stamp.

Gary Burton:
London, 1968

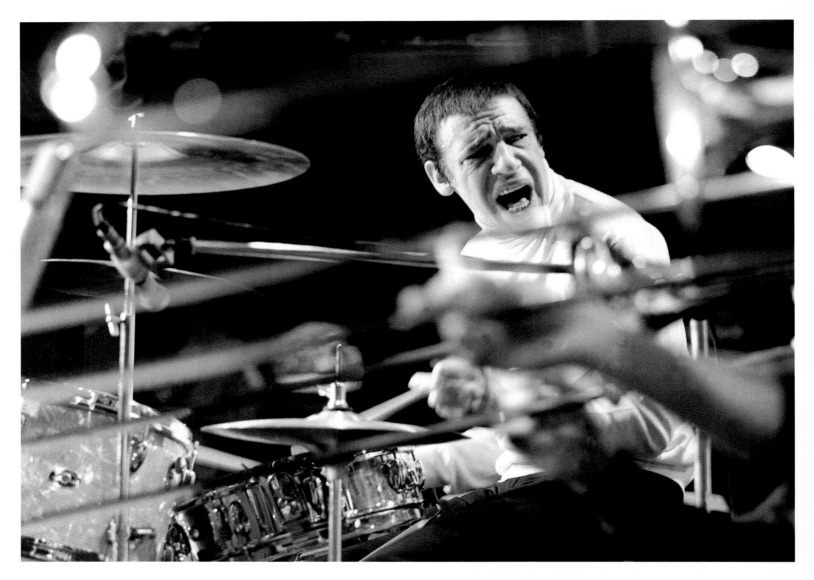

A rich friendship • • • • • Buddy Rich and I had already become good friends, so it was an extra pleasure to find his band on the show. He was always great to work with and, contrary to popular belief, I never found him difficult to please. It was true, though, that he suffered fools rather badly. I was in his dressing-room before a show in New York once. The place was filling up with all sorts of hangers-on, including a couple of well-known stars. Suddenly Buddy stood up and said, "Everybody out – I gotta get ready." I was making for the door with the rest when Buddy said, "No, not you, Dave, I want to talk to you," and we settled down for another five or ten minutes in peace and quiet. Sometimes that's all musicians want to prepare for a show.

He always used to say he didn't mind what I did to get my pictures: "Go when and where you like, get right into the middle of the band if you have to." I can't say I did that, but I did get very close to the fourth trumpet or trombone on a number

of occasions. I once got onto the hallowed Barbican stage during one of his performances – much to the chagrin of the organisers. Now you are lucky if you're allowed to stand right at the back of the hall.

I always experienced a very high adrenaline rush when photographing a man in action like Buddy. Neither drugs nor drink could build up that level of high, not for me anyway. Buddy had major heart bypass surgery in 1983 and, against doctor's orders, was back at work two months later. He showed me his scars, which were hardly healed, before going out on stage and playing a fabulous set. It was a sad day when I learnt that he had died in 1987. It appears that on his way to the operating theatre he was asked by the nurse if everything was okay.

"No," he answered.

"What's wrong," she asked.

"Country music," was his reply.

Monkey on my back • • • • • In November 1964 I moved to a basement in Charing Cross Road, on the same day my first son, Simon, was born. Making repros (reproducing black-and-white prints) was becoming a very important source of income and most of the space was taken up with processing gear. I hired Brian Phelps to run it and, as he turned out to be very good, I let him get on with it. This allowed me to pursue my photographic career unabated, albeit without a studio for the next few years. On the few occasions when I needed one I would hire one – or improvise. One phone call out of the blue asked me to do a studio session for The Bonzo Dog Doo-Dah Band. Could I shoot it in Birmingham? And could I supply a gorilla outfit – with someone in it. To this day I don't know why I was picked. It was definitely not my scene, but they seemed happy with the resulting gorilla album cover.

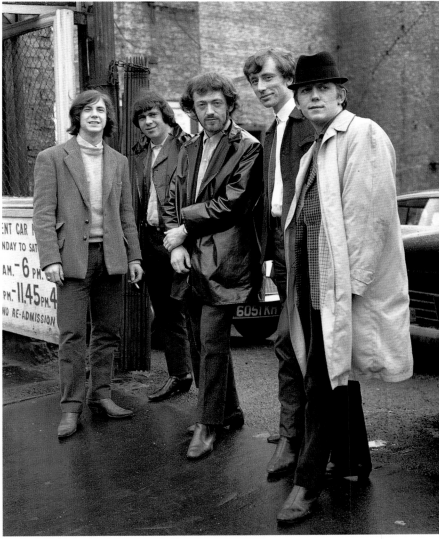

The Bonzo Dog Doo-Dah Band: Birmingham, 1967 | **The Pretty Things:** London, 1965

Another unlikely shoot for me was a session for Philips Records' The Pretty Things. Not really knowing what to do we wandered around the dirty back streets near their offices, which were just off Marble Arch in London. To my mind it summed up the music, but I'm sure the fans at large had other ideas.

More to my taste was a shoot I did for Donovan. They wanted him in a white suit against a white background, in George Harrison's house in Weybridge. Fortunately there were some nice white walls, so I took the pictures with mobile lights. When, after all that, they decided they wanted a yellow cast on all the pictures I had to get the lab to dye them (no photo shop in those days). The end product was used on the rear of the *Mellow Yellow* album cover. At the time of writing I ran into Donovan at MIDEM (the music industry's annual bonanza) in Cannes. We had a good chat, swapping some interesting stories about the old days, and I took some up-to-date pictures.

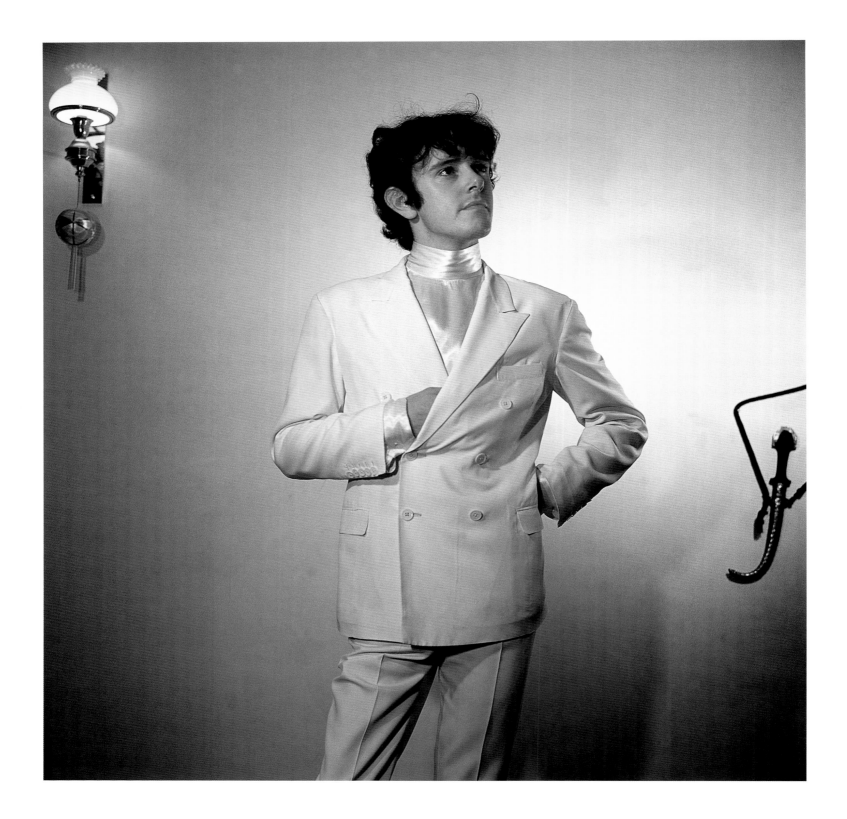

Donovan: Esher, 1966

No Jonah, she • • • • • There is a strange phenomenon related to working in a transitory business. Friendships and bonds hold together through thick and thin. I have many musician friends I see only once every couple of years or so, but we always manage to pick up where we left off.

Without doubt my favourite lady singer of those times was Sixties icon, Joan Baez. I was lucky enough to work with her doing photographs for the record company and myself during her early UK trips. On one memorable tour she was recording a live TV concert in a folk club in Edinburgh. Felix Topolski, an artist of the period, was drawing her while she sang, and this became part of the programme. The following day we wandered around the castle and its beautiful surrounding streets making pictures. Joan hadn't been too well on the trip, and seemed tired. A week later she was due to appear at the Royal Festival Hall. As the show began I was back-stage with the promoters, managers and numerous hangers-on.

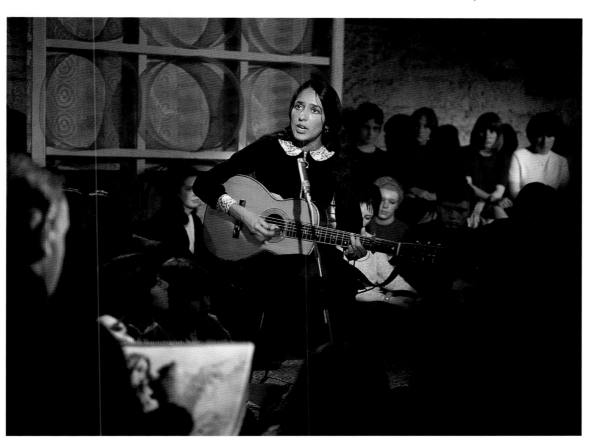

| **Joan Baez:** Edinburgh, circa 1964

Joan was just about to go on stage when she suddenly turned back. The strain was obviously showing. Imagine my surprise when she headed straight for me and threw her arms around me. I gave her a comforting hug and muttered that everything would be fine: "You can do it." She went out on stage and played a beautiful concert.

Some thirty years later, I ran into her in a hotel in Hamburg. We exchanged a little conversation and, after being prompted by my partner Dede as to who I was, Joan asked me for my card as she was coming to London for a concert and would like to invite me. Well, untypically for this business, the tickets did turn up. Best seats in the house and a back-stage pass. Royal Festival Hall yet again, *déjà vu* or what? After the show she came out of her dressing-room to see me. Hugs and kisses ensued. The concert was magical; the reunion memorable.

FROCKED

As I've stated elsewhere in this book, I can't be said to be fashion conscious, but I do know what I like. Are these examples a statement of the times? Or is it in most cases some fashion designer's imagination running wild. The jury is still out, I think.

Tina Turner | Brenda Lee
| Flick Colby

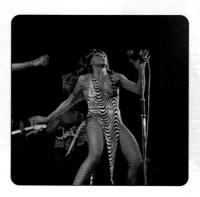
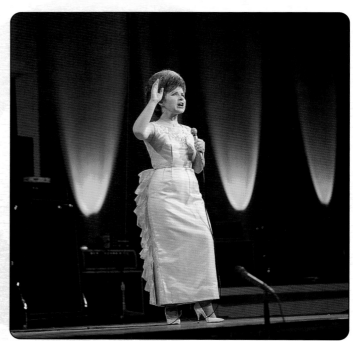
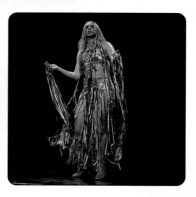

opposite:

The Vernon Girls | Diana Ross
Shirley Bassey | Donna Summer
Ella Fitzgerald | Cleo Laine

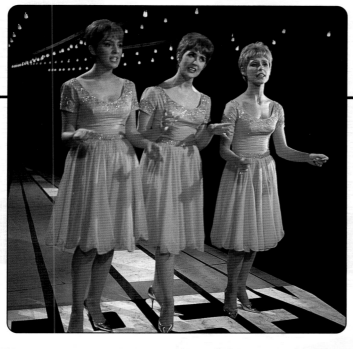

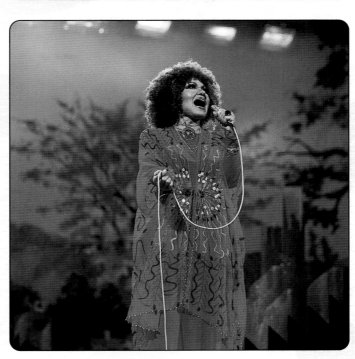

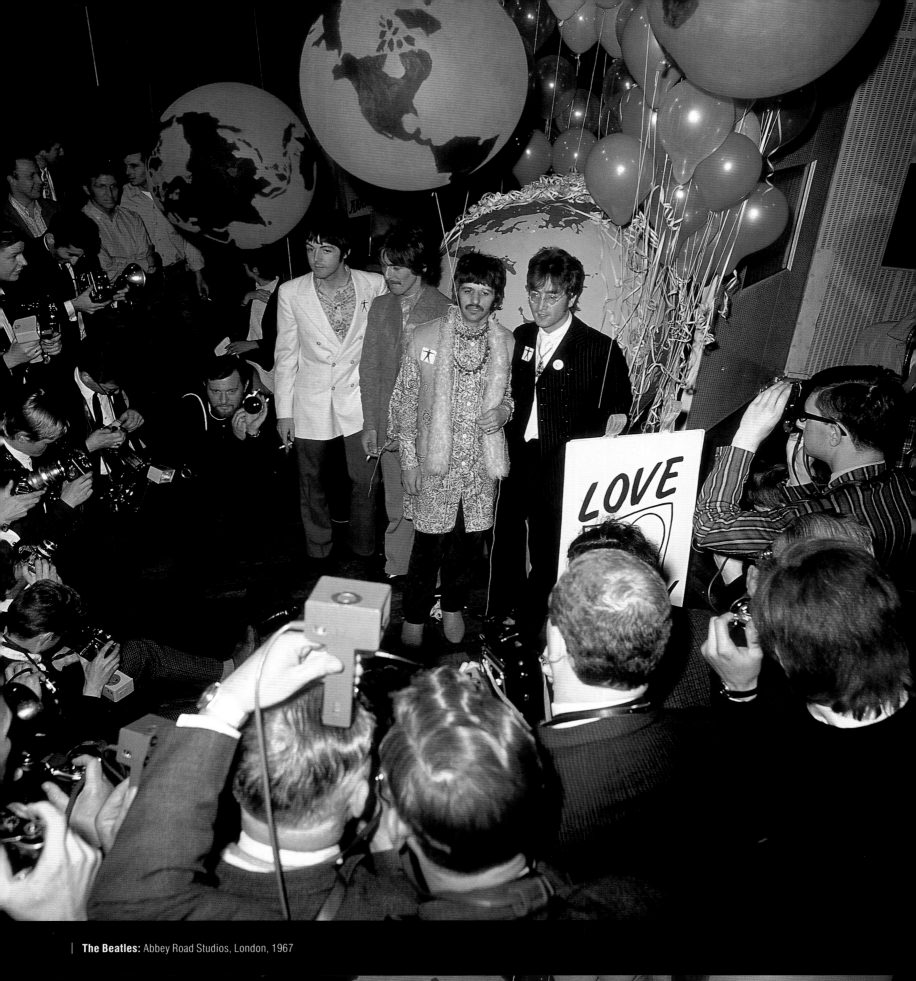

The Beatles: Abbey Road Studios, London, 1967

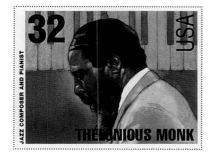

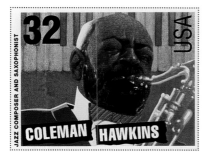

Stamp Designs: © 1995 US Postal Service

Louis Armstrong: New York, 1967

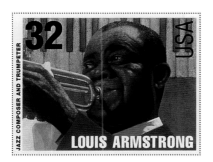

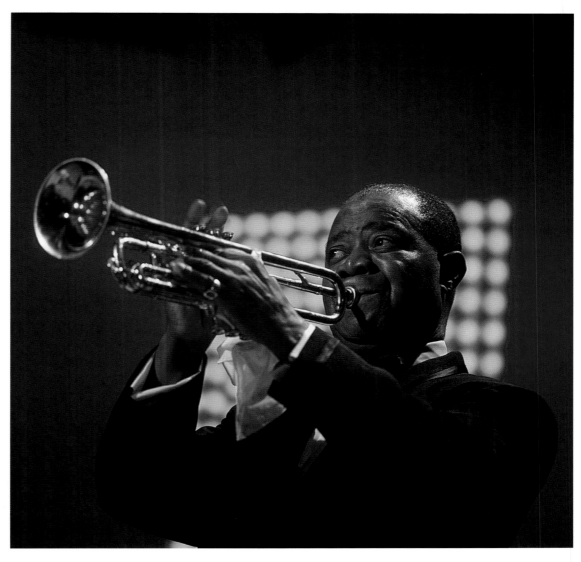

All you need is film • • • • • The year that changed
my life for better or for worse was 1967. It all started halfway
through the year on 25 June. I was at the Abbey Road studios
where The Beatles were being filmed, recording 'All You Need
Is Love'. This was for the first major world satellite television
link to twenty-six countries in five continents and an estimated
audience of four hundred million.

As it happened I was flying to New York the next day so I was
able to take finished slides of that Beatles recording with me to
sell to the American magazines. It was my first trip to the Big
Apple. Exciting? I'll say, and I packed a lot into those few days.
Most notable for my camera was a set of colour pictures of
Louis Armstrong playing three songs for a Herb Alpert TV
recording: great light, great colour. Those colour pictures have
paid for many a transatlantic airfare over the years and one was
used on the Louis Armstrong stamp in the US Post Office
American Jazz series in 1996. I guess that was the most

unusual and prestigious use of my work. The Louis Armstrong
was not only one of the series of ten, but also a stamp on its own
selling by the millions. In all, three of my pictures were used,
the other two subjects being Coleman Hawkins and Thelonious
Monk. I did take the US Post Office to task for not giving me a
single credit in all the PR literature, but I was written up in the
stamp year books.

The next weekend saw me at the Newport Jazz Festival for
the very first time. I had been introduced to the festival by Jack
Higgins of the Harold Davison Office in London who used to put
on most of the UK jazz tours. Accommodation was very limited
as were my funds, even though the exchange rate was about
eight dollars to the pound. The festival used to rent big "high
society"-type houses which were normally in use as private
schools, to provide accommodation for foreign journalists and
musicians. I was lucky because I was able to get a room, and I
had it all to myself. But I suspect the communal shares were fun.

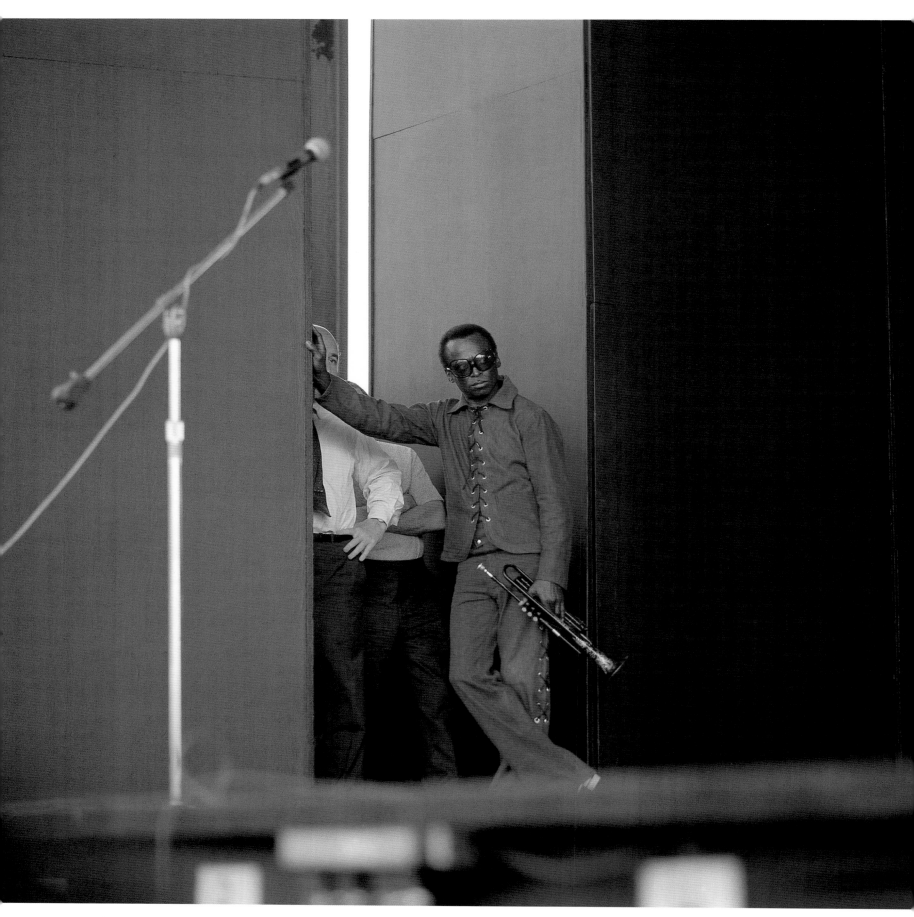

| **Miles Davis:** Newport, 1969

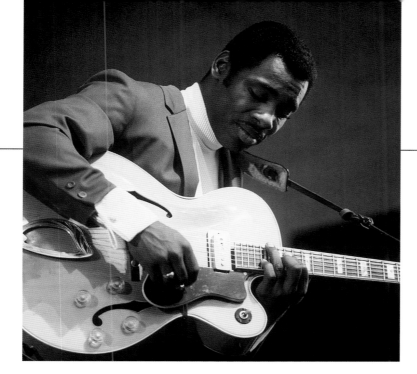

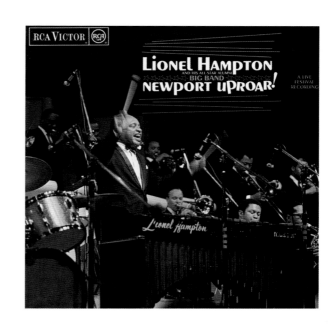

The artists' list was a who's who of jazz and I felt very privileged to be there. As far as I knew I was the only photographer from Europe and certainly the only freelance. I can't count the number of times I was told, "You must be very special, they don't allow freelances in here." I had a great time, with parties every night. More to the point, I made some memorable pictures. My first American album cover sale came out of that Newport: Lionel Hampton and his alumni orchestra. Other notables that year were Ella Fitzgerald, Miles Davis, Bill Evans, Nina Simone, Count Basie and Buddy Rich. I also took some excellent pictures of Wes Montgomery – the last time I would photograph him.

| **George Benson:**
Newport, 1969
| **Lionel Hampton:**
Album cover, 1969
| **Wes Montgomery:**
Newport, 1967

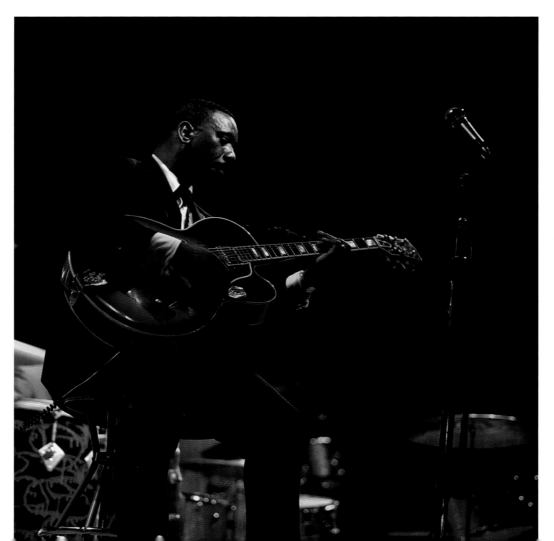

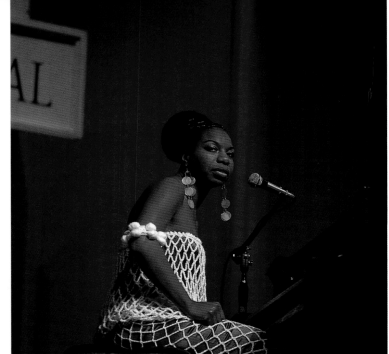

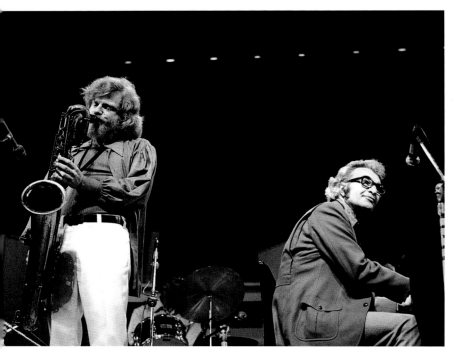

The last set • • • • • I covered Newport every year until its untimely closure in 1971. Halfway through the festival the site became full, with another twenty thousand fans trying to get in. The city authorities decided to close down the whole event for safety reasons. This provoked a mini-riot, and ensured that the festival could no longer be held at Newport.

The last jazz played there was by the Dave Brubeck trio with Gerry Mulligan: the subsequent album aptly titled *The Last Set At Newport* is one of my favourite LPs.

Nina Simone:
Newport, 1967

Gerry Mulligan,
Dave Brubeck:

Newport, 1971 | **Frank Zappa:**
Newport, 1969

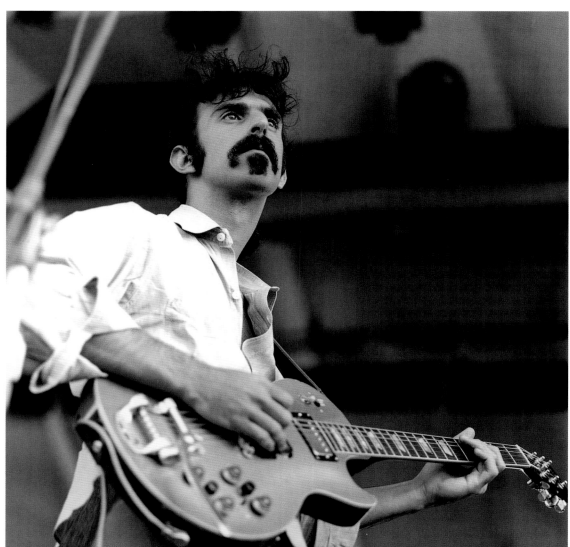

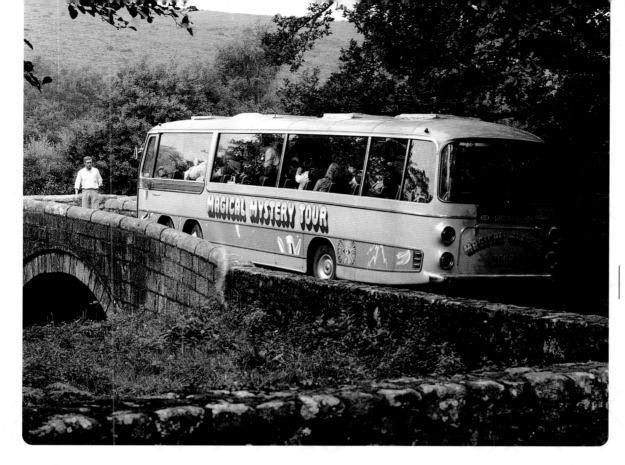

Magical Mystery Tour:
Bus, 1967

Magic, mystery and a car • • • • • Two months later I was off on my travels again, this time to Devon and Cornwall to cover The Beatles' *Magical Mystery Tour*. Information was scant as to what we could or couldn't do, but a telephone call to press officer Tony Barrow was somewhat reassuring. "I can't help you much," he said, "but I won't hinder you, either. We start on 12 September – and that's all I can say."

On the day I took the train to Bristol, picked up a rental car (with lousy brakes, as I recall), and drove to the "secret" start. The first day was pandemonium, because at least fifty photographers were jostling for positions. That may not be a lot by today's standards – for royalty in hospital, for instance – but it was an unbelievable crowd in those days. We had to grab pictures whenever the coach stopped, then leap back into the car, and hang on to the coach like a leech through the English countryside.

On the second day only twenty-five photographers appeared. By the fifth day there were only two of us left. The other one was Chris Walter. The last three days were spent in and around Newquay, where I managed to find a cheap B&B opposite the Atlantic Hotel where the lads and their party were staying.

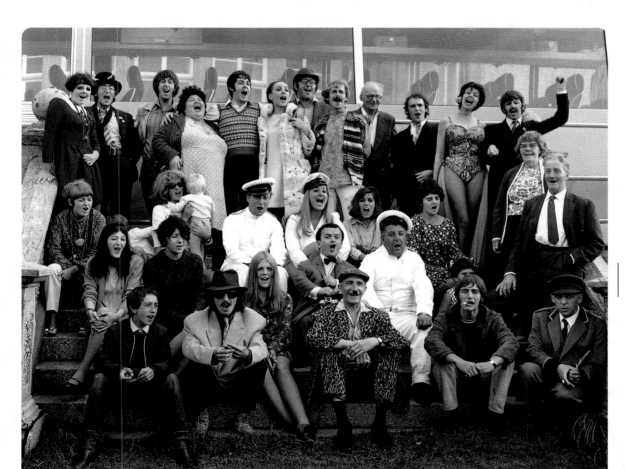

Magical Mystery Tour:
Group, 1967

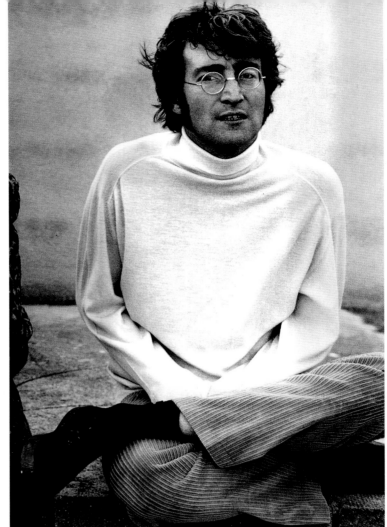

John Lennon

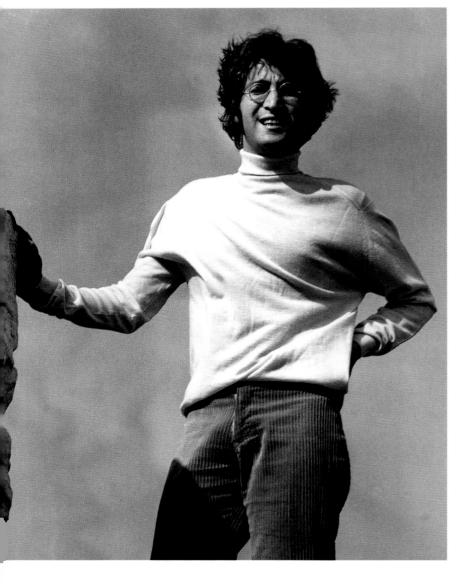

I managed to get only one or two frames of the Fab Four together, but there were plenty of individual and funny shots to be had. The film wasn't a great success: most people could make neither head nor tail of it, but that didn't stop me selling the pictures.

Having given up on me as a photo-journalist, my friend Ian Macintosh suggested that I put my overseas syndication with a more suitable agency. He told me that there was one honest man in Fleet Street one should go and see: Frank Selby who owned Rex Features. Some three months later I received a cheque for five hundred and fifty pounds for *Magical Mystery Tour* photo sales in Japan – just enough for me to buy a brand new car, a Ford Cortina. I had wheels at last.

I photographed individual members of the group several times after that. I didn't really get on speaking terms with any of them, unless you count the time Paul chastised me for not going to talk to him when Wings were doing a *TOTP*. "What's the matter...don't you recognise me or something?" There was no answer to that.

opposite:

John Lennon: Newquay, 1967 | **The Beatles:** Plymouth Hoe, 1967

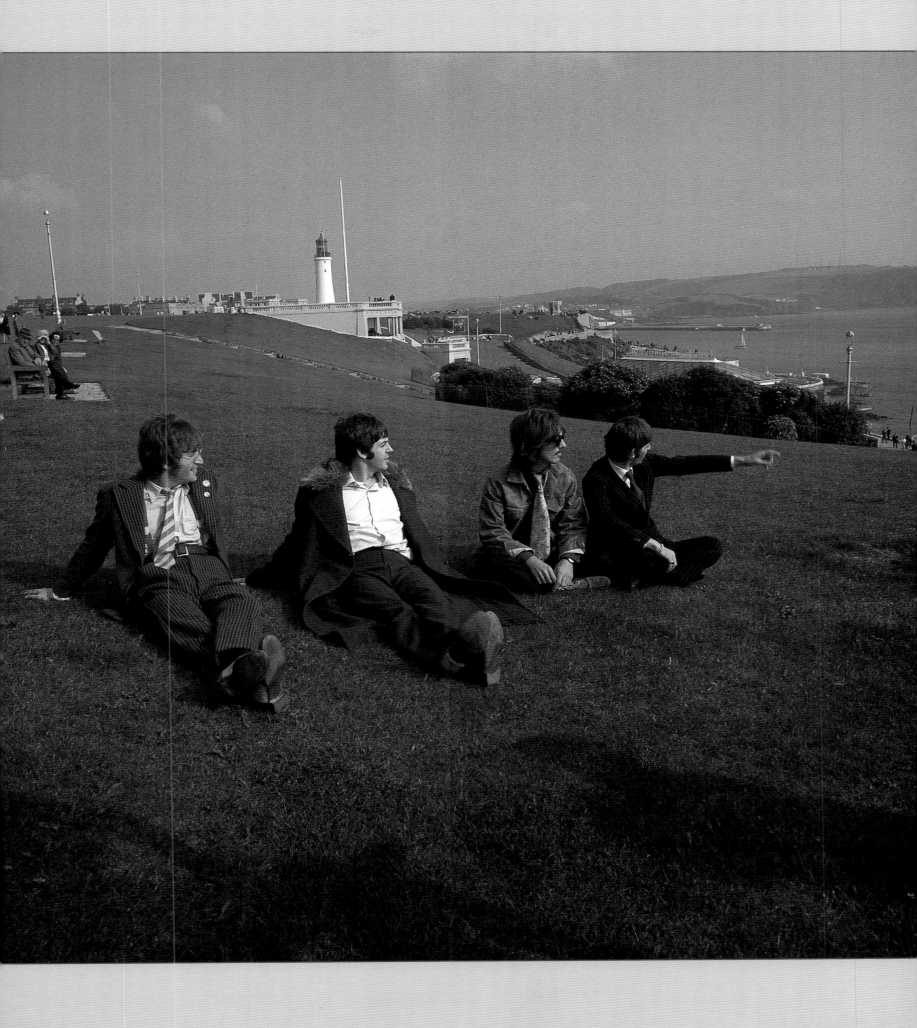

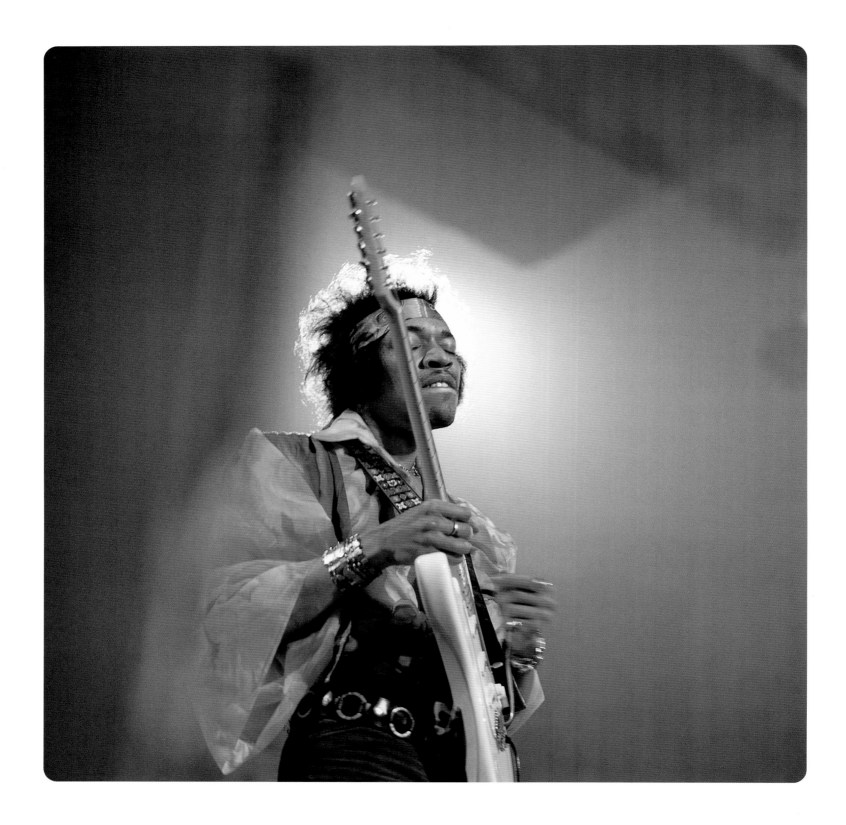

| **Jimi Hendrix:** Royal Albert Hall, London, 1969

LAYING JIMI TO REST

· · · · ·

ONE OF THE MOST IMPORTANT EVENTS I PHOTOGRAPHED
TOWARDS THE END OF THE SIXTIES WAS JIMI HENDRIX'S LAST
CONCERT AT THE ROYAL ALBERT HALL IN FEBRUARY 1969. I
HAVE TO SAY, THOUGH, THAT ITS IMPORTANCE WAS NOT APPARENT
TO ME AT THE TIME. BECAUSE THE CONCERT WAS BEING FILMED
IT WAS DIFFICULT TO GET PERMISSION TO TAKE STILLS, BUT I
KNEW THE PROMOTER, HAROLD DAVISON, AND I DISTINCTLY
REMEMBER BEING ESCORTED ACROSS THE STAGE BY JACK
HIGGINS (HAROLD'S RIGHT-HAND MAN). HE CALLED OVER THE
HEAD USHER AND SAID, "THIS IS MY PHOTOGRAPHER...HE CAN
TAKE PICTURES WHEN AND WHERE HE LIKES...JUST LEAVE HIM
ALONE!" I THINK I WAS THE ONLY PHOTOGRAPHER THERE, APART
FROM THE FILM'S STILLS MAN.

THE LIGHT WAS UNUSUALLY GOOD, ESPECIALLY FOR THE
ALBERT HALL, AND I SHOT IT ALL IN COLOUR ON THE
HASSELBLAD. THE PICTURES LAY IN MY DRAWER FOR AT LEAST A
COUPLE OF YEARS BEFORE I WAS APPROACHED BY PACE POSTERS.
AT THAT TIME THEY WERE THE MARKET LEADERS IN THE POSTER
BUSINESS, AND WERE LOOKING FOR PICTURES OF CHART-
TOPPING GROUPS OF THE EARLY SEVENTIES. THEY ASKED TO SEE
WHAT ELSE I HAD AND THEY COULDN'T BELIEVE THEIR EYES
WHEN THEY SAW THE HENDRIX PICTURES: "DO YOU MEAN TO
TELL US THAT THESE PICTURES HAVE BEEN HIDING HERE FOR
THE LAST COUPLE OF YEARS?" I HAD TO ADMIT THAT MARKETING
WAS NOT MY BEST SUBJECT, AND I HAD BEEN SPENDING A LOT OF
TIME SETTING UP MY COLOUR LABORATORIES.

THE PUBLISHED POSTER FEATURING MY SHOT OF JIMI BECAME
A BEST SELLER, SHIFTING WELL OVER A QUARTER OF A MILLION
COPIES. SOME YEARS LATER I WENT INTO A CLOTHING BAZAAR IN
MOMBASSA, KENYA, AND THERE WAS MY HENDRIX POSTER
HANGING ON THE WALL AS THE MAIN SHOP DISPLAY. IT GAVE ME, I
MUST ADMIT, A VERY SATISFACTORY, WARM GLOW.

No 30 Charing Cross Road · · · · · I had moved to a basement in 28 Charing Cross Road which had its limitations. I had noticed that the five floors above the cafe in the building next door, No 30, had been empty for a long time, but when I asked the letting agents about renting one floor for a studio, I was told, "No, sorry, we can only let it as one unit." Crazily, I explored the idea. And with the help of our bookkeeper/accountant we began to devise a devilish scheme. He suggested we set up a colour processing lab: "You supply the know-how – and I'll supply the money." In the event, neither of us did very well. But by some miracle we were granted a ten-year lease on the building. The managing agents said they didn't need to take up references as long as I signed a guarantee. This came as a bit of a shock. There must be some mistake, I thought, but who am I to argue?

Getting an empty and run-down building was one thing. Fitting it out to a viable business standard was quite another. It had been used as a book warehouse by Bernard Quaritch, the antique book people, and the place was full of abandoned books. When we got

someone in to clear them out, he even give me one hundred pounds for the privilege. Our so-called business plan estimated that we needed twelve thousand pounds to renovate the building and install a state-of-the-art colour lab. The problem was that my bookkeeper only came up with three thousand pounds.

The short version is that an ad in the *Financial Times* produced a White Russian investor prepared to speculate three grand, and through some new accountants we found a merchant bank – M B P Russell – prepared to put up the rest. So Redfern Photographic Holdings Ltd was born, which ran Redfern Colour Labs and Redfern Repros, but, at that stage, not the library. My archive was building up rapidly, and I was beginning to realise it was an important asset .

Parky and the bailiffs · · · · · The story gets worse before it gets better. You know the scenario. You have a five-storey building, so you fill it with people. Parkinson's Law steps in so you hire people to look after the people. At the height of our operation we were employing twenty-six. Needless to say start-up costs were more than expected (aren't they always?), and it took a long time to establish the colour labs' reputation. As a personal guarantor for just about everything, the buck definitely stopped at my desk.

It's a wonder I took any pictures in those few years, as my most frequent visitors seemed to be the bailiffs. The Westminster County Court (conveniently just round the corner) guys were in the main very charming. We developed a mutual relationship such that they used to nip around and warn me if they had a summons outstanding. They'd give me a couple of days to make an application for time to pay before they had to come round officially.

I was at the court one day, looking at the list for that morning, when a voice behind me said, "Good morning, Mr Redfern, no, you're not on today." To which I replied, "Look at the plaintiff list, not the defendants."

"Oh, I'm so sorry, sir."

It was an easy mistake to make, but I was for once suing someone myself.

In general, the law was and still is on the side of the debtor. Another bailiff would often say, "I'm now going to see your friend, Pete King, at Ronnie Scott's to see what he has got for me." We were all in the same club, but at least all our suppliers and staff always got paid in the end, and wages were mostly paid on the nose.

opposite: | below:
Studio Advertisement: 1969 | **Studio Letterhead:** circa 1969

overleaf: | **The Who:** London, 1971

New fan? • • • • • The shit was really hitting the fan as the Sixties turned into the Seventies. My lifestyle and lack of security formed a recipe for disaster in my personal life. I was going through my first divorce; the lab business was, of course, running out of money; and the accountants and advisers had come up with yet another scheme. We had an overdraft of some six thousand pounds. The bank suggested turning it into equity if we put the picture library into the pot. I could have walked away, but, where to? And with what? Especially as I had signed an endless number of personal guarantees.

With a gun at my head I felt I had no choice. So the deed was done, another overdraft arranged, wages paid, and I owned fifty one per cent of the whole business, with the bank having the rest. Not a very satisfactory arrangement, but we were still in business and soon starting to making an operating profit. However, there is little synergy between a processing business and a highly speculative picture library operation, which was starting to include other photographers' work. The only plus in all of this was that with twenty-six staff and a high turnover, the price of an air ticket to the States every so often was neither here nor there on the total expenditure.

Don't call the cops – they'll call you • • • • •
We did have some fun along the way. On one occasion I gave the staff a Christmas party in one of the local pubs, the Round House in Covent Garden, where we frequently had lunch. In those days the pubs shut at three for the afternoon. Because of the numbers involved the landlord suggested that we arrive at the pub at closing time so we could have the place to ourselves. We all sit down to lunch. Three o'clock comes and goes. There are still a few stragglers at the bar, some regulars and a couple of guys in suits. Most of my staff recognised the latter as plain-clothes cops (CID) because they had handled a robbery at the office a couple of weeks prior to this event.

At about a quarter to four the lunch is going very well: wine flows like water, dusk is falling outside. For those that bothered to notice, one of the CID men goes to make a phone call. Five minutes later there's a loud knock on the door. The landlord tells everyone to be quiet. He gingerly opens the door, and in walks a police sergeant and a pretty policewoman. They demand to know why we were still drinking at that time. The reaction of some of my staff was priceless: one girl was caught trying to climb out of the ladies' toilet window – we suspected she had been slipped some illegal substances earlier. Other staff members tried to hide under the table, and an old woman at the bar (not with us), was seen pouring her gin-and-tonic into her handbag. I start to become stroppy, the worse for wear with drink, and the stroppier I get the more my senior managers are telling me, "Cool it, or we will all get arrested." "No," I finally shout, "after all, this is a private party." On those words all the lights go out, a spotlight is turned on, and as the famous song 'The Stripper' starts to play through the sound system, the pretty policewoman starts to give a strip show!

Yes, it was a highly organised set-up, never bettered in my case, and well worth it to see the relief on all those faces. The uniformed police came from a model agency. The sergeant told me that I was so convincing that he thought it was a double set-up. The CID did make that phone call to the local police station (Bow Street) but just to warn them of what was going on and to keep the guys out of the way. The girl trying to climb out of the window in fact did end up in hospital for the night and our CID friends arranged for the uniformed branch to meet her boyfriend in North London that evening to explain where she was. All in all a day I will never forget. I don't know what happened to the old lady's handbag, but I know I didn't have to buy a drink in the pub for the rest of the year.

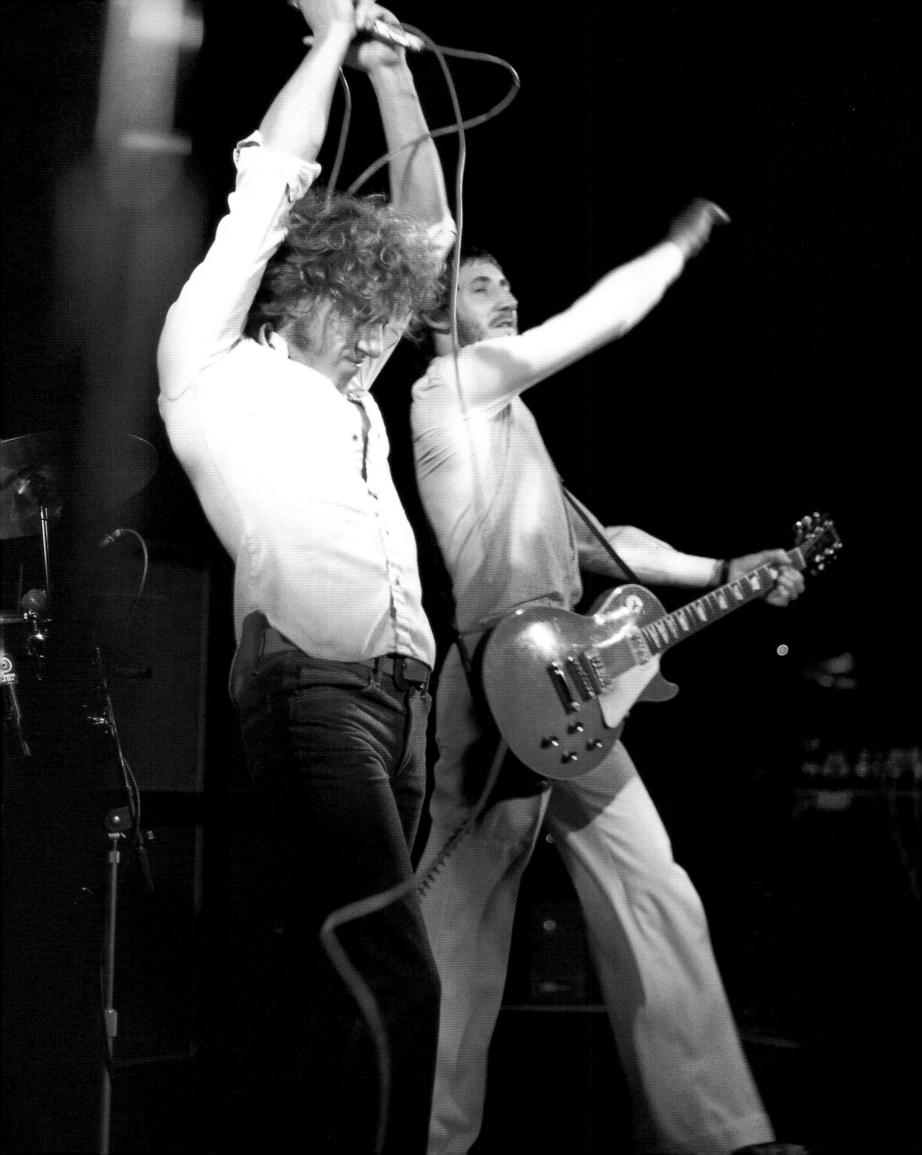

chapter three {**the seventies**}

this page: | **Count Basie:**
Carnegie Hall, New York, 1976

opposite: | **Dizzy Gillespie:**
Saratoga, 1979

THE SEVENTIES

Expansion Stateside • • • • • I soon came to realise that my photographic future lay in spending more time in the United States covering the abundance of festivals, stadium shows and concerts. The importance of America as both a source and a market for pictures was not lost on the bankers (they love global expansion) and Redfern Photographic Co Inc was set up in the early Seventies, in New York. A young man working in the repros department, Steve Morley, was showing promise in the photo direction, and was keen to go to New York to run the business. It

was a big gamble and we really didn't have the money or the expertise to set up a photo operation in New York. But we did give it a good go and poured in thousands of pounds (though never enough). It suited me very well with the moving of the Newport festival to New York, which was the Mecca of the jazz business.

Working in New York had its difficulties, though. You couldn't just go into the big concert halls and take pictures. Even if the promoters agreed, there were problems with the stage unions. It all started with the big magazines – *Look* and *Life*, for instance – paying stage hands to set up shots, or provide extra lighting. This became established as the norm for all show photography, apart from the daily newspapers. I had never had to pay for facilities before and certainly was not going to start then. Nor have I since.

It was a very pleasant surprise when I received a letter from George Wein, saying they were going to solve the access problem by appointing two or three photographers to cover the whole New York Jazz Festival, who would be able to shoot when and where they wanted as they would be technically working for the festival, supplying the news media and producing archive material. Was I interested? Is the Pope a Catholic?

This was a golden opportunity for me. In those early years, my friend, Chuck Stewart, and I had a free hand to shoot what we wanted. I had to get the film processed and supply pictures to the magazines pretty damned quick. One year I borrowed a darkroom on Seventh Avenue – for the first and only time. Trying to load film in total darkness with cockroaches jumping all over me was more than I could take.

For a few years I struck up a deal with *Newsweek* to do all my processing. Colour was not a problem, but the black-and-white processing left a lot to be desired. The film, normally HP4, went through the general soup, which may have been fine for the average small shot in *Newsweek*, but unfortunately the same shots turned out to be quite grainy when we came to blow them up some years later.

Peep, show · · · · · The honeymoon was over relatively quickly at Lincoln Centre and after a couple of years we were only allowed to photograph from the commentary box with a long lens. It did have its moments though. I used to take friends in as assistants, plus the odd bottle of wine, and sit in our own private darkened room with a large peep hole from which to photograph. More fun than serious photography, but I could make some nice three-quarter length shots with the 350mm lens on the Hasselblad, really good in black-and-white. It was an excellent vantage point for photography of whole groups and ensembles and, of course, I could listen to some fabulous music.

Carnegie Hall was easier for a few years. Many times I had the use of a front row seat, as they were held for the performers' friends and families and often not taken up. Most musicians didn't mind me discreetly taking pictures, in fact many would acknowledge my presence publicly which I didn't much care for. There were exceptions. The most notable was Keith Jarrett, who was notoriously difficult, so I chose not to get right down to the front. It didn't make much difference, though, for after I had taken about three frames he suddenly stopped playing and announced, "If the photographer will leave the hall I will carry on with the concert." Embarrassing or what! Try walking out of the concert hall without being noticed after that.

Fortunately that sort of thing happened rarely. The only other time that I can remember was at Marlene Dietrich's final concert in London at the Wimbledon Theatre. It was arranged with her approval that I would go and photograph just the encore. As it was considered a very important event I also took along Tony Russell who was working with us at that time. We crept in and started photographing the first encore song. As most of the audience were now on their feet we felt it was no problem. As soon as Marlene had finished she announced that if the photographers would leave the hall she'd sing another song. We could have floated out on the audience's "get out of here quick" vibe. Still, we made the front page of the *Daily Express* the next day.

Buddy's buddy Barry · · · · · Just after the Jazz Festival in New York, a series of weekly concerts in Central Park was run by promoter Ron Delsner and sponsored by Shaffer Inc. The music was always of a very high standard, and included a lot of jazz. The atmosphere was pretty relaxing, and I made some great pictures of Buddy Rich and his orchestra. Many years later a letter arrived from a man in Florida, saying that he had seen one of the pictures from that Central Park session on display at Ronnie Scott's Club, and would like to buy it. He offered to pay one thousand pounds. We thought he must have put the decimal point in the wrong place, but just to make sure I wrote back and told him I would sell the picture if he sent a fifty per cent deposit. Imagine my shock when a cheque for five hundred pounds turned up. Opening that show for Buddy was a little known comedian who also sang a couple of songs. His name? Barry Manilow. Little did I know then how popular he would be in just a few years.

Miles more difficult • • • • • One of those concerts in Central Park was particularly memorable because it was the second – and last – time that Miles Davis actually came up and talked to me. It was a Sly And The Family Stone concert, I was standing at the side near the front of stage and I had with me a crazy lady. She was dancing on a wall, totally dressed – or not, depending on your attitude – in leather: it was a very hot and humid August in New York.

Miles came up to me and said, "Hey, man. Where's Ron?"

"Oh, I think he's back-stage."

"Yeah, man, you sure have to know where Ron is, hanging out with a chick like that." In the early years he was a very handsome man, always looking immaculate and a joy to photograph and listen to. As time went on it became more difficult and Miles spent a lot of time with his back to the audience. He would tease the photographers, suddenly walking right up to the edge of the stage, and thrusting the bell of his trumpet on to your camera lens. Unless you were fully

prepared with a very wide angle lens, you didn't get the shot, especially as the lighting at the edge of the stage usually drops right off. I've seen many photographers struggle to change lenses to no avail as Miles always turned away just at the crucial moment.

Photographers were intimidated by Miles. In the early years I was no exception. On one occasion arrangements had been made for me to accompany the incomparable Peter Clayton during an interview for *Jazz News* in 1962. I heard that *Melody Maker* photographers had flown to Paris the week before to get some pictures of Miles, but they'd come back with nothing. So, when we knocked on the door with me standing there with a camera, I was more than a little nervous.

Miles opened the door, saw me, and shouted, "Get out!" I smiled nervously and remained frozen to the spot. Suddenly he grinned, and said, "Hi, how are you? Come on in."

That was Miles: a bit like his music, straight and complicated at the same time. I love it all, especially the early stuff.

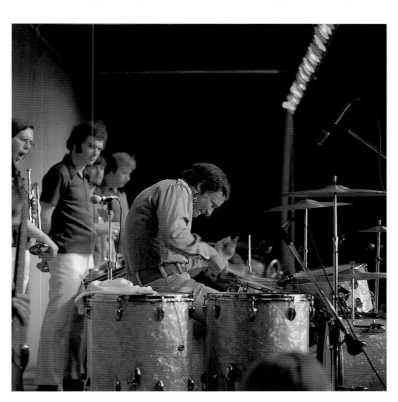

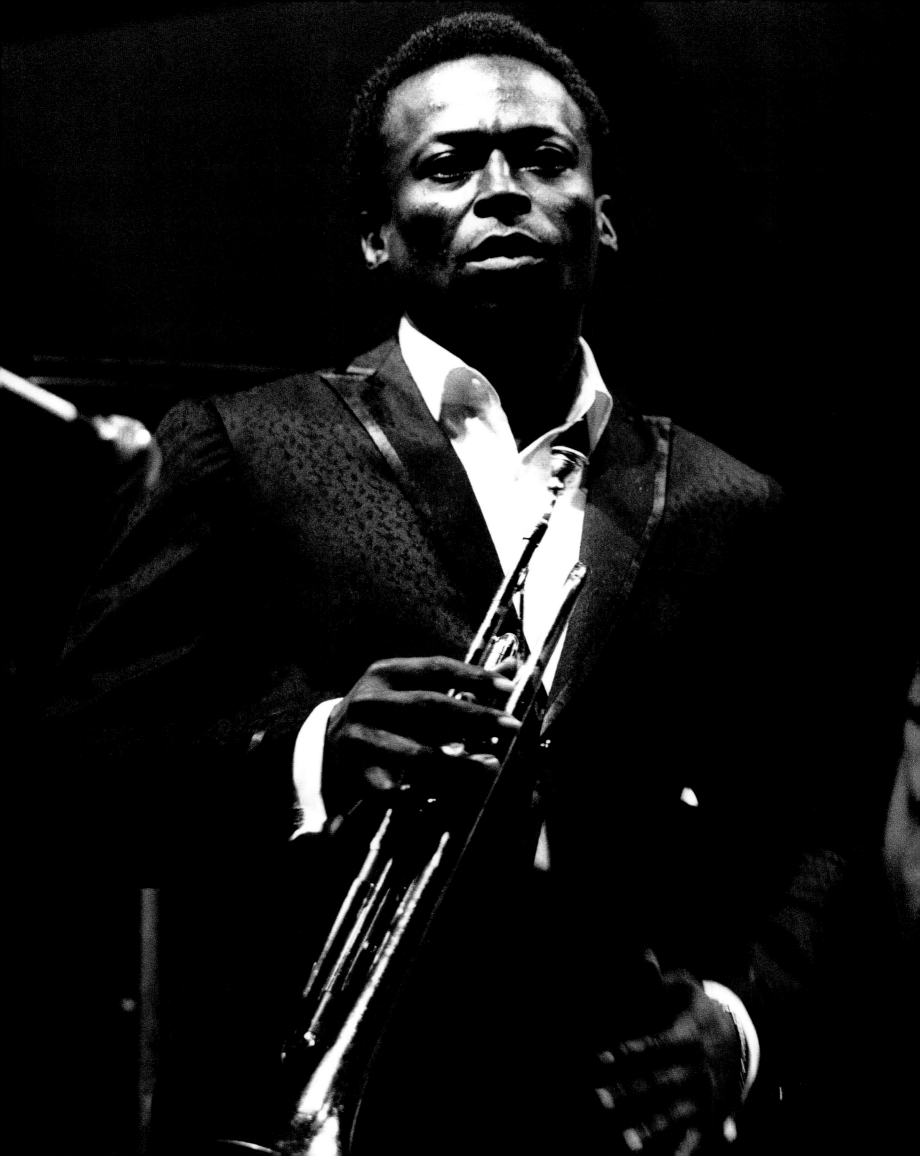

Walk on the wild side • • • • • They thought I was
mad to be walking around Central Park late at night with all
my cameras, especially the Hasselblad with a 350mm lens, on
my shoulder. But the only feasible way to get there was to
walk, and that was easy from the apartment on Fifty-Fifth
street. I never had a hint of trouble, being sensible and feeling
confident; although I guess my size was half the battle. In any
event I figured the 350mm lens would have made a very
expensive cosh, but fortunately, it never came to that. Mind
you, I once took a cab to a club in Harlem with George
McCrae's manager. He reckoned there was only one place to
walk around there, and that was in the middle of the road:
either be mugged on the side-walk, or get mown down by
demented New York cab drivers. Not a lot of choice, but then
this guy was a bit of a nut case.

It was one of those situations where you make a single
phone call to photograph a concert – and get much more
involved than you ever dreamt of. When George "Rock You,
Baby" McCrae and his Cuban band were quickly climbing the
charts here, I was at first given a hard time – "What do you
want pictures for?" and so on. I ended up going on tour for a
few dates with the band and I'll never forget the faces in my
office when that mad manager came in to pay us for the many
prints ordered – and peeled off hundred dollar bills from a
wad he had tucked down his socks.

I had a similar problem getting permission to photograph
Led Zeppelin at Madison Square Garden in July 1973. I started
by calling the manager, Peter Grant, whom I vaguely knew. I
played the "I'm British" card, and many phone calls later
Peter said, "I'll see what I can do." Eventually the PR people
called me and asked how many nights could I shoot for them.
We agreed that I would do two nights for them for a fee, and
one for me for the library. There's no contest all these years
later which night was the most profitable.

Once, in a lift talking to Steve Morley, a lovely girl got in
and said, "Oh, I love your accent – please speak some more –
please say some Shakespeare." To ****, or not to ****: our floor
had arrived. I'm often accused of being American here in
England, but I played up the Britishness to great advantage in
America – especially after our Princess Margaret married
photographer Anthony Armstrong-Jones – who later became
Lord Snowdon.

opposite:

Miles Davis: | **George McCrae:**

Newport, 1967 | Sheffield, 1974

To dress, or...be stripped • • • • • Talking of women, I soon discovered that record companies wanted pictures of girls in various states of dress and undress. There was a big market in Holland and Germany for all types of model pictures, ranging from *TOTP*-type covers, and romantic Mantovani-style shots with the girls in chiffon in candlelight, to naked silhouettes on the beach at sunset. Many of these shots were achieved in the studio, but many more were shot on location. During the Seventies I took dozens of models on trips to sunny climes.

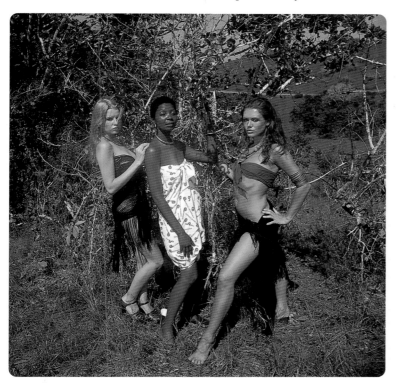

One of the most memorable was to Kenya. I had arrived before the models to do the tourist bit with my wife, Mary, visiting game lodges and other tourist attractions. As well as getting free travel in return for pictures from the airline, East African Airways, I had managed to borrow a house for free on Diani beach.

The night before the models and my assistant, Colin Fuller, were due to arrive found me alone in this large, creaking house on the deserted beach. I woke at three in the morning hearing noises. I can't say that I was comfortable about that, but I thought it was just the wind in a strange house. I tried to get back to sleep again. Minutes later I was fully awake – there was definitely someone in my room. I put the light on and shouted at the black man running out with my camera case which had been beside my bed. I rushed outside, but he had vanished into the bush. Anyway, it would have been rather dangerous to pursue the robbers any further in my naked state (or even dressed). I threw on some clothes and raised

the alarm, rousing the house boy in one of the out-huts. He suggested that I drive down to the nearest hotel, where I had been a guest earlier in the week, and use their telephone. I knocked up the manager, with whom I had become friendly, and we called the police. They said they wouldn't be able to come out with tracker dogs until the next morning, there being no ferry across the river at night. Of course, by that time the scent would have gone.

The thief took all my cameras – and my air ticket and passport. Needless to say I was somewhat tired and depressed

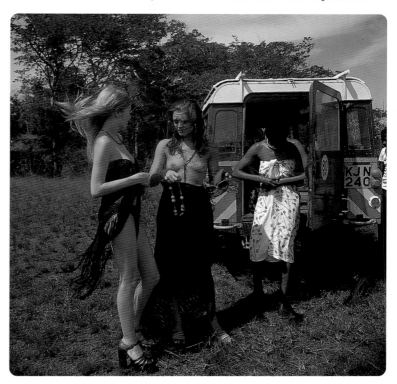

when I met the model party that arrived the next day. Thankfully I managed to borrow a Mamiya camera for a couple of days, whilst Mary, who had by now gone off to write some travel pieces, managed to persuade a Nairobi photographer to rent me a complete set of Hasselblad cameras and have them flown down by private plane. This was no mean feat. Meanwhile I had attempted to have the spare set we kept in New York sent out to me. Inevitably third world customs made sure that they never arrived in time. The bottom line is that the pictures were great and they graced many a magazine and record cover, not to mention a host of calendar sales.

opposite:
Led Zeppelin:
Madison Square Garden,
New York, 1973

left:
Lindsey, Jody, Joelle

Suzie Page: Camber Sands, England

Lindsey: Kenya

Carol Augustine: | Model:

London | Trafalgar Square, London, 1966

Going to sea in a pea-green – *piano*? • • • • •

The crossover was complete when I was commissioned by Polydor in Holland to do a whole series of model pictures to brighten up their LP catalogue. The art director was a very good friend of mine, Wiebe Andringa, and we spent a week in England photographing – in all sorts of locations – anything from semi-naked girls in trees playing the trumpet, to long flowing dresses besides an inaccessible waterfall in Derbyshire. For this, of course, I had to hire a Land Rover which was great fun and very necessary. The final shot was to be a girl sitting on a piano in the sea.

We had managed to buy an old upright piano, and taken out all the metal bits and somehow we got it on the roof rack of the Land Rover, but it was still extremely heavy. We drove to Camber Sands in Kent, where I knew you could drive right on to the beach. We struggled to get it into the water, and finally we were able to take the pictures. At the end of what had been a very long day we decided just to let the piano float out to sea on the tide.

A few weeks later I'm in the BBC bar, having a quiet drink, and I overhear this man saying he was sailing in the English Channel and couldn't believe his eyes when he came across a floating piano. I kept my mouth shut, and dreaded seeing a story in the papers, "Boat hits piano at sea, all hands lost".

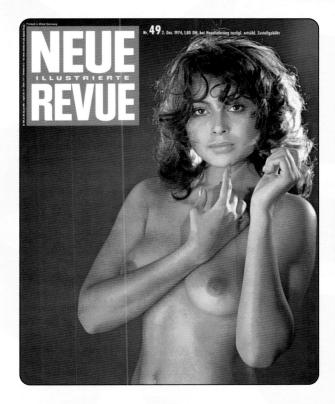

| **Lindsey:** London, 1975

Murder inquiry • • • • • Some years after one of my
first model trips to Menorca I had a strange set of visitors to my
offices. Two men in suits and a guy in a trench-coat – straight out
of the movies. The suits were from Epsom CID and the trench-coat
from LA FBI. Apparently one of the models we'd taken on the trip
had been murdered by the LA Strangler. The girl in question we
had nicknamed Jupiter Jane as she was always spaced out. We'd
had a spare ticket and the agency sent her along free for the ride.

Steve Morley and I were questioned relentlessly.

"Look," they said, "no holds barred, this is very confidential,
tell us about her sexual proclivities."

We couldn't help them too much, although I could testify that
she was much better at giving massage than she was at
modelling, and as it turned out she'd worked in a massage
parlour in LA. I finally told them that maybe they should talk to
the other girls I had taken on the trip. The next day on the front
page of the *Evening News* was a story "I shared a room with
murdered girl" by model Nina Carter. I declined to contact the
News Of The World with my pictures.

Party time, please • • • • • The other popular demand
for pictures using models in our field was for disco pictures in the
Seventies. During that time I did half-a-dozen sessions which
involved begging, borrowing, or hiring a club or disco; hiring three
or four models (three girls, one boy); and putting up notices in
dance studios offering dancers a party with some pretty girls and
boys. I offered them a nominal fee of ten or twenty pounds each,
plenty to drink, and a chance to strut their stuff. All they had to do
was sign a model release. I put in extra lighting; invited a lot of
good-looking friends; arranged for a good DJ; and prayed. In
terms of organisation I might just as well have been making a film.
The set-up was just the same – and once the booze and music was
going it was very hard work to keep my head and produce some
good pictures...

These parties had a life of their own, but once I'd done a couple
they became easier to manage. The pictures sold very well
because we were photographing a real party, whereas pictures of
studio set-up parties looked too clinical and clear, very sharp, you
could spot them a mile off. Our pictures were authentic: a little
grainy, lots of movement, some flash and blur – and they were all
shot on 120 tungsten film.

Gary Glitter:
TOTP, 1973

Tina Turner:
The Venue, London, 1982

Marc Bolan:
TOTP, 1973

In fashion: hardly • • • • • I wasn't exactly fashion conscious myself (friends and family will testify to that), but photographing models in the Seventies obviously did capture the spirit and styles of the time. And at the time of writing these Seventies pictures are having a good, and profitable, revival. Fashion statements were not confined to models, which would be confirmed by a visit to *TOTP*, which I did regularly. For me, Pan's People summed it all up. With artists like Gary Glitter, The Rubettes, Marc Bolan and Wizzard, the music itself didn't seem to matter. My one regret as far as *TOTP* is concerned was that I missed photographing Otis Redding by five minutes. My one and only chance to capture him missed by being just a few minutes late.

Fashion is relentless and continues to invade the music business. One of the first shows packed with fashion statement was Blondie at the Odeon Hammersmith. It was being filmed, so the lighting was excellent, and in those days I was able to shoot the whole show from the pit. It didn't get any better than that,

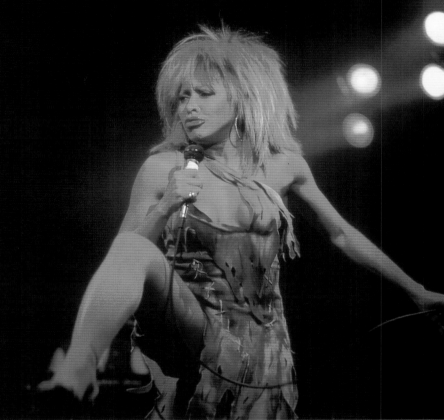

although the vibrancy of Tina Turner and the knickerless Millie Jackson got very close!

The Venue was a converted cinema (the Metropole) in Victoria which Virgin ran for a few years in the early Eighties. Access was easy and, as it was always standing only in front of the stage, it was very easy to get some great pictures – on the same level as the artists for once. Two magical shows immediately come to mind. Tina Turner was the star of one of them; James Brown the other. For some unknown reason both these shows weren't over-crowded which gave me lots of room to shoot.

Blondie:

Hammersmith Odeon, London, 1978

Tina Turner:

The Venue, London, 1982

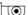

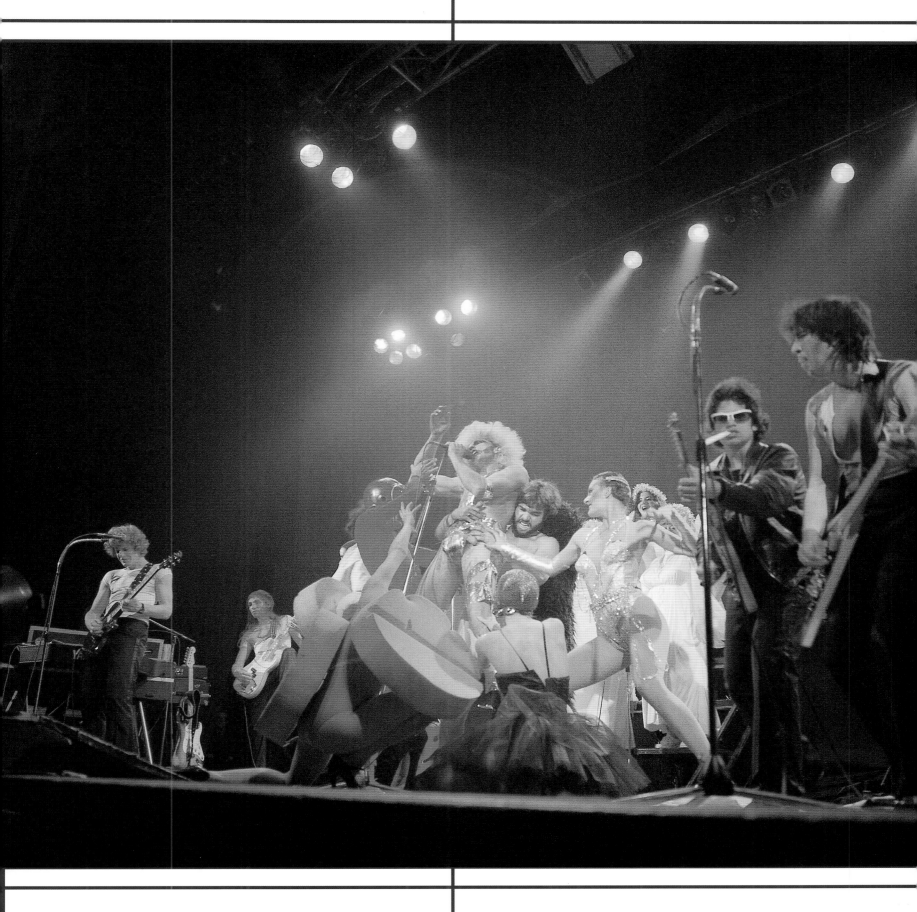

The Tubes: Hammersmith Odeon, London, 1978

opposite:

Millie Jackson: Hammersmith Odeon, London, circa 1979

this page:

James Brown:
The Venue, London, 1981

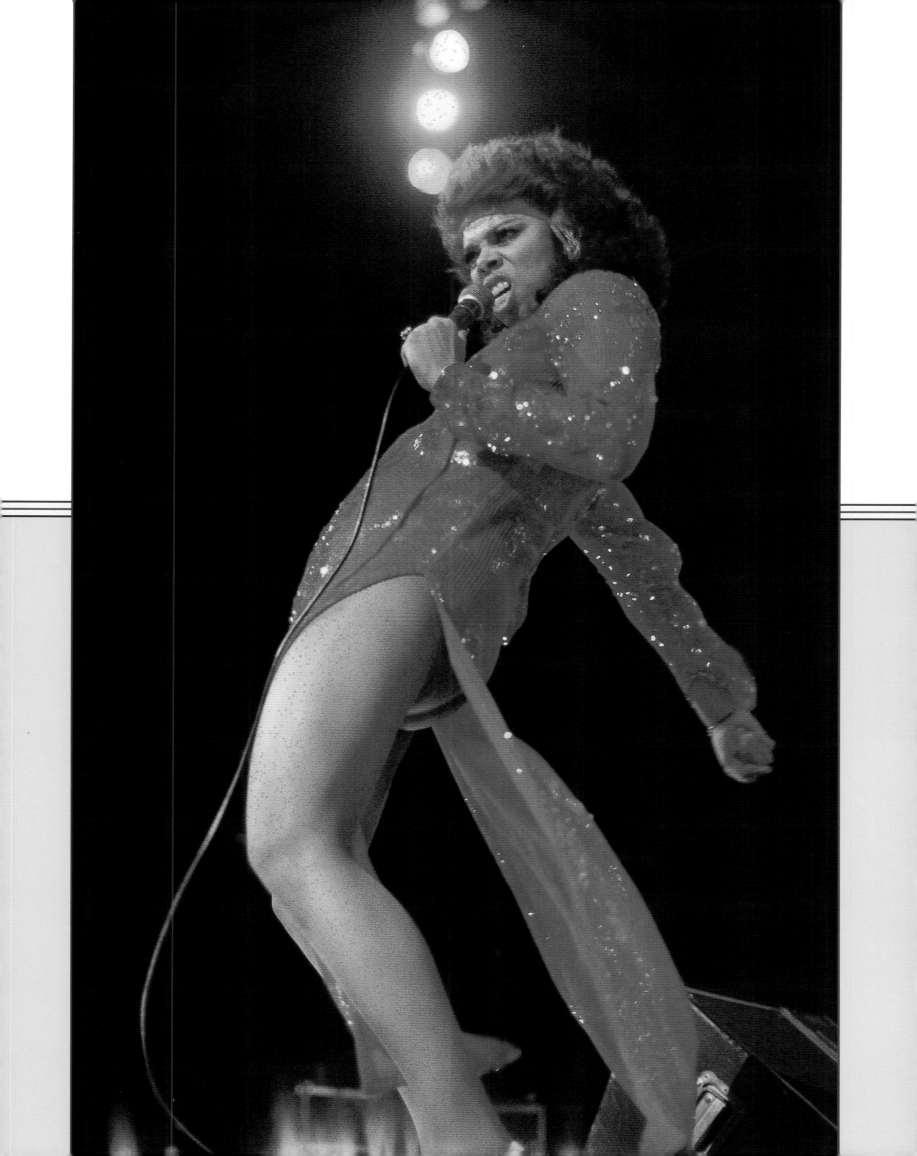

Management: definitely • • • • • I don't know that I
would call The Bay City Rollers a very fashionable band, but they
sure were popular. I suppose it was the first time I personally came
across band management trying to control the output and use of
pictures. I had a call from my friend at the BBC, Anne Rosenberg,
who said the boys were doing a couple of songs for *Blue Peter*, and
did I want to come down and take
some pictures. I had a feeling it was
not going to be that easy, so I said,
fine – and I'll bring an assistant
down if that's okay.

When we arrived at the TV
Theatre, I said to Colin, "I'm bound
to be spotted working on the floor,
so why don't you go upstairs and
quietly shoot from the balcony." I
don't know how it happened, but
Colin was the one who was spotted.
Sure enough the heavies demanded
his film. Quick-thinking Colin
shoved the real roll down into his
boots, and gave them unexposed
film. No-one seemed to notice I was
taking pictures as well, on the floor
with the TV cameras, and I have to
say they made a nice poster or two.

Mama: naughty • • • • •
The Osmonds were also trying to play the same game. I had gone to
the State Fair in Philadelphia having arranged with the tourist
people to photograph the whole event. The Osmonds were billed to
appear, so I thought once I was there I could capture the musical
act as well. Somehow I got to meet Mama Osmond who told me,
"We are having so much trouble in England, with papers like the
Melody Maker running pictures without our approval."

"Oh, how naughty," I said, trying to keep a straight face.

"But you go on and do your travel pictures – that's okay," she said.

That session became a second "magical mystery tour" for me,
as I was the only person in London to have decent live pictures –
and they were due to tour the UK for the first time in a few weeks.

Mama did complain to the record company, but they were
delighted with the coverage and bought many of my pictures
for themselves.

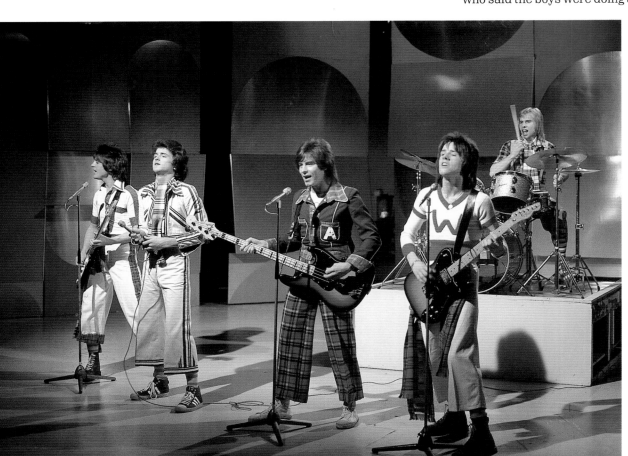

The Bay City Rollers:

BBC TV, 1975

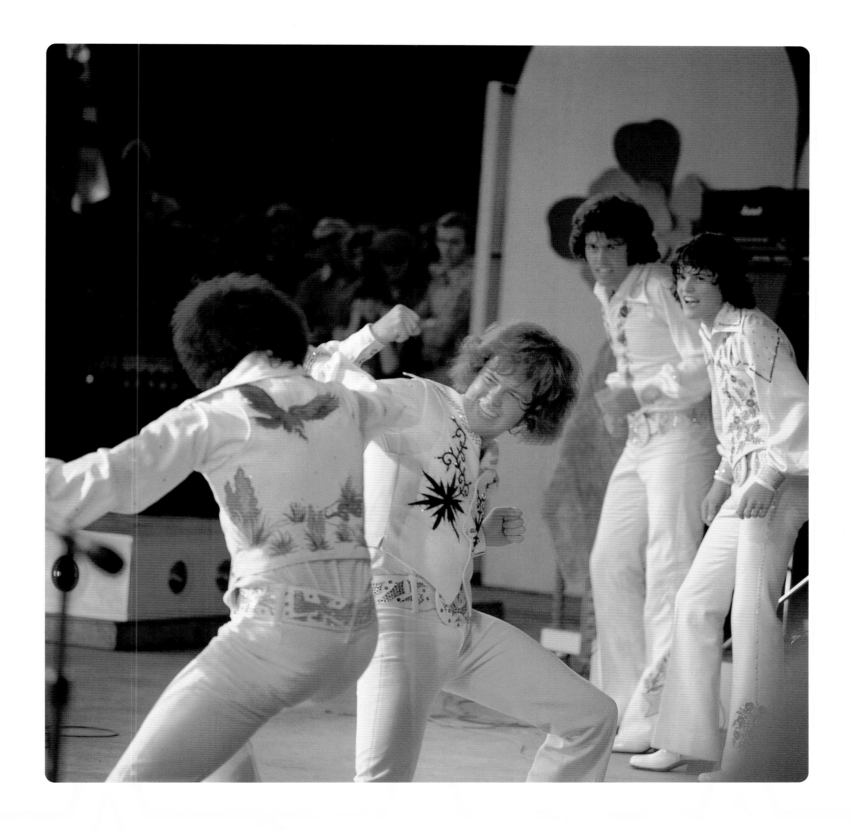

| **The Osmonds:** Philadelphia, 1972

His way · · · · · I don't particularly want to be known as a passport photographer, but I seem to do a fairly good job, as my partner Dede will testify. Every time we go to America the immigration people stop and compliment her on her passport picture. And a friend of ours flew all the way from Germany so that I could take her passport picture. The reason: they knew that for ten years my picture of Frank Sinatra was on his passport.

One day Jack Higgins called me, saying that Frank Sinatra needed a new passport photo – and would I take it? I went to the Churchill Hotel to do the deed, where I remember being very nervous. I was ushered into a room, camera ready, where there were several other people all rabbiting to Sinatra. I had to take the snaps very quickly and get out. And, of course, I had to hand over the negatives with the prints. What do you charge for something like that? We agreed on a hundred dollars, which wasn't bad for five minutes' work in those days.

for instance. The Chief of Police in Rome was there (no, I didn't recognise him) and so were other more or less sensational people.

As it turned out I was summarily fired and re-hired three times during the evening: "Don't take pictures of Mr Sinatra when he's eating"; "Don't take pictures of Miss Simmons"; then, "Take all the pictures you want". I had with me as my assistant the daughter of a very famous actor. By this time she was getting fed up with the treatment we were given, so we decided to play a little game. I had a quiet word with the man who had hired me (not fired me).

"Do you know," I said casually, "who my assistant's father is?"

"No," he said.

"Peter Ustinov," I murmured.

I'd barely uttered the name when he spoke quickly.

"Has she eaten?"

"Well, no, she's been standing in the corner over there with me."

"Bring her here."

| **Jean Simmons, Frank Sinatra:** London, 1976

| **Frank Sinatra:** London, 1980

Some years later, Sinatra was in the UK for a concert season. I was asked to photograph a dinner party he gave in the River Room at the Savoy Hotel. I was happy to do it, but shooting parties is definitely not my scene. It felt good, though, to stroll in past all the paparazzi. This dinner was given by Frank for his lawyer, Mickey Ruddin, who came up to me and said, "It's my birthday...and everyone wants to be photographed with Mr Sinatra – get to work." Photographers are usually treated badly on these occasions, and rarely offered food, let alone drink. This was no exception. I did recognise some of the guests; Jean Simmons and Andy Williams,

And he took her to an empty place on one of the tables, and tried to rustle up a whole dinner for her, although most people by this time were on their dessert. They behaved as though a VIP had suddenly arrived, not just a photographer's assistant. It was lovely to watch, as Pavla carefully took the piss: "Why are you offering me all this food now?" Most of the people at the table were totally oblivious to the fact that they were being sent up something rotten, apart from Sinatra's piano player who understood exactly what was going on...a true musician!

The next time Sinatra came to London was in September 1980.

| **Frank Sinatra:** Royal Albert Hall, 1980

I was hired to photograph the whole event. This was six nights at the Festival Hall and five nights at the Royal Albert Hall. I was told by the PR people that they wanted very few pictures, just be there to be on the safe side. For the first couple of nights I did nothing at all. On the third night they decided they wanted one picture for the newspapers of Frank conducting the orchestra, which he did for one song. I was seated at the Festival Hall organ with a PR minder next to me, and was allowed to take only six frames. The next night or two I took nothing.

The following night Frank was drinking with the British promoters after the show. He casually asked to see all the pictures that had been taken every night. The next morning I got the phone call: "How many photographers are you bringing tonight? Mr Sinatra wants loads of pictures, and he wants to know why pictures hadn't been taken before." I told them that if it would make them happy I'd bring a couple of assistants, but that I could manage the photography by myself.

Now I really started working. They wanted 15x12 prints of everything the next day. Frank was anxious to capture the rapturous mood of the audience at the Albert Hall.

"At the encore," he told me, "you come right on stage and

follow me. Don't worry about anything else – just keep shooting."

After the first night of this, he called me into his dressing-room.

"I like the pictures you've taken of me – but I can't see the audience. What do you need to get them in shot?"

"Lots of light," was my reply.

He snapped his fingers and shouted, "Get me the lighting man!"

Frank told him he wanted the whole of the audience lit at the encore so that I could get my pictures: "Do whatever it takes."

The next night hundreds of kilowatts lit the whole of the Albert Hall, which soaks up a great deal of light. I got my picture; Frank was happy; and, as ever, his timing was superb because it was the last night. It must have cost a fortune.

It was a sad day when Frank died in May 1998, and, of course, the world's media went crazy. I had phone calls from magazines thinking I had hidden treasures – pictures that could only be released after his death. The reality is that the pictures I have capture the man as he sings on stage, cigarette and glass in hand. Anyway, the big American magazines had already done the trawling and fighting for exclusive pictures months before.

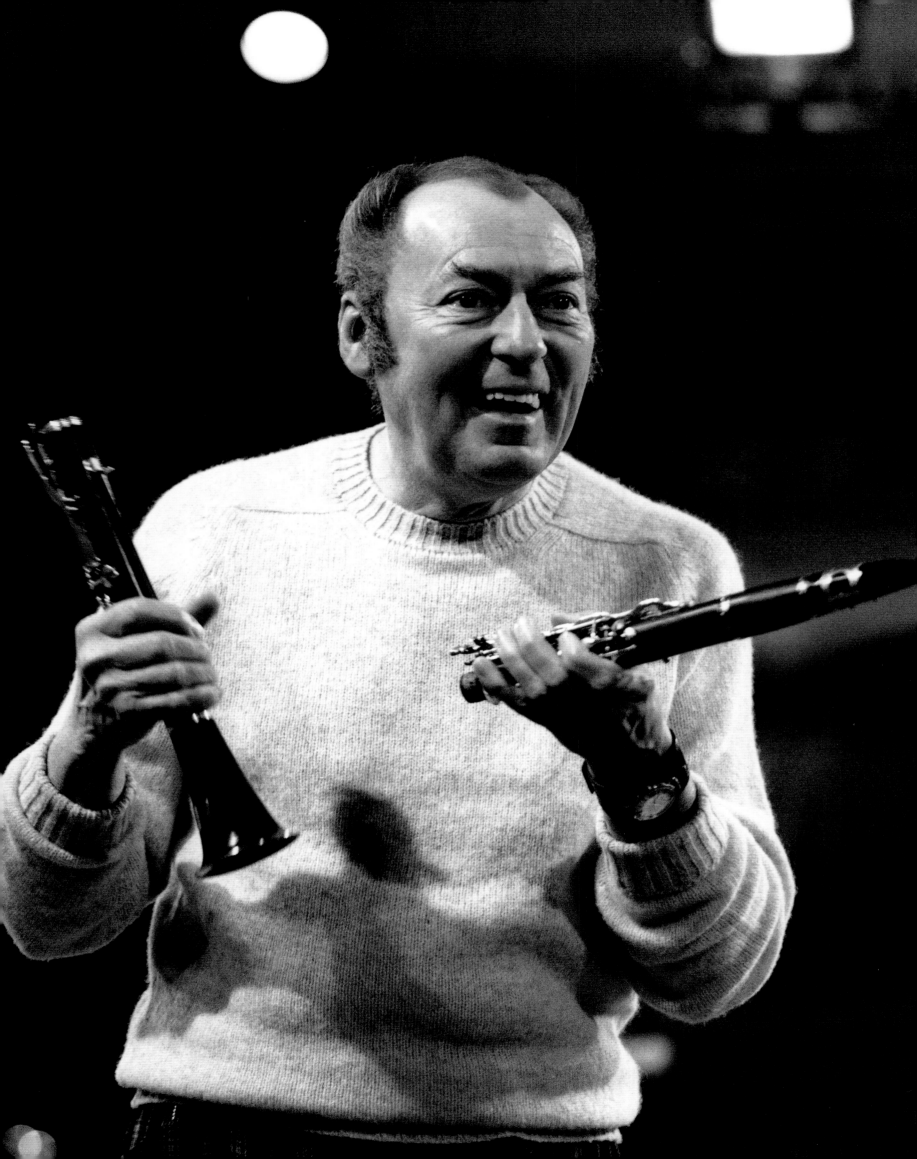

above and opposite:
Woody Herman: London, circa 1974

No hermit • • • • • One of the last times I did photograph
Frank was in Philadelphia where I went with Woody Herman as
his band was backing the great man. Woody gave me a lift in his
car. It was an interesting drive but Woody was not impressed with
the driver, and asked for Redfern to drive us back to New York:
"He will be much better, even though he's used to driving on the
other side of the road."

Woody was a great guy and we always had a lot of laughs. I was
photographing him in London and had my young son, Simon, with
me, taking a few pictures. Woody split his clarinet in half, and
posed for Simon, but I think I was the one that got the shot. Behind
that jovial exterior was a very serious musician, who had more
than his fair share of financial troubles. He'd had a couple of bad
managers who cheated the IRS and him and it was only Ronald
Reagan's intervention that prevented Woody from being thrown
out of his house shortly before he died. But my memories of him
will be that relentless driving force which kept the music going
through thick and thin whatever the price.

UnaCustomed as I am... • • • • • In 1976 I went on
the road in the UK with the band. Just before they left England
there was a sequence of one-night-stands around the country.
After the final London date, one of the guys gave me a little packet
of – well, I guess it was cannabis. He said, "I can't take it with me –
so why don't you have some fun..." Apart from eating some hash
cake in Hamburg and unsuccessfully trying to smoke grass in
Kenya, I have always left drugs well alone. But I took the
substance off him, and just put it in the car, thinking no more
about it. Until two weeks later. I'm driving up to the Customs
inspection in Harwich on my way to Holland when I suddenly
realise that I still have that "shit" on me. I decide that the only
thing to do is to put it in an envelope and post it to myself. There I
am looking for a letter box when a customs officer says, "Can I
help you?"

"No, I'm just looking for a letter box," I cry.

"You won't find one this side of customs," he says, "but never
mind, I'll post it for you.

The letter arrived safe and sound at my office – and the
contents were swiftly flushed down the loo. Inevitably, I've known
many people who have been ruined by drugs. Many are long since
gone; the lucky ones have managed to give it up and survive, but I
suspect that they were in the minority.

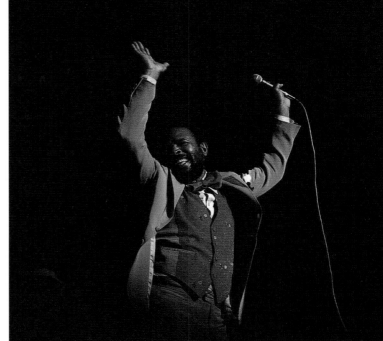

Marvin Gaye:

Cincinnati, 1976

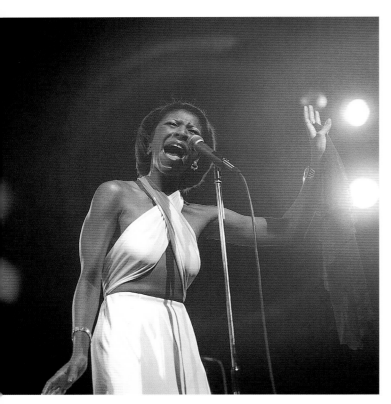

Natalie Cole:

Cincinnati, 1976

The Temptations:

Cincinnati, 1976

Kool temptations · · · · · During the mid- to late-Seventies I was covering some of the Kool Jazz Festival national series. These were mainly soul events in giant stadia, with the stage in the middle of the field. The artists were videoed and their images projected on to enormous screens. As long as I kept out of the way of the cameras I could do what I liked. I was, after all, the size of a pinhead to the audience who were miles away, and often the only photographer with access. This proved to be very important when, many years later, I got into a dispute over ownership of some of the pictures that I had taken in Cincinnati in 1976. But I was the only photographer on the field; so it was an open and shut case. Certainly my best pictures of The Temptations were taken there, followed closely by Marvin Gaye, Natalie Cole, Harold Melvin and many more.

Another of these giant events took place in the Yankee Stadium with rather more jazz content, notably the original Dave Brubeck Quartet with Gerry Mulligan. BB King played some wonderful guitar solos, and the stadium lights were unbelievable – almost too bright – but it was a pleasant change and gave some interesting results.

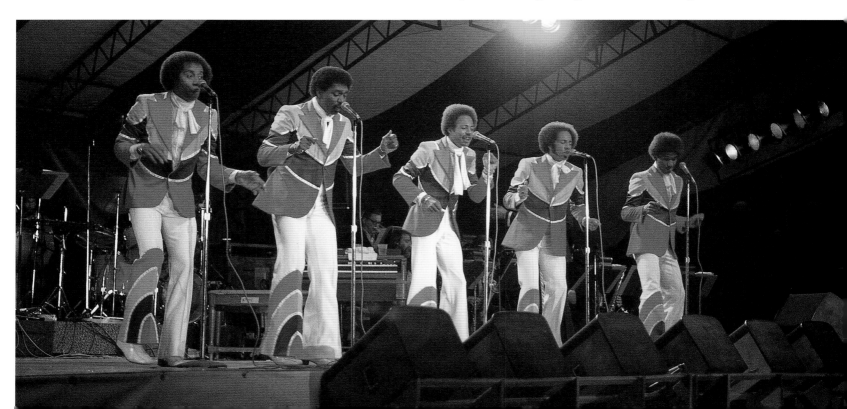

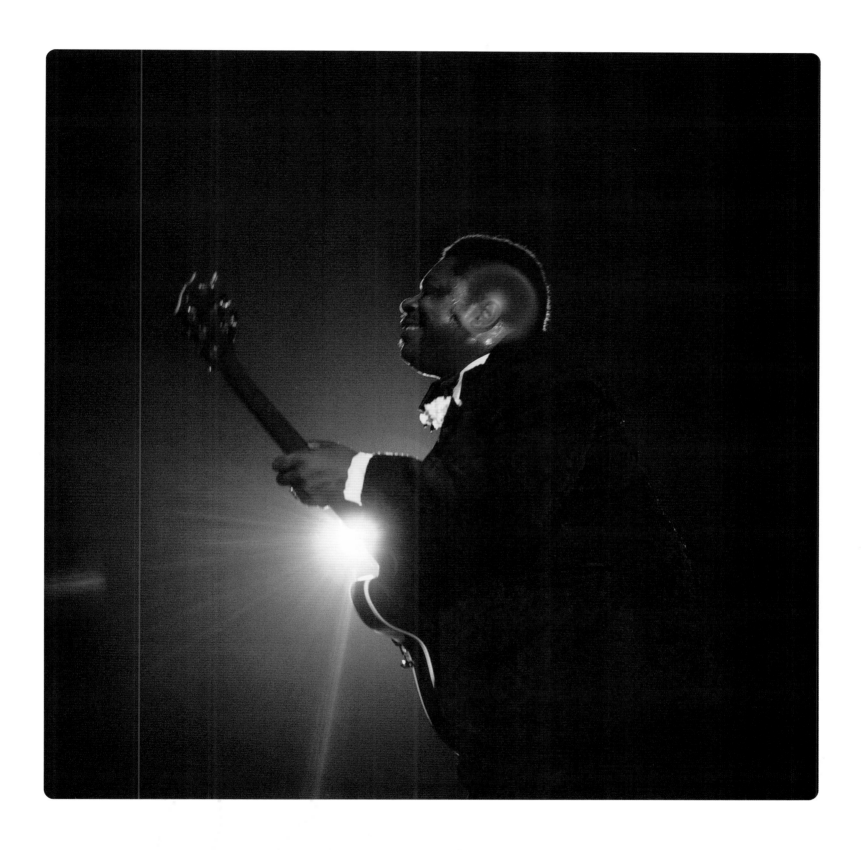

| **BB King:** Yankee Stadium, New York , 1972

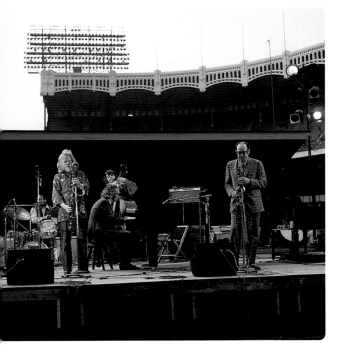

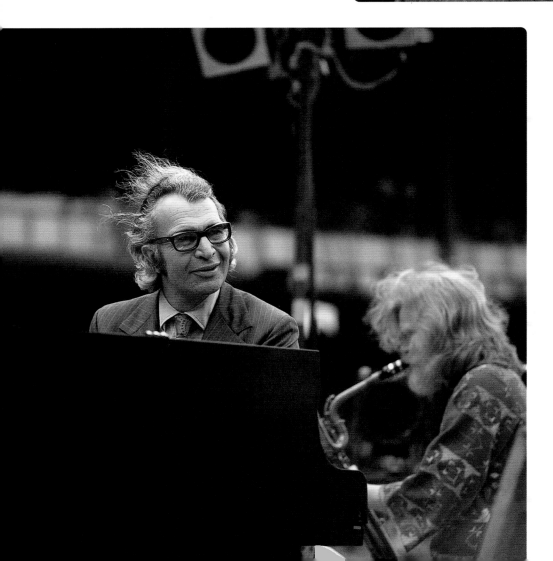

top left:

**Gerry Mulligan, Dave Brubeck,
Jack Six, Paul Desmond:**
Yankee Stadium, New York, 1972

left:

Dave Brubeck, Gerry Mulligan:
Yankee Stadium, New York, 1972

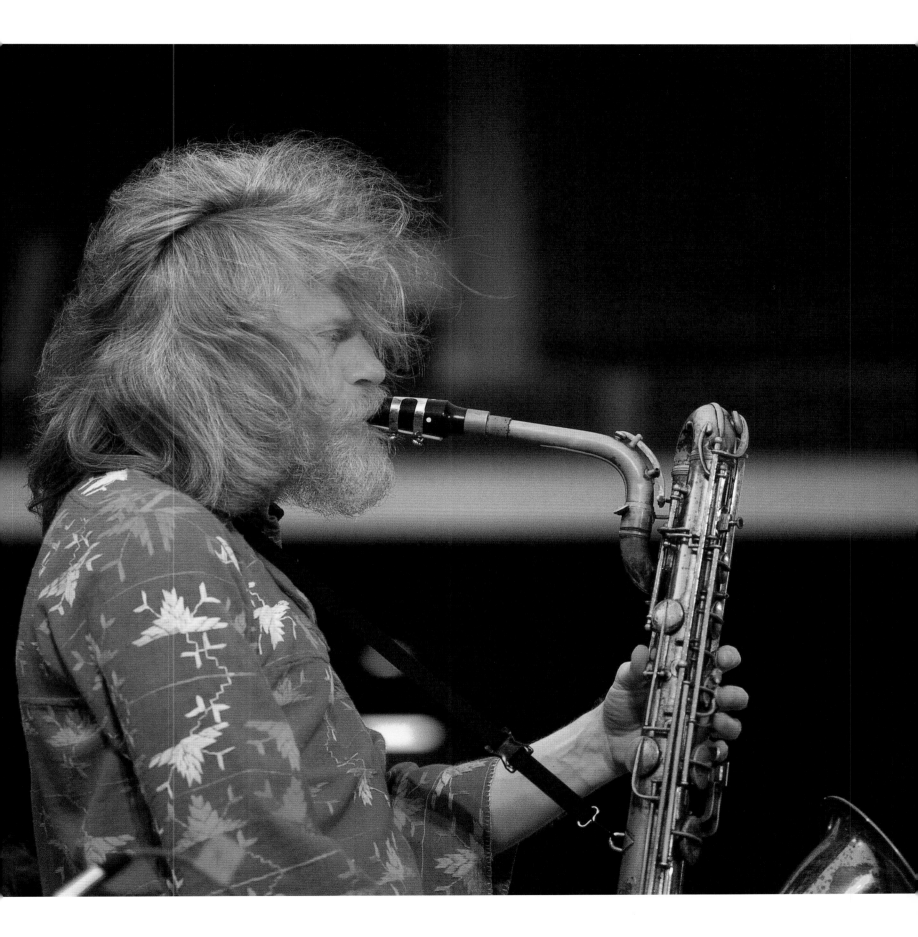

| **Gerry Mulligan:** Yankee Stadium, New York, 1972

opposite:

Bob Dylan: Isle of Wight, 1969

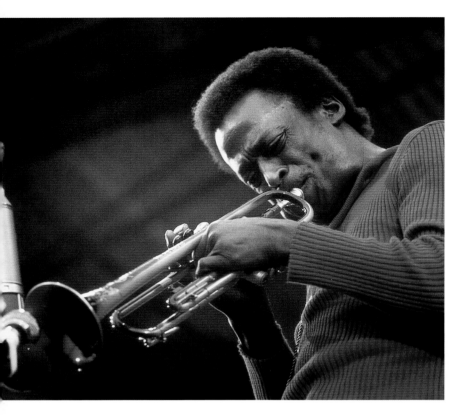

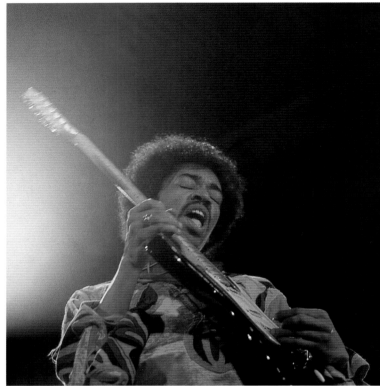

Isle see you – all of you... • • • • The major festival in England at the end of the Seventies was in the Isle of Wight. The first one I attended featured Bob Dylan. I think he was the only person I managed to photograph. It was very chaotic and I spent my time tripping over VIPs – the likes of Mick Jagger – who were all sitting on the pit floor. It was difficult to get any decent pictures as Dylan was surrounded by a lot of microphones. I think I managed about three usable shots.

The last Isle of Wight festival a year later was a much bigger affair which totally overwhelmed not only the promoters but also the island itself. I had managed to book hotel and car ferry well in advance, which was okay, but the whole island became more or less one big traffic jam. I had made arrangements to go and see Joan Baez at her hotel the other side of the island, but

we missed each other because while I was still only half way there, she was on her way to the festival site (no mobile phones in those days). Hotel rooms were like gold dust, so as I had one I was determined to use it – even if it meant missing some of the big acts as everything was running terribly late. I was around, however, to capture two notables, Miles Davis and Jimi Hendrix. The most interesting pictures for me were to be had on the beach, where the sight of naked photographers photographing crowds of naked fans on the beach must have been quite a picture (what other way could we honestly do it?). A year later Johnny Saunders, who was editing the *Photography Year Book* told me a photographer had submitted a shot of me taken at the Isle of Wight festival. I didn't ask if I was just wearing my Hasselblad at the time...

this page:

Miles Davis: | **Jimi Hendrix:**
Isle of Wight, 1970 | Isle of Wight, 1970

Isle of Wight, 1970

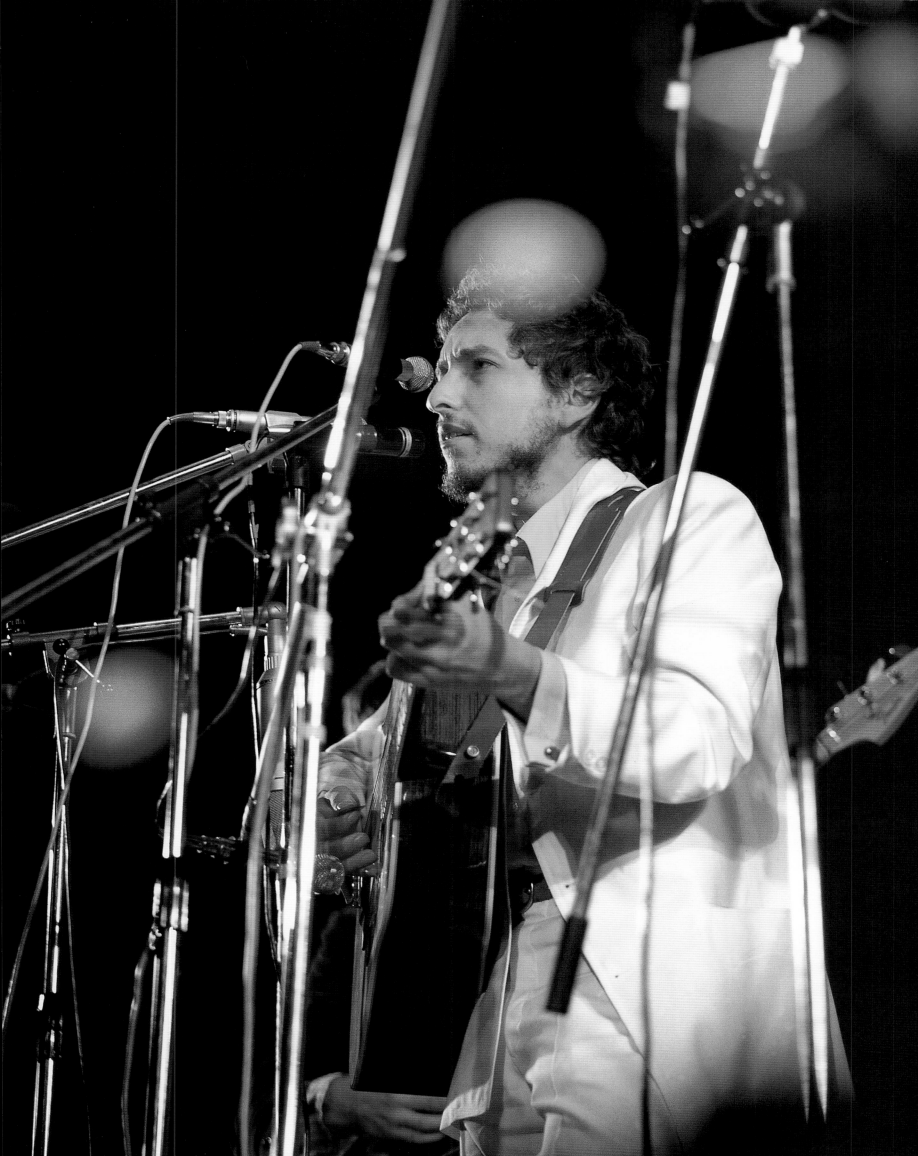

dilapidations on the building in Charing Cross Road – and, of course, the bank overdraft. Luck must have been smiling on me because none of the managing agents' employees would go to bat for the landlords on their claim, and the merchant bank was purchased by a Midlands law firm not interested in calling in any guarantees. Better be born lucky than rich, I always say.

Luck was still with me. I'd found a large dilapidated loft with wonderful beams in Long Acre. The famous flower and vegetable market had just left Covent Garden and they could hardly give properties away. I was given a three-year lease renewable for twenty years. I had a six months rent-free period to fix the place up; another year at ninety pence per square foot; and another two years at three pounds per square foot. I enjoy fixing places up which is just as well, because it was not going to be the last time. It is a great challenge: most people said I was crazy to take it on, but that made me even more determined, and the gods were still looking kindly on me.

On the ground floor of my building was a branch of Lloyds Bank, so close I had to give them the pleasure of doing business with me! Fortunately, I had just sold many pictures for publicity use for the TV series *All You Need Is Love*. During filming in the States they had failed to shoot stills, either because they didn't have the money, or didn't think of it. So when production manager Paul Medlicott knocked on my door saying that they needed lots of pictures, the timing could not have been more perfect. My new neighbourly bank manager was a rare animal, who confessed to liking photographers and picture libraries, so we were made. He did, though, once complain of one of his photographer clients, that he didn't mind him buying the Porsche on the overdraft but not the Range Rover as well. Yes, I did manage to get my own Range Rover a couple of years later, but that friendly manager had already moved on. With more luck, his younger successor was just as co-operative – especially on the Gold Card front. I fear they are not allowed to make them like that anymore.

So there I was, starting all over again: but with two decades of pictures behind me, only two employees, the re-birth of Covent Garden, and the close proximity of Fleet Street; I felt that at last I was in the right place at the right time.

Moving times • • • • By 1977 I was downsizing. And moving to Long Acre in Covent Garden. The lease had run out in Charing Cross Road; Kodak had announced their new colour process, E6, so our colour machine was becoming obsolete; I didn't have the cash (or inclination) to set up a new lab somewhere else; closing the company seemed the only option.

This presented me with many problems. The main one was my picture library, the accumulation of negatives and transparencies over twenty years that was now my greatest asset. The library legally belonged to the company which now had to go into voluntary liquidation. I owned fifty one per cent of the company, so morally those pictures were mine, but the whole lot had to go. It was a very difficult period. Eventually I borrowed money to buy the library back from the liquidator. I had also personally guaranteed large sums to pay for

| **Studio:** Covent Garden, 1977

chapter four {**the eighties**}

Stephane Grappelli: | **Art Blakey:**
London studio, 1973 | London studio, 1978

THE EIGHTIES

The new studio had an old conservatory-type roof-light which leaked all the time, but it did make it possible to obtain some interesting pictures. I have always used tungsten film in the studio because you can see what lighting effects you are getting without using Polaroid film. And the musicians would get more of the feel of a music venue, even if they did complain sometimes about the heat on the set.

with lots of moaning and groaning, effing and blinding. Eventually they did get into it, and when they saw the pictures they couldn't apologise enough for being so grouchy. We became good friends and for years afterwards every time Jaws and I met he would recall that wonderful photo session.

Most musicians are not really at ease in the studio, and have a very short attention span. But sometimes they'd get into the groove

– even between sets at Ronnie's. Maybe it was a little ambitious to get from Soho to Covent Garden, and up my stairs, between sets. But it worked, even with Stephane Grappelli, although I did feel a touch guilty for making him struggle up four flights of stairs.

Norman Grantz hated the pictures I took of him, and proceeded to tell everyone so in a very loud voice back-stage at a JATP concert at the Festival Hall. Oscar Peterson, who was managed by Norman, was happier, but the best pictures of him I took are at the piano.

Sometimes a wife or girlfriend would accompany my subjects – and sometimes I wasn't sure which was which. One of my best sessions in Covent Garden was with Art

Groovio in the studio • • • • • I did a session with Eddie "Lockjaw" Davis and Harry "Sweets" Edison, who were appearing at Ronnie Scott's. My studio was four floors up – and no lift – so by the time they reached it, the air was blue, to say the least,

Blakey. The sun was shining too brightly for the ineffectual skylight blackout, the background in the studio was the original brick wall painted black and sunlight filtering through the skylight turns everything it touches into blue on tungsten film.

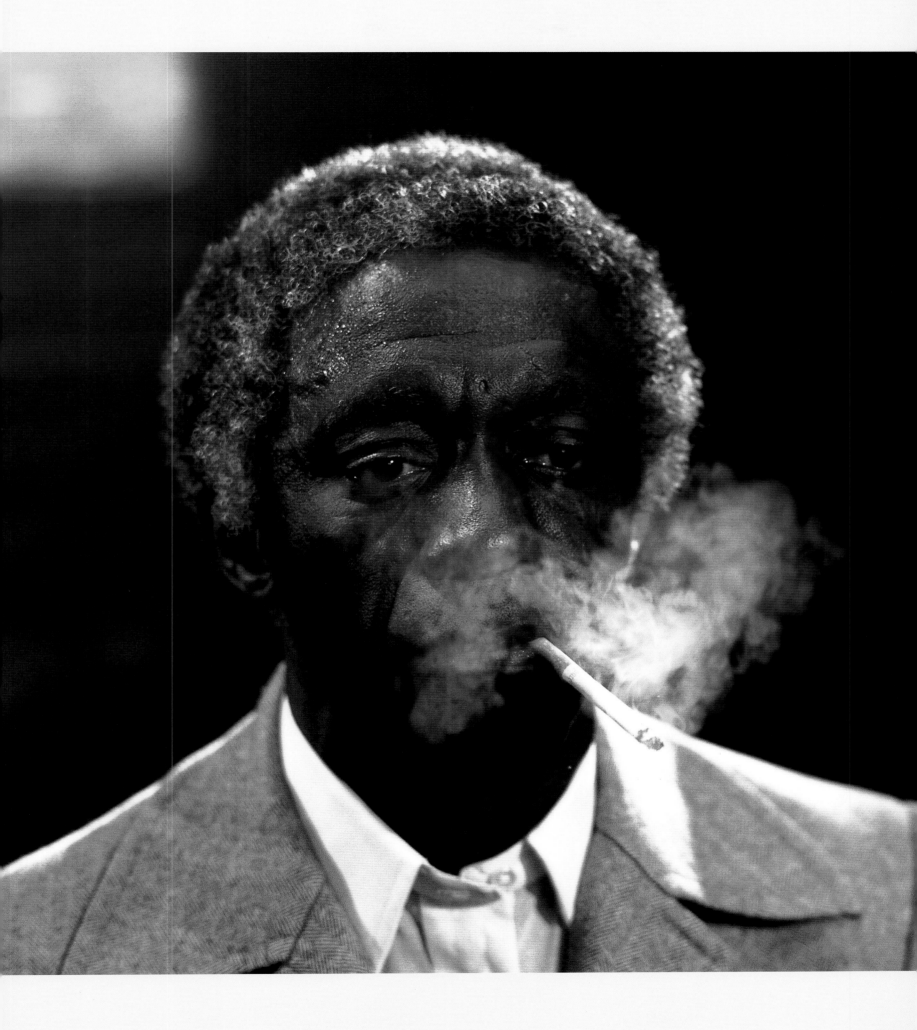

GETS IN YOUR EYES

What can I say about smoking? I don't like it, I've never done it, we have a non-smoking office and car, and I've known far too many people whose health has suffered as a result of this terrible habit. Being a photographer in the music business, it's been impossible to avoid at least the passive kind, and the smoky atmosphere sure as hell made for some good pictures! So much so that nowadays many concerts use the non-toxic variety as a special effect, but here is the real thing.

Jimmy Raney |

opposite:

Count Basie	Eartha Kitt
George Melly	Buddy Rich
Oscar Peterson	Eddie Lockjaw Davis

Charlie Mingus:

Montreux, 1975

Louis Armstrong:

BBC TV, 1965

Elvin Jones:

London, 1979

Vienne, 1992

An invaluable wife • • • • • One of my more willing
sitters was the great drummer, Elvin Jones. I had been
photographing him for over thirty years, and it's fair to say that
for most of the Sixties we hardly exchanged a word. I was awed by
his charismatic presence: I didn't have the courage to knock on
his dressing-room door for many of his earlier visits to London.
But by the time Elvin and his Japanese wife, Kako, came to my
studio we had been firm friends for a long time. They say that
every successful man has a good woman behind him. This is
certainly true in Elvin's case. He was always telling me, "She
saved my life." I can bear witness to the fact that she has saved
many a gig in her day. During a taxi strike in New York, Kako
physically humped all of Elvin's drums on the New York subway
by herself. I was very saddened to hear of Elvin's death in May
2004. I felt that I had really lost a true friend, not to mention the loss
to the jazz world of such a musical giant.

Elvin and I had lots of fun hanging out in 1997 at the Juan-les-
Pins Jazz Festival. It always amazes me how many long-lost
friends I suddenly have when I'm sitting in hotel lounges rapping
with the likes of Elvin. He always liked to have a drink, although I
suspect he wasn't really supposed to, but he had the bartenders
well trained, and I hope I'll be as fit when I'm seventy. One bear-
hug from him had you counting your ribs to see if they were still in
one piece. His version of Coltrane's 'Love Supreme' with Wynton
Marsalis on trumpet was one of the musical highlights that year.

Another wife • • • • • Another studio visitor was Illinois
Jacquet who brought his wife. Now there was a man who liked a
drink, so, knowing that, I produced a bottle of Scotch. An hour or so
later after I'd shot the pictures, Jacquet was walking out of the door
clutching the half-empty bottle. His wife uttered a half-hearted
protest, to which Jacquet replied, "Oh, Red knows that's okay." And
so it was. Later that evening I'm in Ronnie's taking pictures of Ben
Webster, when Jacquet appears on the stage totally out of it. He
grabs the microphone and shouts, "Red, why don't you take our
picture?" It's at times like this I just want the floor to open up. Many
years later I find myself in Ruby Braff's dressing-room in Saratoga
with Illinois: you wouldn't think those two had very much in
common, but they had me in stitches recalling the times they both
worked for Benny Goodman. Here's one.

It was very cold in a New York rehearsal room. The band was
waiting for Benny to appear. When he does, someone shouts out,
"Benny, it's very cold in here." "Hmm, yes, it is," says Benny,
walking out of the room. Three minutes later Benny walks back in
with his overcoat and scarf on, and just carries on with the
rehearsal.

Another one always makes me laugh. When the musicians
asked to be paid for rehearsals, Benny replied, "Why should I pay
you for something that I already know? You should be paying me."

Miracle on Charing Cross Road • • • • • Getting
Ben Webster to my old studio was a miracle. He'd agreed to come
a number of times, but never managed to make it. However, on
this occasion I became more determined than ever, having set it
up the previous night at Ronnie Scott's. I waited, and waited.
Slowly as time passes by, you realise that it's not going to happen
again, but you wait in hope. It reminded me of my youth waiting
for that date to turn up, just another half an hour – but it never
happens. We tried again the next day. Show-up time (three
o'clock in mid-afternoon) came and went. So this time I called
Henry Cohen, Ben's unofficial minder from Ronnie's (he who used
to eat furniture for dinner). Henry went to Ben's hotel, banged on
the door and dragged him round to my studio, on the fourth floor
in Charing Cross Road. I hadn't mentioned it to anyone before, but
there was a goods lift that people were not permitted to use. Ben
was in no state to walk up – so the lift it was.

Ben sat on a stool and drank a couple of beers while I set up
the lights. I try to light my subjects as though they are on stage
or in a television studio. This gives me the freedom to work

around them, but not to pose them as such. Ben was no
different. He lit a cigarette and just sat there, didn't move or
talk. He didn't have to, the face said it all, and I quietly took the
pictures. The session over Ben went back down in the lift. This
was Ben's last visit to London. And as the lift totally collapsed a
week later, yes, it was a bit of a miracle.

above: | **Benny Goodman:**
Capital Jazz Festival, Knebworth,1982

opposite: | **Ben Webster:**
London studio, 1973

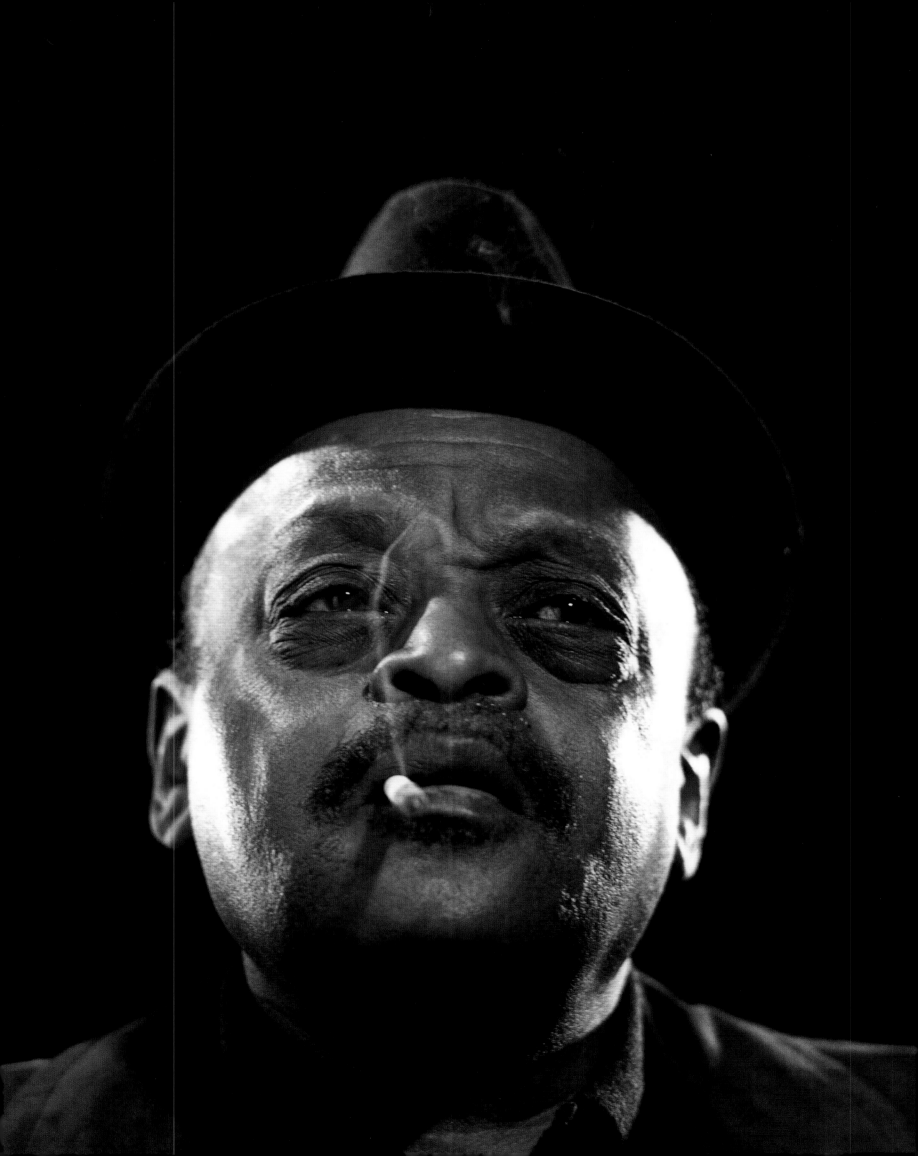

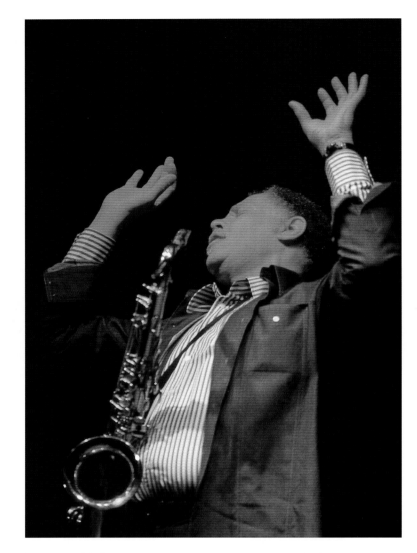

Disturbing the even tenor • • • • Another tenor giant was Dexter Gordon. He was one of my all-time favourites. This may have been helped by the fact that he used to say to people, "Hey, you know Redfern, he's the Cartier-Bresson of jazz." In the summer of 1980 I found myself in a very uncomfortable Department of Corrections vehicle, with writer Brian Case and Dexter Gordon with his band. We were going to cover Dexter giving a concert to the inmates of Rikers Island penitentiary. Dexter was no stranger to the inside as he had previously done time for drug offences. So I'm sure it was even more poignant for him to be behind bars again, this time on the right side entertaining all the lifers. I was allowed to take as many pictures as I wanted providing the inmates could not be individually recognised or at least not without their written permission. It was a fascinating day. I prudently stuck to 35mm black-and-white only, which was highly suitable for this dark situation.

New York, 1981 | **Dexter Gordon**

Rikers Island Penitentiary, 1980

Dexter Gordon, Kirk Lightsey: | Rikers Island Penitentiary, 1980

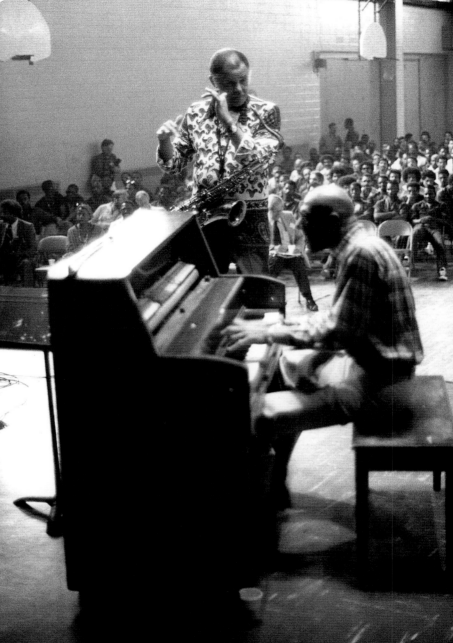

Dexter Gordon:

Rikers Island Penitentiary, 1980

Sonny Stitt, Dexter Gordon: | New York, 1975

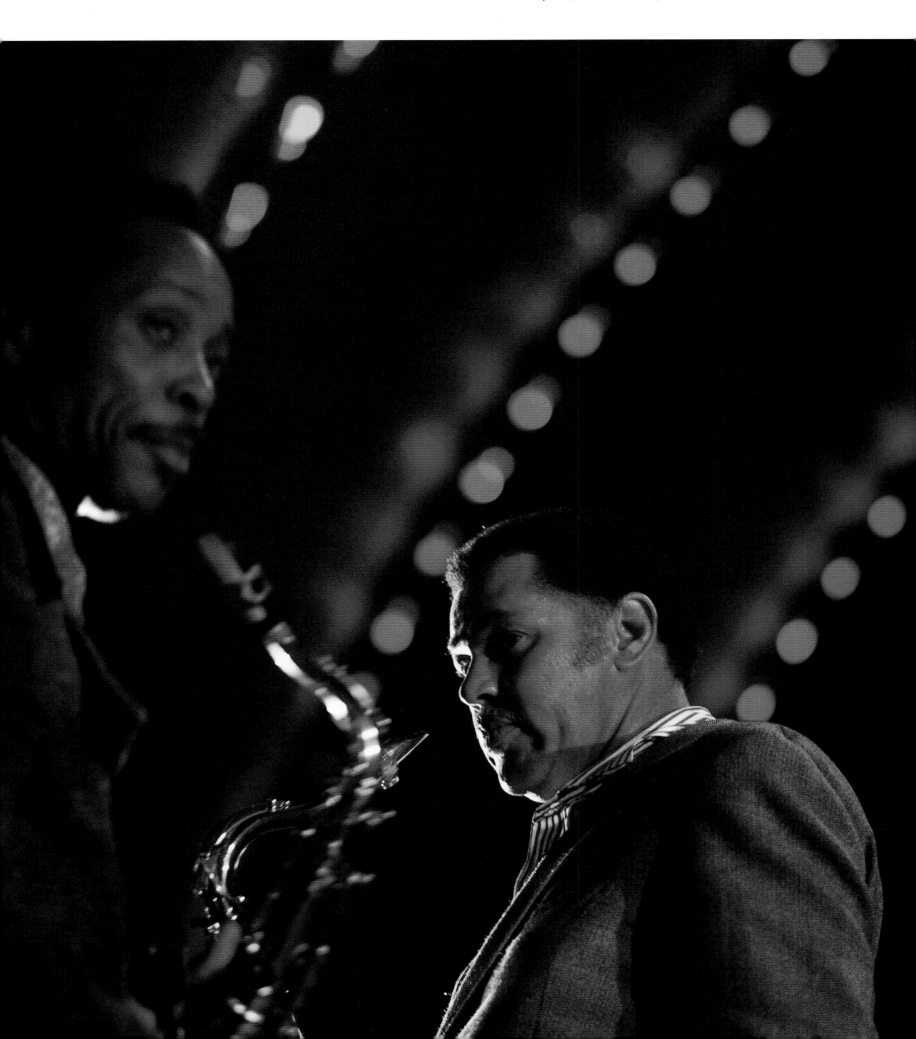

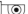

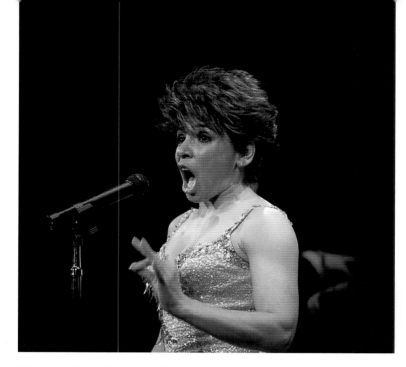

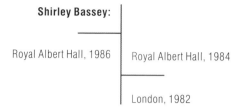

Shirley Bassey:

Royal Albert Hall, 1986 | Royal Albert Hall, 1984

London, 1982

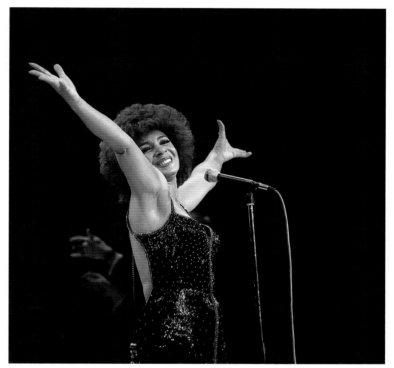

Touching base with Bassey • • • • • The great thing about the photography business is that you never know what's next in store for you. I was asked if I would do a friend a very special favour and photograph her wedding (not something I do lightly or very often) but I said okay and turned up to do the number. The guest of honour was Shirley Bassey and as we chatted (as you do at weddings) I casually asked her what the future had lined up for her. She told me she was going to Jamaica and Florida to film a TV series with Stuart Morris for BBC1. "There must be some great pictures in a trip like that," I said. "Oh, would you like to come?" said Shirley, to which my immediate reply was "Yes!" – but I knew it was not going to be easy to fix with all the BBC union stuff, not to mention things like airline and hotel bills. Shirley said she'd fix it – and fix it she did. It was arranged that I get the *Radio Times* gig (much to the chagrin of the staff photographers). There was about a week's filming in Jamaica, where it was very, very hot (swollen ankles like I'd never had before), but with some beautiful locations. Back to Florida, where I arrived a couple of days after the crew and found myself without a hotel room for the night. It was the worst time I have ever had getting a room. I couldn't find one anywhere, until a taxi driver took me to a place which would make an English doss-house look like the Ritz. I've never seen so many prostitutes and junkies, not to mention hordes of cockroaches, in any one place.

I was very glad to catch up with the crew the next day. We did the Keys, Cape Canaveral and Disney World all in a few days. Shirley was always very professional no matter how arduous the filming was. I always described her as the Maria Callas of pop and will defy any photographer not to be moved by her performances which I have photographed for nigh on thirty-five years.

I remember getting a call when she was playing a season at the Talk Of The Town. She was about to "come out" with her Australian boyfriend, Ken, because the papers had got hold of the story. Ken once remarked to me, "Don't know why they call me a chauffeur...I can hardly drive a bloody car – I'm a race horse owner." So this time he calls me: "Dave, you've been good to us, and kept your mouth shut about our relationship. I know you could have made a lot of money from the papers, so we would like you to come down and get some pictures of us so you can make some money." There was nothing more to add to that. I have always found that it's the real stars that are the genuine ones. There are so many second leaguers, pretenders to the throne, that always give the aggro.

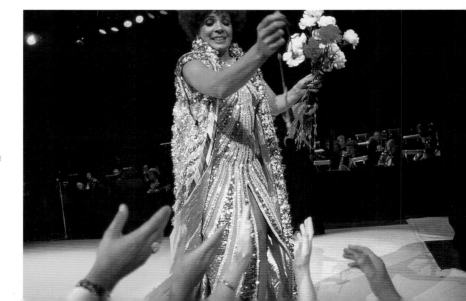

Shirley Bassey:

Royal Albert Hall, 1986 · Jamaica, 1979

Bristol, 1996

At Last in Amsterdam • • • • • Another true artist is the German band leader, James Last. Musicians love to work for him because he looks after them so well. I had to fly to Amsterdam to do a whole day's shoot with him at all the famous landmarks, for an album to celebrate Amsterdam's seven hundred years. It poured with rain most of the day, and lighting conditions were far from perfect, but it didn't show in the end result. Some lesser stars would have given up hours before.

A couple of years later I was covering a TV filming on Brighton Marina. It was a very cold crisp winter morning. At about 8.30 we stopped for a well-earned coffee break. James was nowhere to be found. Five minutes later he turns up, and goes round pouring brandy into everyone's coffee. He could have easily asked some minion to go and find something, but, no, he went off himself. Where do you find a bottle of Remy in Brighton at 8.30 in the morning?

I used to love photographing his concerts. Like at a Shirley Bassey show, the James Last audience is always on your side. Many a time I have been sitting on the floor in the centre aisle changing film, and I've got a nudge from someone if I was in danger of missing any of the action. James Last was one of the first people to introduce Irish dancers to large audiences in this country. He picked up a couple he saw in Dublin and bought them over for his Albert Hall season long before Michael Flatley and his crew.

Gordon Bennett, it's Tony • • • • • It was a great pleasure to work for Tony Bennett when he did a season of television shows at the Talk Of The Town in London. I was introduced to Tony for the first time by Buddy Rich when they were touring together in the early Sixties. I would certainly endorse Frank Sinatra's words that Tony Bennett is the greatest singer in the world today. His consummate professionalism has always impressed me. He always goes out of his way to greet me whenever we meet, be it in his local diner on Sixth Avenue in New York, or on stage – like the last time I met him, at the Newport Jazz Festival 2002.

James Last:	**Tony Bennett:**
Royal Albert Hall, 1990	Nice, 1998

Budding talent • • • • Roy Budd and I had become friends over the years. He was probably better known for his film and TV theme writing, but he was a very good piano player. When he announced that he was marrying German musical star Caterina Valente (one of my childhood idols...'The Breeze And I', for example) he asked me if I would take the engagement pictures and photograph the wedding. He told me there would be lots of media interest, but we would have the whole event as an exclusive. I can't say that I concurred with his view but we went along with it. How wrong can you be? The media interest was intense, especially from Germany and the rest of Europe. Roy seriously managed the event which was just as well, as I'd never seen such persistence by German magazine photographers trying to break our exclusive in this little country church in Surrey. They were hiding in the rafters, lurking in the church tower and disguising themselves as guests. We managed to evict most of them – and made many covers and spreads in the big continental picture magazines.

| **Caterina Valente's** marriage to **Roy Budd**

The trouble with management • • • • • During the Eighties I was travelling even more than before. It was becoming progressively more difficult to shoot concerts in London, as everyone was latching on to the first-three-numbers rule making serious photography very difficult. This is now the norm for all rock and pop concerts in most of the big venues. I can see that from the management's point of view they don't want the audience disrupted, but with some notable exceptions little effort is made to make sure only photographers that know how to behave are allowed to cover an event. And nowadays most shows have incessant flash going off from the audience which I would find much more disruptive. Anyway, it's time people were educated to the fact that these tiny cameras have a range of about fifteen to twenty feet, useless for a big concert.

Many a time a promoter has called me the day after a concert and asked me why I was not there, as arranged. I'm always happy to say, "Yes, I was there, and, no, you shouldn't have seen me, I'll send the pictures over." At the risk of repeating myself, as photographers we are in a very privileged position and should never form a barrier between the punters and the artists.

Fats on form • • • • • Sometimes, of course, the artists themselves will draw attention to your presence, usually in a positive way. Buddy Rich was like that, he would talk to me through the microphone. Fats Domino's actions once took some beating. During the finale at one of his concerts, the band was screaming, he's thumping those ivories, when suddenly he gets up, walks over to the edge of the stage and gestures me to come over. He just wanted to shake my hand. Then he walks back and carries on with the show. He's such a great man, so full of grace.

In New Orleans in 1985 I was at the recording session that he did with Doug Kershaw when they made the single 'Don't Mess With My Tutu'. Fats said to me, "How did you know I was going to be here?" I said, "Well, a friend told me." "No," he said, "how did you know I was going to be here, because I didn't know myself until a couple of hours ago!" He once invited me to his house to eat oysters, but I can't stand them, so I made my excuses. I'd have loved to have seen the inside of his house, though. I'll never tire of photographing Fats live in concert, which is in no way easy because of the microphone. On the other hand, he's a good poser and over the years he has given me many a straight shot looking into the lens.

LOUISIANA

Fats Domino: New Orleans, 1982

High in Louisiana • • • • Some of the best live concerts I went to were part of the New Orleans Jazz And Heritage Festival, where they used to have a showboat ride for the evening concerts. The boat – no oil painting – used to go up and down the Mississippi, but it didn't matter whether it actually moved or not: the atmosphere for these shows was always electric. I usually managed to get a front row seat which was very close to the artists. Inevitably these shows were sold out, but it cost you nothing to get high – you only had to breathe the smoke-filled air, let alone soak up the loud and brassy music.

The Cajun experience • • • • • I first went to New Orleans in the early Seventies when the festival was very small by today's standards. I couldn't afford to go for a number of years after that, but as things looked up in the early Eighties I returned and have been covering it ever since.

Mind you, in the early visits I'd shoot anything and stay anywhere just to be able to afford to cover the festival . One

twelve stages at once from eleven in the morning to seven at night, and I find it extremely tiring work, being spoiled for choice. I end up playing musical chairs, trying to avoid being at any one stage as the music stops. Trying to cater for commercial considerations I find I shoot far too much film. At least I don't have time to be tempted too much by all that delicious Cajun food.

The Cajun music is another story, though. Apart from the

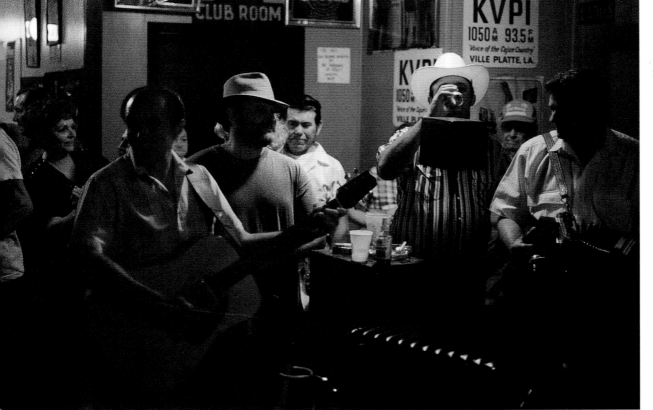

odd tours, it's still quite difficult to find genuine Cajun-Zydeco music outside Louisiana. In 1992 Dede and I set our watches back twenty years and drove to Eunice, the capital of Cajun country. Finding accommodation was the first hurdle to overcome, and inspired by numerous invitations from the local tourist board ladies to "stay in my B&B" house, we eventually found a rather run-down motel. But the word was out: the English are in town. The first club we went to was a small shack miles in the country. It was like walking on to the set of one of those dark

year I was asked to photograph the Prom party of a well-known lawyer's daughters at very short notice. It would be an honour if I could take a few pictures, so there I was, very late at night after one of the boat-ride concerts, being driven round by my friend, Paul Lentz, looking for an all-night drugstore which would sell me a roll of negative film. My flash gun was, as always, for emergency use only, but somehow it all worked out – and the two hundred and fifty dollars cash was very useful.

The best deal on accommodation in the early Eighties was our special press rate at the Palas Suite Hotel on Canal Street – twenty five dollars a room irrespective of the number of people staying in it. These days (and for the last ten years) nothing but Le Richelieu on Charters Street will do.

The main part of the festival takes place at the New Orleans Fairgrounds race track. Bands will be playing on anything up to

Southern movies. As we walked through the door everything stopped and we were the total focus of attention. "Hi, you must be the folks from England", "What can we do to help you?" and so on: they couldn't have been nicer. They even went scouring the building for some electric bulbs to give me a little more light for some pictures. After the show by some ageing Cajun musicians, there was free supper, red beans and rice all round. That was pretty good, but the highlight of the trip was the 8.30am visit to Fred's Lounge in Mamu, a Saturday morning only club. As I can't do anything without a good breakfast, it was around 9.30am when we arrived and the show was in full swing. The scene was fantastic, with a Cajun band grooving away. It was a live local radio breakfast show, with the announcer also reading the commercials – unbelievable! People were dancing, Dede was dragged on to the floor and plied with

beer; and it seemed every other man in the audience had served in the US forces in Britain at one time or another. Before we knew it, it was 1pm – and closing time. Everybody was moving on to the next venue as we made our excuses and left. That evening we went to Richard's, a black Zydeco club. We were the only white folks there. All in all the whole Cajun trip was a fascinating experience.

opposite and left:
Fred s Lounge

bottom:
Pointe Aux Loups Playboxes

Rhythm – and blues • • • • • The jazz festival in New Orleans is famous for all types of heritage music, not least blues and R&B. One of the greatest stars from the latter is Chuck Berry who manages to straddle many musical genres, judged by the many festivals he has constantly appeared at over the years. I was absolutely captivated by Chuck's performance of 'Sweet Little Sixteen' in the film *Jazz On A Summer's Day*. When I first met him, at Finsbury Park during his first London concert, he had just been released from jail in the States for taking a minor across the state line. It was somewhat ironic, then, that as I walked into his dressing-room a very young girl was coming out.

Chuck was always great to photograph, he would give me the ready signal when he was going to do his duck walk, not that it was always that easy to capture, but I've had my fair share of those pictures over the years.

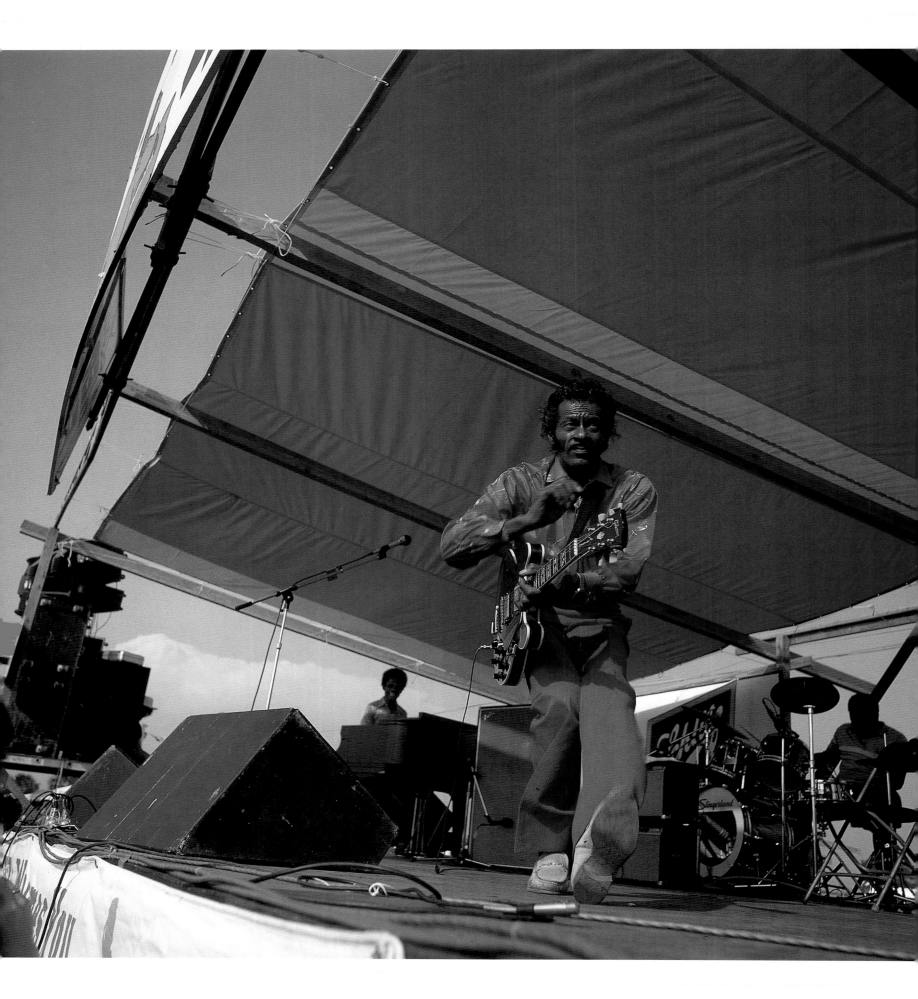

Chuck Berry: New Orleans, 1982

Blue backing • • • • • The jazz festival stage decorations in the Eighties were very photographic, with wonderfully vibrant colours – greens, oranges, reds and blues. BB King playing his heart out against an azure blue background takes a lot of beating. It's fair to say that some of my best blues images have been taken at the New Orleans festival. Evidence for this is my blues calendars, published in the last few years, which have included many pictures taken at this festival. Jazz Fest often throws up artists that I'll never see anywhere else. A classic example is blues man Deacon John, who plays a great set every year without fail, but as far as I can make out doesn't even have a record out. One thing is certain: it's the very last festival I shall give up.

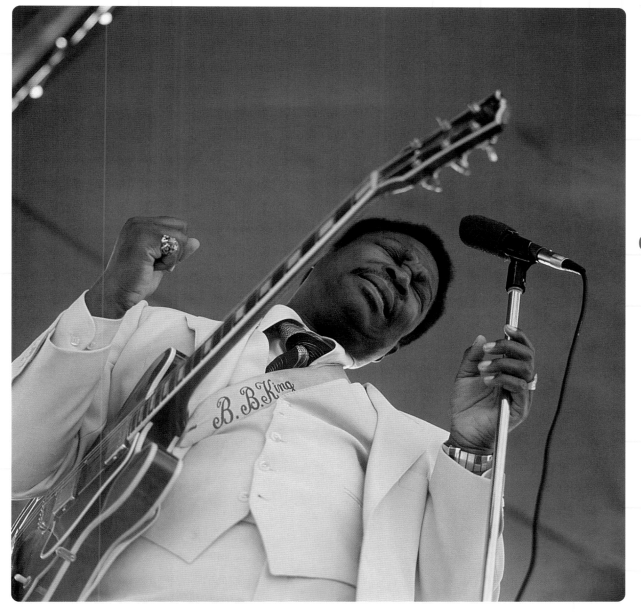

Roosevelt Sykes:
New Orleans, 1982

BB King:
New Orleans, 1978

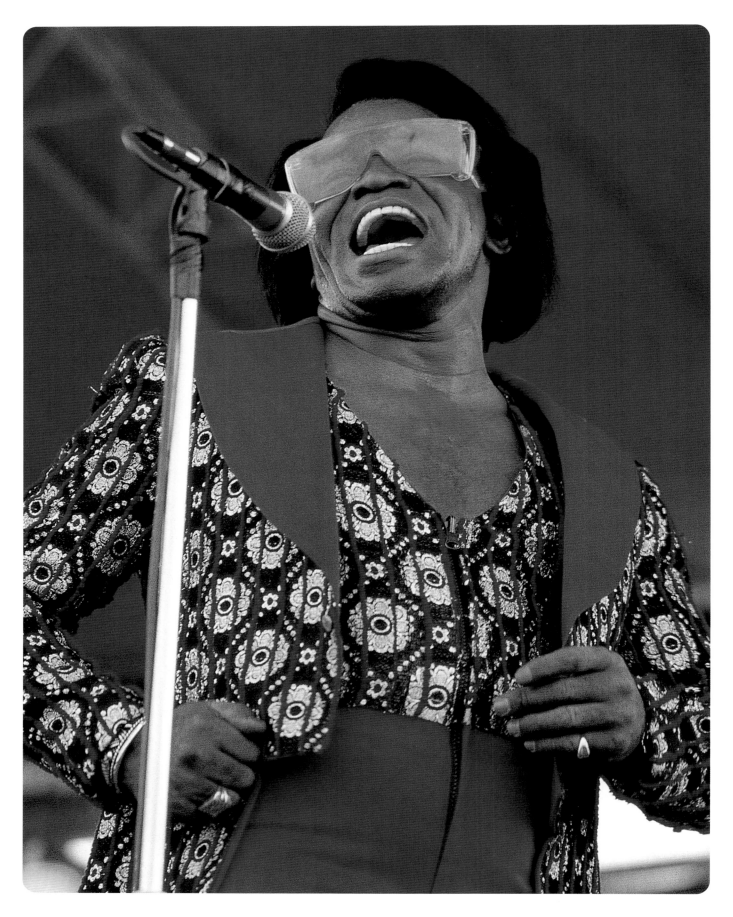

James Brown: New Orleans, 1988 | **Miles Davis:** New Orleans, 1991

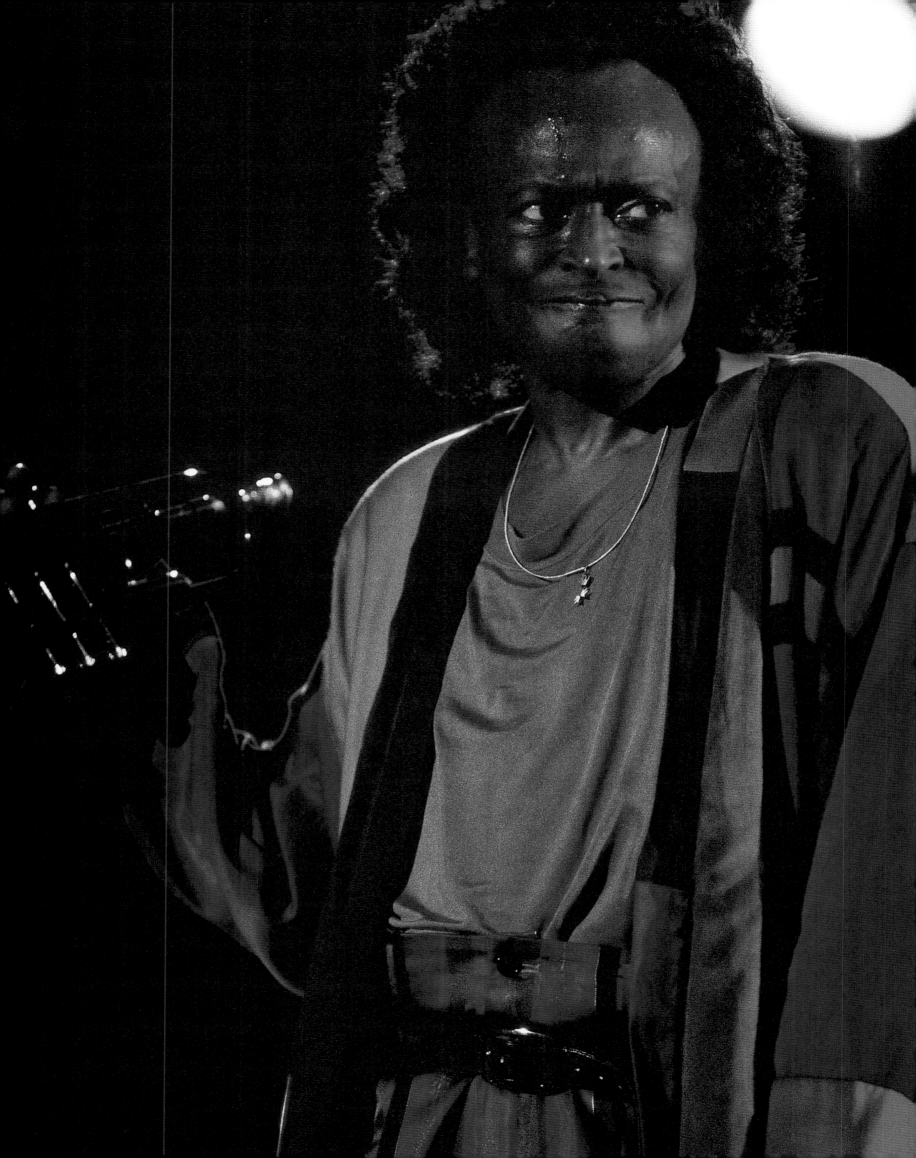

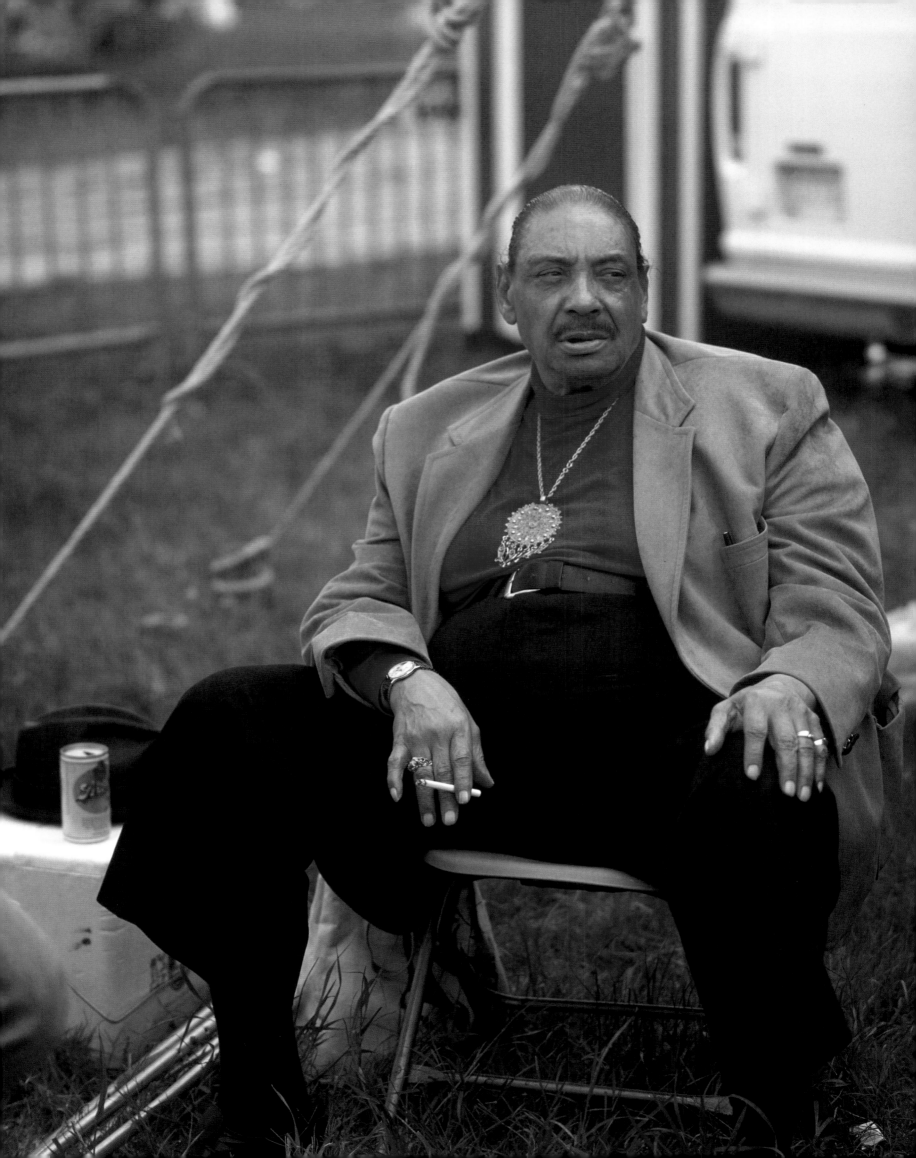

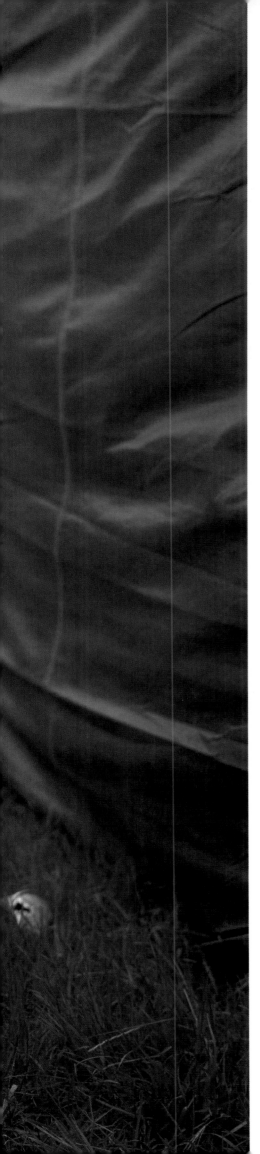

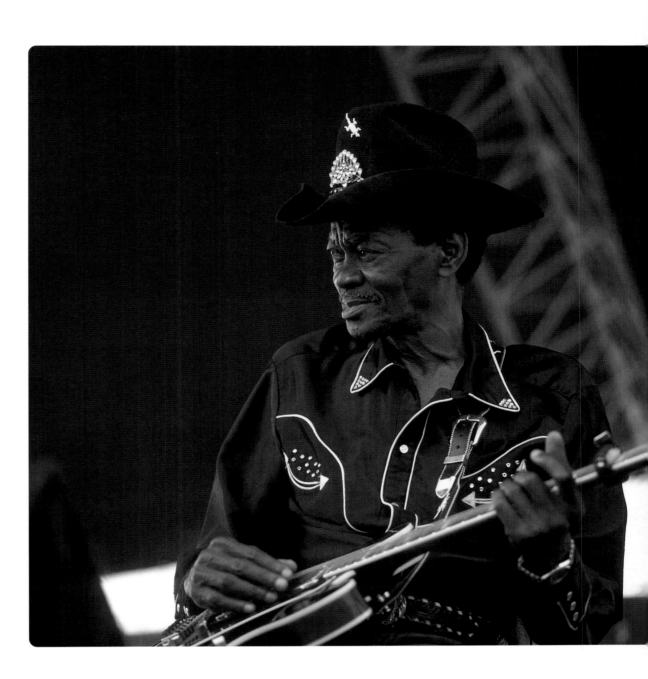

Big Joe Turner:

New Orleans, 1983

Gatemouth Brown:

New Orleans, 1987

Bo Diddley:

New Orleans, 1984

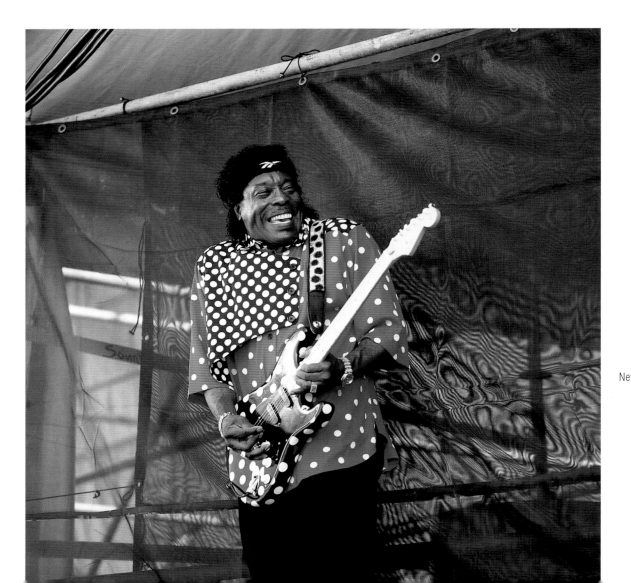

opposite:

Buddy Guy: | **Lightnin Hopkins:**

New Orleans, 1996 | New Orleans, 1978

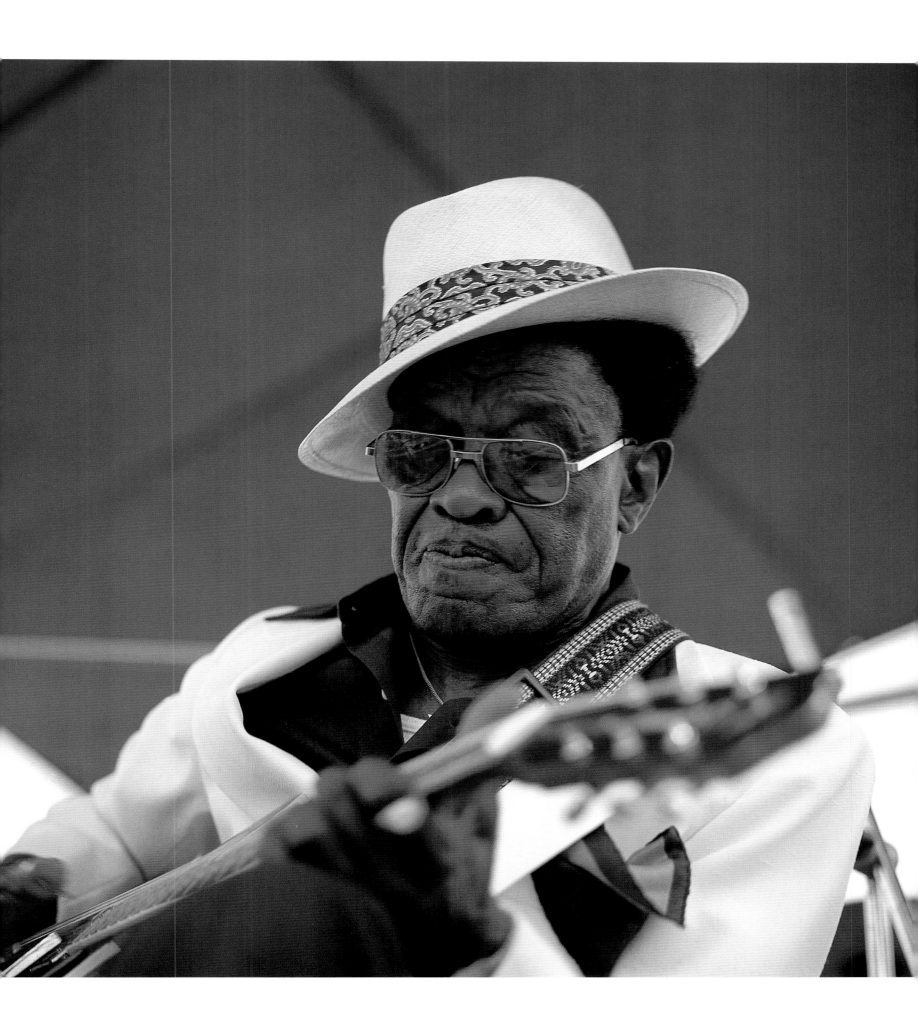

Gospel heat • • • • • Gospel music has always fascinated me. Maybe because I used to sing in my father's church choir, I soon came to realise that the holy-roller preaching lifestyle is not always practised off-stage. I've certainly known a few gospel groups who were not averse to having a quick slug before going on stage to preach the ways of the Lord! But the genuine article will always be found in the gospel tent at the New Orleans Jazz And Heritage Festival.

opposite:

Kennedy High Gospel Choir: **Cosmopolitan Church Choir:**

New Orleans, 1991 New Orleans, 1995

HATS OFF

opposite:

Stevie Ray Vaughan	Aretha Franklin
Josephine Baker	Sun Ra
Betty Carter	Tammy Wynette

An old English advertising slogan was "If you want to get ahead…get a hat", devised by the famous hatters Dunn & Co. In any event I don't think it applies to the music business. Photographing artists wearing hats on stage is a nightmare, as the light to the face is usually obscured. Here are a few examples of some milliners' work. I have of course excluded the dreaded baseball cap; they are definitely not hats.

| Taj Mahal |
this page:
| Wynton Marsalis |

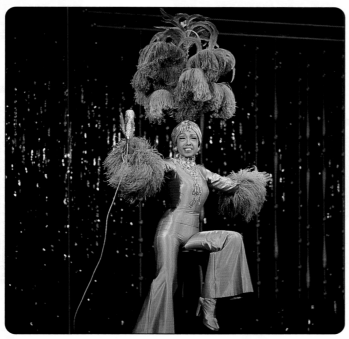
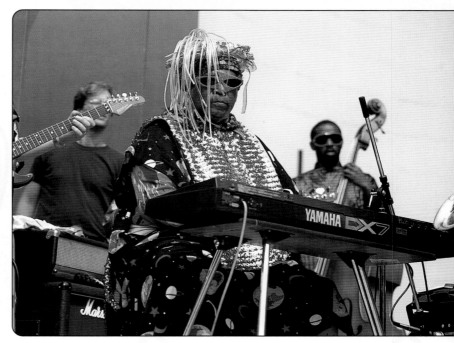

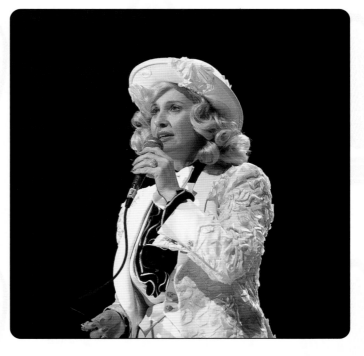

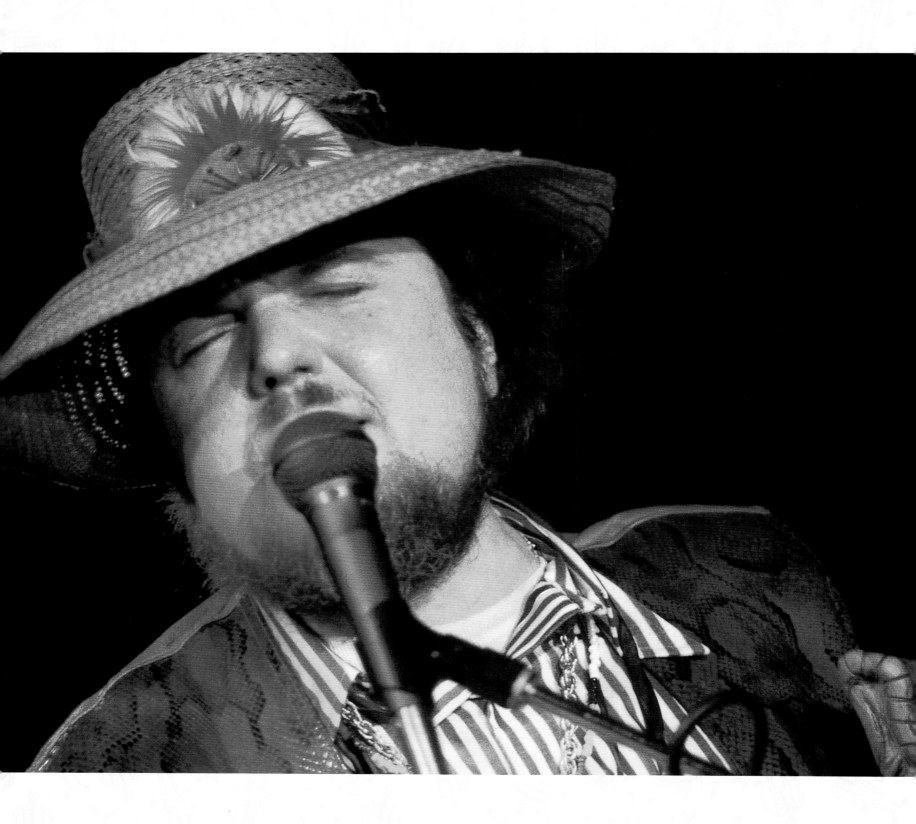

Dr John | New Orleans, 1982

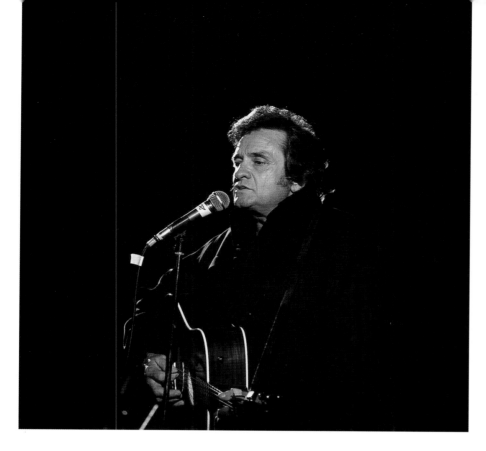

Johnny Cash:
Portsmouth, 1980

Ella Fitzgerald:
Annabel s, London, 1971

Non-exotic • • • • • Festivals don't always have to be in exotic locations to work for me. I took some of my best pictures of Johnny Cash at a country music festival on a disused airfield near Portsmouth where there were nearly as many people back-stage as out front.

Then there was the time that the Cleveland County Council was persuaded to part with lots of money to put on the Newport Jazz Festival at Middlesbrough football stadium, one of the strangest venues for a jazz festival. We were told to tread very carefully on the hallowed turf – which in a few weeks' time would probably be a mud bath. But in spite of over-zealous security I made some of my best black-and-white pictures of Ella Fitzgerald, as well as some of my best colour shots of Art Blakey. Incidentally, I got even better shots of Ella at another bizarre location: Annabel's, the famous club in Mayfair. She was making a charity appearance for the British Olympic ski team.

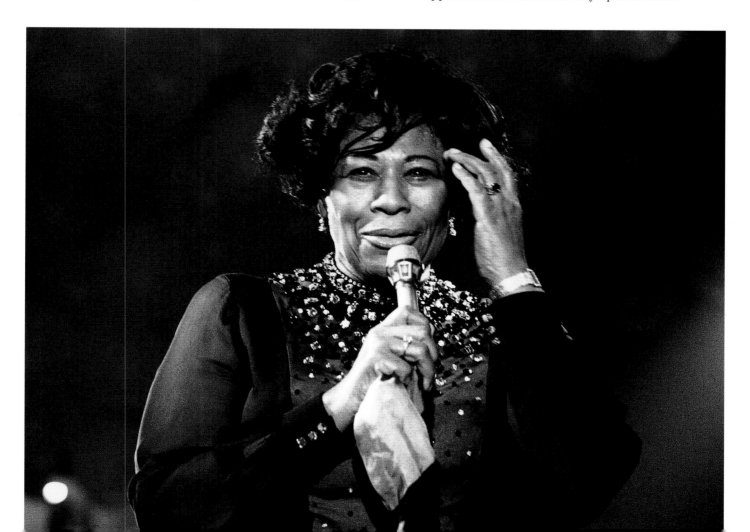

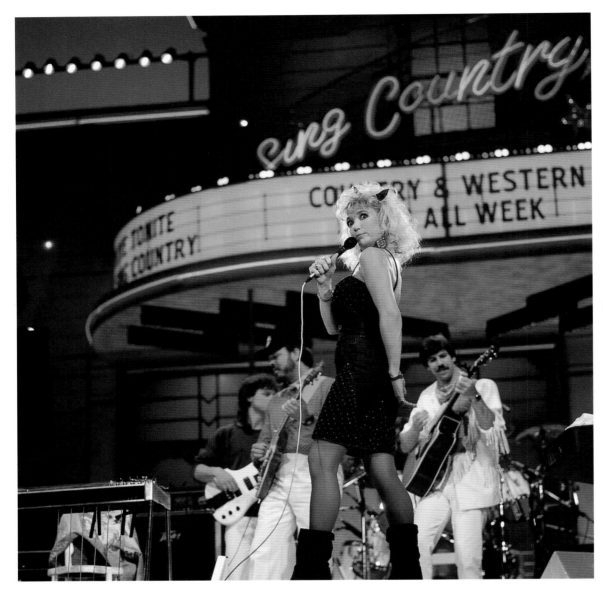

| **Tania Tucker:** Wembley, 1987

Wembley is the country • • • • • If it's Easter it must be Wembley: that was the cry and groan for many years during the Eighties. I was covering the International Festival Of Country Music promoted by Mervyn Conn which took place for three days every Easter. Mainly ignored by our competitors this highly colourful event was a golden opportunity to photograph country artists in good colour. Photographers were put in the pit with the TV cameras, and the sets and lighting were usually excellent. Unfortunately, one had to listen to country songs non-stop for at least six hours a day – not everyone's cup of tea. But it suited Dede, my partner, who is a country fan. She became the perfect assistant, plying me with sandwiches, and wine from the wine-box she smuggled in.

It took me some time to work out that when the artists were talking about their Number One hits, they were referring to the *Billboard* American country charts, which is no mean feat in itself. Many of the artists, although famous in their own field, are unknown to the general media – apart from the steady air play some of them get on Radio 2. I'm talking about such colourful artists as Box Car Willie, who sings nothing but train songs; Marty Robbins whose lilting Tex-Mex renditions had captured many a heart; and the lovely four-times-married Tammy Wynette who played her life out through her songs – and who sadly died in 1998.

Then we had the world-class stars: the man in black, Johnny Cash; and for me the best of them all, Willie Nelson, a superb entertainer who is able to transcend all musical genres with his charismatic style.

opposite:

Marty Robbins:	**Willie Nelson:**
Wembley, 1987	Wembley, 1987
Dolly Parton:	**Box Car Willie:**
Wembley, 1987	Wembley, 1987

Big apple in the sky • • • • • Sometimes it's an unusual picture subject that pays for one's travels. This was certainly the case in New York for many years. I had often thought that I would like to photograph the New York skyline, so one year I telephoned the Visitors and Convention Bureau, and asked where was the best place to take this picture. They told me of a very small park (about the size of a lay-by) at Weehauken in New Jersey and they gave me a very detailed description as to which bus to catch, and where to get off. Well, it was (and still is) the perfect place. In July towards sunset the sun is right behind you as it goes down reflecting on all those glass buildings. Shot with the 350mm lens on the Hasselblad the results were magic. I went back for a number of years, taking a shot every year, and those pictures paid for my annual trip to New York for a long time. We sold one of the pictures to an Italian poster company. The director told me that when they presented it to a sales conference all the reps stood up and applauded. It can't get better than that.

New York skyline: | opposite:
1989 | 1988

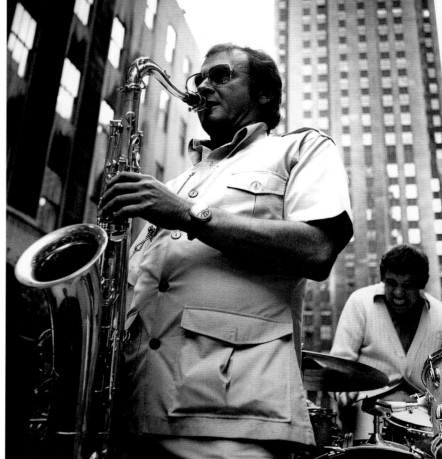

Stan Getz, Buddy Rich:
Rockefeller Plaza, New York, 1976

Moving times – again! • • • • • Back at home at the end of the Eighties, I was starting to feel restless in Covent Garden. I'd lived in the studio part illegally for many years since my second marriage broke up. Covent Garden was becoming very crowded and tourist-infested. Only a few years before, I could look out of my loft bedroom window down Long Acre on a Sunday morning and not see one parked car. Times had changed a lot: it was common not to be able to park anywhere before the theatres came out at 10.30pm. But for a while there was a friendly traffic warden – blonde, young, female – who'd let me park on single lines, and buzz me when the heavy mob with the tow-truck were in the offing.

I had often talked to Dede about the possibility of putting some spare money into property if I ever had any. I had lived until I was over fifty years old without ever having a mortgage. But all the rents were going up, and large repairs were starting to be necessary to that building. I had just discovered that the fashion designer, Victor Edelstein, on the floor below me had just sold the remaining part of his long lease for a lot of money. It was time to go. This was 1988 – and prices were still high. So I thought I could sell mine, but where to go and what with?

It was not going to be easy getting a mortgage at my age, but first you have to find a property. I started by looking round the Clerkenwell area where lots of media groups were already located, but the buildings were very large and it would be difficult, if not impossible, to split them up. And the prices were twice what I could afford. So I started driving around looking at areas for their suitability. South of the river was out, although I did check out the Waterloo area. North London I didn't fancy. That left West London. After enough cruising around to arouse the law's suspicions, I eventually came across a very derelict building in Notting Dale, North Kensington. It had a very small For Sale sign on it with a telephone number. It could be ideal, I thought (for a man of vision, that is). I took along an architect friend, John Read, who told me, "The bonus is in the basement – it's dry."

Was I worried about moving so far from the newspapers and magazines that contributed so much to my turnover? Yes, I was. But by the end of the Eighties Fleet Street had already gone, Associated Newspapers were moving to High St Ken and a number of record companies were moving into North Kensington.

So I agreed a price – and faced the problem of finding the money. It's always been Catch 22 with derelict buildings; no building societies will lend you money until the property is fixed up. So you have to borrow from the banks. Well, five banks later, and through the good offices of my auditors, John Whitworth of Daly Hoggett, we managed to find a Nat West bank manager who was brave enough to lend me money to buy this very dilapidated Victorian shop. He also had to lend me most of the money for the conversion, because I was going to live in the flat above, once we had added another floor. It was all very touch-and-go as far as time was concerned. I had to get out of Long Acre by the end of the year to avoid the massive repair bills I would be liable for in the New Year.

The building contract for my new building was only signed on 13 December. Two doors down in Bramley Road there was another shop which had some empty floors above. I talked to the owner who said if I could fix the electricity (there wasn't any) I could borrow the two floors for a few months. Later that day an out-of-work electrician was literally walking down the street looking for work. Duly signed up we were able to move all my filing cabinets into the temporary accommodation with new phone lines strung down the street from a new building site. We were in business. The only trick now was to discourage visitors at all costs until we finally moved into the new converted building some five months later. It worked, we had very few visitors apart from messengers, and in May we were finally

Redferns staff: April 2005 | **Gallery:** 2005

(Photo by Kevin Goodall)

settling in the new building. It's no secret that in order to get various loans you have to have a business plan. Mine was produced on a bit of a wing and a prayer but it made a good read. I remember the advice from a good friend of mine, John Wilson, who told me to build a buggeration factor of ten per cent into any contract, for all these extras and unforeseen items you will need along the line.

Two things saved me in money terms. One was my Amex Gold Card bank account at the previous Long Acre bank, which was good for a ten grand overdraft. The other was being able to get a grant to finish off the flat, as there was no gas, water or electricity. The third thing that saved me was the Dede factor (not previously built into the equation). Dede and I had been together for about five years when I moved to Bramley Road; at the time of moving she was between jobs; and my sole library employee couldn't take the change from Covent Garden to Notting Dale. So Dede said, "I'll come and help you sort it out,

and we'll see if it can work." Obviously it did. Turnover immediately started rising to meet my financial targets and beyond, and in six months we had become partners in business as well. That was fifteen years ago. Now we represent some four hundred photographers, against twenty in 1988. We are now ten strong at Redferns: we must be doing something right! In 1997 we managed to buy No 3 Bramley Road, which had been our original camping spot, so I've gone through the whole renovation process yet again.

Now we have two buildings and represent some 400 photographers and collections as against 20 in 1988. We are now ten strong at Redferns.

Duran Duran:
Montreux, 1987

Pop goes the festival · · · · · Another phenomenon in the Eighties was the pop festival specially done for TV. The biggest of these was the Montreux Rock Festival, basically put on by Swiss TV but produced by the BBC. Many of these events have a short but sweet life. The trick is to get in first and early before the hordes turn up. The first year of the event was like that, just a couple of us from the UK. It took place in a smallish venue called Hazyland and we were up in a box with all the spotlights. The main band was Duran Duran at the height of their popularity – which certainly made that trip worthwhile. In the years that followed the event moved to a

bigger venue (the casino), and featured many more artists – as well as many more photographers. But the atmosphere of that first one was never repeated.

A short but sweet life was also the fate of the Diamond Awards in Antwerp in Belgium. Among the many awards they had was one for live music photography, so the organisers could hardly turn round and say, sorry, no pictures of the live gala event. This took place in the massive barn of an arena full to the brim with screaming teenage girls. But the TV lighting was excellent and it was a good event to cover for a couple of years.

Barry White:
Diamond Awards,
Antwerp, 1987

5

chapter five { **the nineties** }

Woody Herman, Ronnie Scott: | Ronnie Scott:
London, 1964 | London, 1988

Ronnie Scott: | Ronnie Scott, Sonny Rollins:
London, 1991 | London, 1965

THE NINETIES

Great Scott • • • • • One of the few things I missed about not living and working in the West End was being close to Ronnie Scott's Club. It was literally ten minutes' walk away, but I don't think the move cut down my visits very much.

My association with the club goes back as far as I can remember. I did take some pictures at the old place in Gerrard Street, but it was when they moved to Frith Street that I became more involved. Over twenty-five years ago I had supplied them with pictures. As times were hard all round, I had difficulty in getting my bills paid, so I said jokingly I'd better come and eat and drink my way through the debt. Pete King, Ronnie's partner, took me seriously and said, "I'll tell you what, Dave, you supply us with pictures and an invoice, we will invoice you for food and drink, and every decade or so we'll balance the books!" What a wonderful mutual arrangement. Needless to say we have never swapped invoices, Pete has always said treat the place as your own, do what you want here.

In the early days I probably had about fifteen framed pictures around the walls, until one day I got a call from Ronnie. "David, I want to cover the whole place – yes, all the walls in the club with pictures, how many prints can you let me have?" Ronnie came over and trawled the files for every jazz-related picture and poster there was around. The result is the club basically as it is today.

Ronnie himself didn't much like to be photographed, but he had to have some publicity pictures, so I arranged to set up additional lights and Ronnie appeared in-between visits to the bookies across the street. I was trying to get something different, a smiling shot, not seen very often. Pete came to my rescue with a joke machine from Hong Kong someone had given him. Every time you pressed the button it gave you a new one-liner. It was perfect: lots of shots of Ronnie smiling. He always said that they were his favourite pictures of himself.

| **Ronnie Scott:** London, 1988

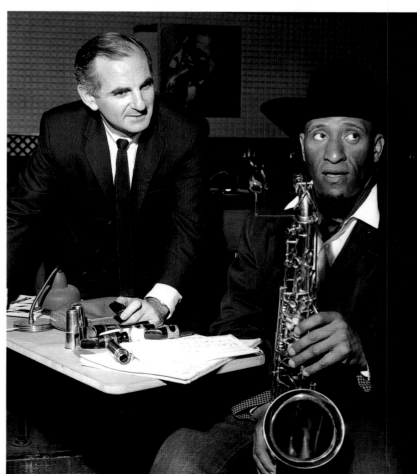

Johnny Griffin: | **Roy Ayers:**
London, 1989 | Taunton, 1992

It's not always easy to take pictures in the club, unless there
is additional lighting. Once someone was making a TV documentary
on the club and wanted footage of me taking pictures of a musician.
Fortunately I had a very willing subject in Johnny Griffin, who, as it
happened, needed some new pictures, which he used for many
years after that.

I'm frequently asked if the club has changed since Ronnie's
untimely death in December 1996. The answer is, both "yes" and "no".

"Yes", because we all miss Ronnie, his playing, his wonderful
sense of humour, those famous jokes which I would still laugh at
without fail, although most of them I've heard hundreds of times
before – every year or so we'd get to hear a new one, a red-letter day.

And "no" because his memory lives on. Pete King did a marvellous
job keeping it all together. Now theatrical mogul Sally Greene has
taken over. Physical changes are needed. Let's hope that'll be all.

| **Ronnie Scott:** Kew Gardens, 1989

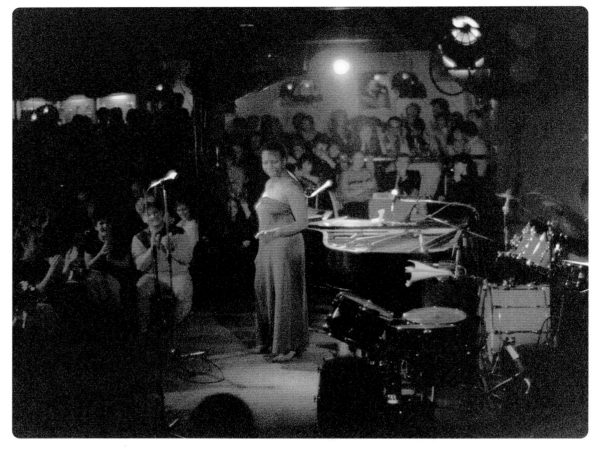

Nina Simone:

London, 1984 opposite:

Dizzy Gillespie:

Havana, 1990

Naughty Nina • • • • • Some of Ronnie's acts were more difficult. Around 1983 or '84 Nina Simone was doing record business in the club night after night. Her appearances helped to put the club back on its feet after some very hard times. Every time I saw her coming towards me during that engagement I knew it meant trouble of one sort or the other, for she was a bit of a Jekyll and Hyde. For one session I decided to put on a special exhibition of Nina's pictures in her honour, only she didn't see it

like that. I had sold a 10x8 print to a fan for a fiver (not a lot of money) and when the fan told her as she was asked to sign an autograph Nina went ape shit on me: "I won't do any more pictures for you, you have enough already, besides you're making money out of me." A moment later she asked me out to dinner, but, as they say in the trade, I made my excuses and left. I said I had to have dinner with my son. "Stop," she shouted at the top of her voice as I was walking out of the door, "tell your son from me he has a wonderful father."

Once when Nina was on the war path I could be found with Keith "Monty" Tangyuk, the general manager at the club, hiding on the floor in the cloak room! Some years later when Nina was doing her autobiography the English publisher sent a photographer all the way to LA to shoot the cover. She rejected all the shots and said, "Go to Redfern – he has lots of pictures of me." A few months later at the book launch with my picture on the cover, when I dared to ask her to sign a copy for me, she wrote, "Okay. You're good with photos."

Then there was the time she was booked for a concert in New Orleans. Half an hour before she's due to go on stage, she telephones the theatre and says, "If you send my money over, I'll come down." The reply went back, "Get your ass down here, and you'll get paid after the concert." So Nina turns up and starts the concert. About half an hour into the show I'm on the side of the stage talking to Bob Jones, the producer, when Nina, still playing the piano, pushes the microphone to one side and says to Bob, "Have I played enough for my money yet." That's showbusiness. And maybe the world is a poorer place without the likes of Nina. She was a spell-binding entertainer.

HAVANA

Dizzy Gillespie:

Havana, 1990

Arturo Sandoval,
Dizzy Gillespie:

Havana, 1990

Havanas in Havana • • • • Being part of the Ronnie's family I was lucky enough to be invited to Cuba on a number of occasions for the Havana Jazz Festival. The first time I flew out with Air Cubana on a very old Russian jet. This plane couldn't reach Havana in one go, so we stopped at Gander in Newfoundland for refuelling. I'd often seen the place in old movies (*No Highway*, for example) and was fascinated to be there. Mind you, at minus twenty degrees a forty-five minute stop was enough.

The festival itself was dedicated to Arturo Sandoval who was still living there at that time, and we spent quite a lot of time together. One didn't go to Cuba for the food and drink, but the atmosphere was fantastic and the natives were very friendly.

In 1990 the festival was built around Dizzy Gillespie and the United Nations Orchestra. I took a sequence of very interesting pictures: Dizzy on the back of Sandoval's motor bike; diving off a very high board; and, of course, conducting the orchestra with a large Havana cigar.

Three years later in 1993 I managed to get upgraded flying Iberia from Madrid – a definite improvement, but the standards of hotel and food hadn't changed. It wasn't so much that the girl serving my fish one day had a cockroach on her hand, it was that she didn't brush it off until the fish was on my plate! This particular festival was a co-production by Pete King for Ronnie Scott's which featured Ronnie's band, Roy Ayers, Chico Freeman and Andy Sheppard from our side of the water. Chucho Valdes and Irekere headed the local talent with Gonzalo Rubalcaba following a close second. I had put on an exhibition at the main theatre, and was assigned a personal "minder" complete with transport, which consisted of a large old van. It was sometimes better – and often more comfortable – to actually walk the streets by oneself – if allowed. The non-musical highlight was a splendid lunch at the superb British ambassador's residence: how the other half lives!

French connections • • • • • I don't know what it is in the French psyche that makes them the producers of some of the finest jazz festivals in the last twenty years or so. I'm sure that the weather has something to do with it. Maybe it's the French attitude to photographers that makes it special for me, although I do shudder when a crowd of them are shoving cameras with 28mm lenses up some poor jazz musician's nose. The phrase "stand back" obviously doesn't appear in the French language.

My first trip abroad was to the Antibes/Juan-les-Pins Jazz Festival in 1962. It was there that Dizzy made his famous record *Dizzy On The Riviera*, produced by Quincy Jones. I managed to get in to the session and take some pictures. It was also that year that I was first introduced to Fats Domino and Jimmy Smith – and the first time I came across a band marching through an audience playing 'The Saints'.

The journey down there was interesting. I booked my second class couchette ticket with Thomas Cook and shared the carriage with an elderly Scottish gentleman and four pretty young girls. There were worse ways of travelling.

It wasn't until the mid-Nineties that I started returning to Juan and I'm pleased to say that the town hasn't changed that much, with a few new hotels like the Garden Beach and a lot more traffic, but it was always very crowded.

That doesn't mean that I've been ignoring the Cote d'Azur since the Sixties, because in its day the Nice Jazz Festival was second to none in the world. Organised by George Wein the atmosphere was very free and easy on the surface. But like all his shows the world over, the Nice festivals were highly organised and ran like clockwork and to time, which is very important if there are a number of stages running at once. Photographers and journalists always had access to all the artists, who, anyway, were often to be found in the Cajun-style open restaurants, and then late at night jamming in the artists' bar at the main festival hotel. George lost the contract after the 1993 event and it went down rapidly for a while. Now, after those years in decline, it seems to be on the up again, but not much jazz content is in evidence. Jazz á Juan, now in its forty-fifth year, continues to thrive on the Cote d'Azur.

A couple of weeks before going south I go to the Vienne Jazz Festival, set in a Roman town some twenty kilometres south of Lyon. The Roman amphitheatre can hold eight thousand people on permanent seating making it the perfect summer concert setting. But what makes it special from my point of view is that I have total access to the artists before and after the concerts. It is a photographer's dream because we are actually made welcome. We are allowed to shoot most of the soundchecks (ideal for those informal pictures in good light) and all the shows from right in front of the stage. What most concert and festival organisers and, more importantly, managers fail to realise is that we all have a life outside their particular event. I know many of the artists personally – probably better than they do. Artists are glad to have a chance to see a familiar face, and talk in their own language – however briefly. I find it very frustrating when I am prevented from making contact, which is what happened in Nice in 1998. I do wonder who or what these managers think they are protecting (only their own egos, I suspect). I fancy I'll still be around when most of them are long since gone.

| Vienne Jazz Festival

opposite:

Pinetop Perkins: Vienne, 1993

Dave Holland,
Joe Henderson:
Vienne, 1993

Carla Bley:
Vienne, 1993

Luther Alison:
Juan-les-Pins, 1996

| **Clark Terry:** Vienne, 1995

| **Al Grey:** Nice, 1989

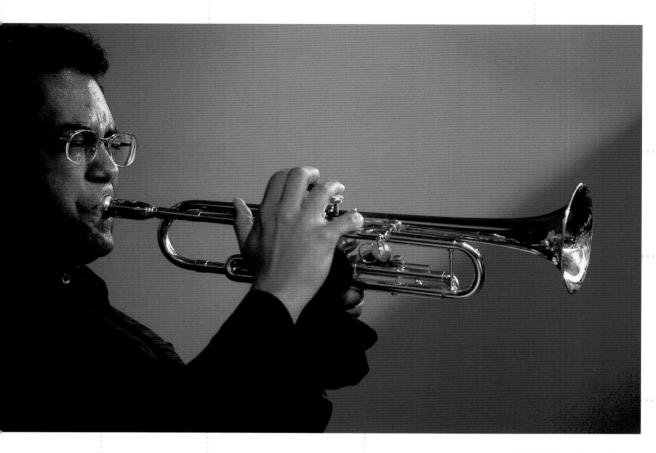

Jon Faddis: Brecon, 1997

Bobby Hutcherson:
Brecon, 1995

Welsh rarebit · · · · · The French, of course, don't have a monopoly of the European festivals, but many of the city events are just a series of concerts strung together under one banner. This is mainly the case in the UK. One of the exceptions to this rule is the Brecon Jazz Festival set in deepest Wales. The venues are not always ideal – the Market Hall always smells of fish for the first day's concert – but now they have a new theatre, courtesy of the lottery, and the whole town is taken over by this international-star-filled event in mid-August.

Green with envy · · · · · There are a few artists that are so alive on stage, so electric, that I find listening to their CDs is always a disappointment. The "Rev" Al Green certainly fits that bill. I would travel a long way to see one of his performances. The aura and vitality he brings to the stage is incredible. Is it soul? Or is it gospel? I don't know. I just love it!

opposite:

Wynton Marsalis: | **Al Green:** Vienne, 1994
Brecon, 1993

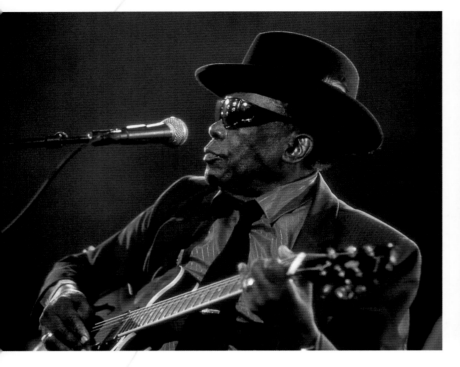

Caught short with Clapton • • • • • When you get a call from PR man Richard Wootton with a tip, you know it's worth heeding. So we found ourselves at the Mean Fiddler to photograph the then little-known blues man, Robert Cray. I took my usual number of pictures and moved up to the balcony to enjoy the rest of the gig. Towards the end of the show he said, "I'd like to bring on a friend of mine for a couple of songs." It was Eric Clapton – and, yes, sod's law, I'd run out of film. The next time I caught Robert Cray with another artist I was more prepared: it was a dressing-room shot with John Lee Hooker.

John Lee Hooker: | **Robert Cray:**
New Orleans, 1991 | New Orleans, 1987

opposite:
Jeff Beck: London, 1990

Not my scene – now • • • • • I haven't shot many rock 'n' roll concerts in the last ten years, and I guess I don't always keep up with who's who. I was back-stage at the Hammersmith Apollo waiting to photograph a Jeff Beck concert, when in walked a couple. I recognised the lady because she had been introduced to me at Ronnie's. She was a well-known TV star, Anita Dobson, who came over and we got talking, chatting about my photography. Her man asked me if I had ever photographed the band he was in and I must have looked slightly blank because he quickly said, "You know, Queen." He was Brian May.

These days I'm not too keen to take all the crap you face in that scene. I once drove all the way to the Birmingham NEC for a Prince's Trust concert a few years ago. Six of us – photographers – were escorted in by a minder. Not unusual, but at the end of the concert I started to pack up my equipment and walk out along with the audience. The minder shouted to me that I couldn't leave yet, as he had orders that we all had to be escorted out together. I told him not to be so stupid, but he became even more frantic. I kept on walking; he kept on shouting; I vowed not to do any more of those stadium events.

Most photographers rush to point the camera when someone is playing – or trying to play – an instrument they are not known for, and I have to admit I'm no exception. Was Duke Ellington really trying to show Cat Anderson how it was done? Or Dizzy doing the same with Art Blakey on his drum kit? Ornette Coleman is very accomplished on violin, as was Don Cherry on piccolo trumpet.

In particular, I've always loved the sound of the tuba. I think it adds a very special tone in a large jazz orchestra.

| Josie Davila

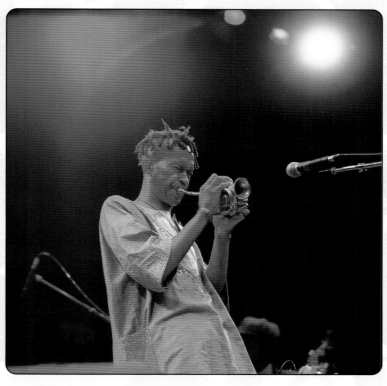

Ornette Coleman | Duke Ellington

Dizzy Gillespie | Don Cherry

opposite:

Stan Tracy: Ely Cathedral, 1996 | **Diana Krall**: Nice, 1998

In cathedra • • • • • One of the most interesting venues in recent years was Ely Cathedral in December 1996 for a concert with Stan Tracy conducting the orchestra playing Duke Ellington's sacred music. It was difficult to shoot because there was an actual mass as well. However, I felt very much at home, and was able to reassure the lady PR cleric that I was the son of a preacher man, used to serve at the altar, and could be relied upon not to get in the way. It gave me a nice feeling to see my picture and credit in the *Church Times* the following week, a paper I had not looked at for at least forty-five years, and, yes, they paid.

Career steer • • • • • It's always nice to discover a new artist for oneself, so to speak, and the Nineties has been no exception. There's an added pleasure in going to a concert not knowing what to expect. At one of these, maybe on a tip off, was Canadian guitarist and singer kd lang. She gave a spell-binding first London performance at the Forum in front of a predominantly young female audience, but I felt very much at ease and made some nice pictures throughout the whole show.

Cajun country singer Alison Krauss and the Union Station were another personal discovery, but they were much more difficult to photograph. With the fiddle-playing and close-harmony-singing there is always a plethora of microphones on stage – a photographer's nightmare – but nonetheless a joy to listen to.

I guess I had listened to jazz singer Cassandra Wilson's distinctive style for some time on CD and the radio before I had the pleasure of photographing her, and I was not disappointed. With all those wonderful braiding hair styles she's a photographer's delight.

The first time I photographed Diane Krall was in 1997. The session had been fixed up by *Mojo* magazine and she didn't know the name of the photographer. I was pleasantly surprised when she told me that she had gone out and bought my earlier book, *David Redfern's Jazz Album*, when she was fourteen, and that it had influenced her career. It was even nicer a year later at Ronnie Scott's Club when she announced the same story to the full house on her opening night. I gave her a copy of the first edition of this book in Vienne. After giving a wonderful concert, as she emerged from the dressing room on the way to her car, she threw her arms around me giving me a big hug. 'You have no idea what it means to me for you to give me your book' she said. That was pretty special for me, too - not to mention the looks from all the other photographers and journalists. Moments like that can't be faked in a million years. I think she's a fabulous entertainer: the future of that type of music is safe in her hands.

Cassandra Wilson: London, 1996 |

Alison Krauss: | **Claire Martin:**

Manchester, 1997 | London, 1993

THE FUTURE

Andy Sheppard: | **Guy Barker:**
London, 1993 | London, 1996

It's a tough job • • • • • The late nineties saw me as active as ever on the festival front, and I was even then fending off questions about my retirement. "Why don't you take it easy?" was the often envious cry. (More on that subject later) Attending more festivals and trade shows than ever before I can say this sometimes: "'It's a tough job but someone's got to do it". Often done solo, because of the nature of the event or conference, it can appear to be a lonely furrow to plough, which on some accounts especially in the late nineties it was.

But the music and those long term fleeting friendships always saw me through.

I can't say that there was much new and innovative to listen to for my taste towards the end of this decade, but there were some wonderful sounds and sights to hear and photograph.

Many of the greats I was fortunate to have photographed and listened to have left us. But there are younger rising and established stars that will carry the torch - and the music - onwards and upwards, many of whom I have already written about. Some of the critics say that there is nothing new anymore, and that many of the bands are just re-creating the old sounds. Isn't that just what classical music has being doing for the last two hundred years?

Jon Faddis and his many jazz orchestra versions are a classic example of what I mean. They play many of the old jazz standards with great style and fervour. With some superb soloists, the music is as good as it ever was.

The brilliant trumpet player Wynton Marsalis has captivated me for many years with his interpretation of the jazz classics and his original writing. As Artistic Director of the world-renowned

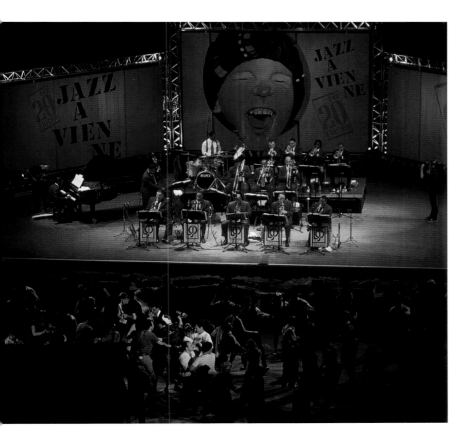

Wynton must have teaching in his blood as anyone who saw those delightful TV programmes he did in Tanglewood for children will know. Brother Branford is a pretty mean saxophone player as well.

Blues fans had plenty of new talent to listen to with the likes of Keb Mo. And listen to Sonny Landreth and then try to tell me that white men can't play the blues.

The young Zydeco band leader Geno Delafose enchanted me in 1998 in New Orleans when he called on to the stage Cajun Christine Balfour, daughter of the late famous Dewey Balfour, to play a few numbers. It was a marvellous merging of cultures and styles.

Big band boys - and girls • • • • • Jazz orchestras have always been my passion. To hear - and photograph - the Maria Schneider Orchestra for the first time in Vienne in 1998 was a great delight. Another of my pleasures in the nineties had been to capture and listen to the music of Carla Bley, especially the big band sounds. Her orchestra is always full of marvellous talent not least because it usually includes a number of British players. Saxophonist Andy Sheppard and trumpeter Guy Barker are two such musical giants. They would be household names the world over if they had been

Lincoln Center Jazz Orchestra which has recently moved into a brand new home in New York City, he continues to hold the banner very high for orchestral jazz. Wynton comes from a true jazz family with his father Ellis an exquisite piano player and a fine teacher.

| **Lincoln Center Jazz Orchestra:**
Vienne, 2000

| **Branford Marsalis:** New Orleans, 1990

opposite: | **Jon Faddis:** Brecon, 1997

| **Sonny Landreth:** New Orleans, 1997

| **Maria Schneider:** Vienne, 1998

born in the USA. Mind you, Guy has done pretty well in the last few years: he arranged the music and appeared in Antony Minghella's film 'The Talented Mr Ripley' which was released to critical acclaim in 1999. In 2002 his album 'Soundtrack' secured him a second nomination for a Mercury Music Prize . Recently, alongside his playing, he has become a radio personality, presenting such shows as BBC Radio 2's *Jazz At the Movies* and is now making a third series of Guy Barker's *World Cafe* for BBC World Service.

I can't talk about British talent without mentioning John Dankworth and Dame Cleo Laine. Those two have done so much for my kind of music over the years, from the very early days of the Dankworth Club to the '98 performance at the BBC Promenade Concerts in London. During the years in between I have had the pleasure and privilege of capturing them on film innumerable times all round the world. I'm proud to count them as my friends.

Rosie Ledet:

New Orleans, 1998 **Geno Delafose, Christine Balfour:** opposite: | **Keb Mo:** New Orleans, 1997

New Orleans, 1998

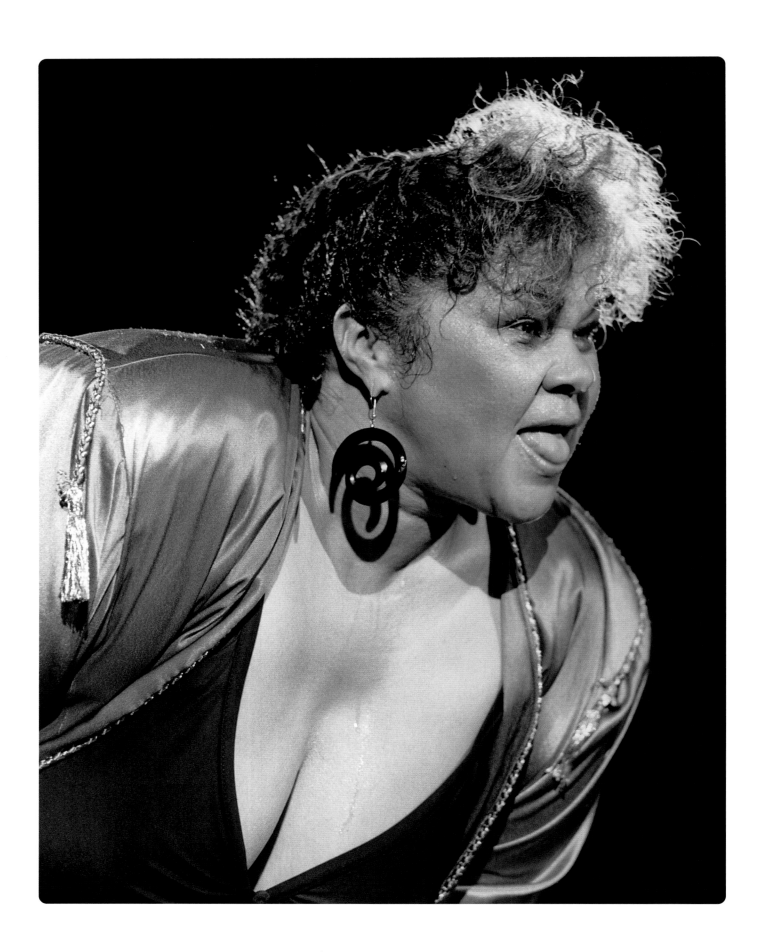

Etta James: Vienne, 1991

6 ⊙[chapter six {**the noughties**}

Ike Turner:

Kenny Neal: | Vienne, 2004

Vienne, 2003

THE NOUGHTIES

Millennium plus • • • • • Who could forget all the millennium hype? It all seems a little crazy now some four and a half years on. I remember it well. There I was on Blackfriars Bridge on New Year's Eve with my sons - and millions of others - waiting to see if all the lights would go out at midnight. Way back then it was very different: we had had proper computers in the office since '95 and the library was just embarking on a digitalisation programme, so the end of '99 had to be taken pretty seriously. I even went on a government millennium bug course. Needless to say, the lights didn't go out. It now all seems lot of fuss about very little.

The millennium bug may well have been a storm in a teacup, but the whole digitalisation of photography and its effect on the picture library business was more like a tsunami by comparison.

Photographic methods had been pretty consistent since I started in the late fifties right until the end of the century. Of course there were some changes - cameras and lenses got faster and sharper and the same applied to film.

In the good old days we photographers would take pictures, get the film processed, edit them very quickly, have some dupes made

of the best ones for reproduction, and the rest would be put away waiting for their request by a phone or fax.

Newspapers and magazines - and for that matter anyone else who wanted some pictures - would call with their order, we would search them out, type a delivery note, put them in an envelope to either await collection (all at the client's expense) or we would put them in the post.

The client would pay a minimum of £25 service fee for the privilege, whether or not the pictures were used. If they were used, they would, of course, pay a repro fee. They would also scan and clean the pictures they wanted, and then eventually return the lot to us at their expense.

Those golden days are certainly over. I think it all started off with Rupert Murdoch's News International. They finally beat the unions, which threw out lots of old practices and by doing so heralding the introduction of electronic typesetting and page make-up. Times Newspapers was certainly one of the first major players to accept pictures electronically, with all the rest quickly following suit.

Fingers out: digits in • • • • • The digital revolution had arrived. This fundamentally changed the way we conducted our business – forever.

The cost has been enormous, both in monetary and human terms. There was a period some years ago when picture libraries were changing hands for vast amounts of money - telephone number figures when the likes of Getty started in the picture business. They quickly bought up libraries such as the very successful Tony Stone. Bill Gates founded Corbis and also went shopping with a vengeance, leaving us minnows gasping at the sidelines of the pool while the two big sharks slugged it out.

Of course, those big spending days are over now and some semblance of normality has come back into the market place. That's not to say some of the offers were not very tempting. Some people took the money and ran off into the sunset. But my

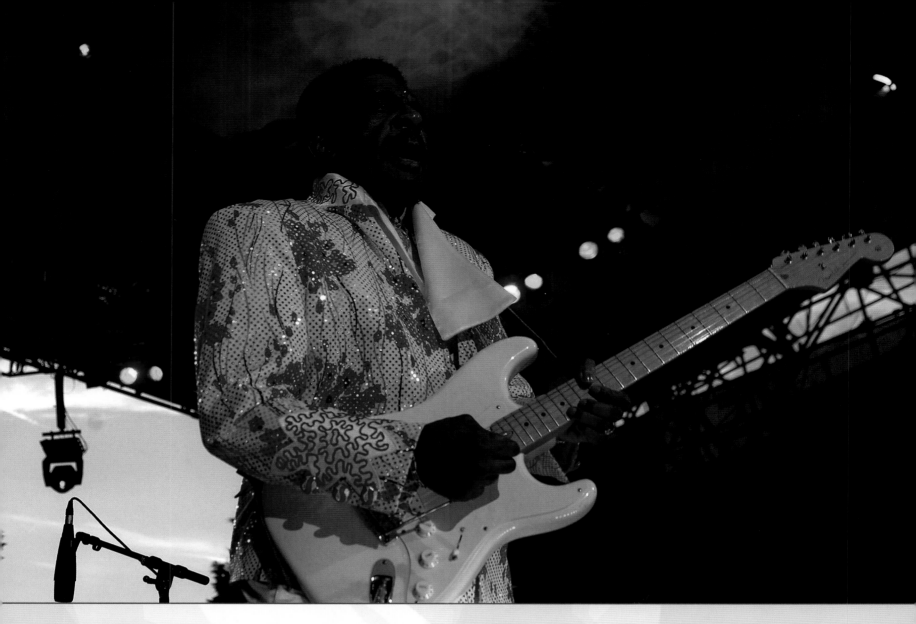

photography, the picture library, and now the gallery form so much a way of life that no amount of money could compensate me for their loss. Mind you, as I write this on a very warm beach in St Lucia on holiday with my partner Susan in February '05, it could be tempting, but I know I would get bored very quickly.

Golden scanner · · · · · The story of our first scanner is an interesting one. Born in Israel at the cost of £44,000 it went to Corbis in north London, spent two years there, then came to Redferns for £9,000. We had to get a giant crane to get it through the window of our first floor scanning studio. Three years later we had to break it up and take it to the Wandsworth recycling dump. This well illustrates how everything is changing at such a rapid pace - and how expensive it all can be.

The tasks of getting a website together, setting up a scanning department, and choosing and prioritising artists and pictures to scan first from the million odd pictures we had in our 65 filing cabinet drawers were daunting enough - let alone finding the wherewithal to do it.

I guess for most picture libraries the golden years were 1999/2000 and it was those profits that helped finance the

digitalisation process. My eldest son Simon set up and owns our initial website *www.musicpictures.com* at no initial cost to us. This now runs in parallel with our own professional site *www.redferns.com*, which at the time of writing has around 120,000 searchable images online.

Nightmare on Bourbon Street · · · · · My first, and so far only, digital camera is the Fuji FinePix S2 Pro. I chose it for two reasons: it uses Nikon lenses; and one of our scanning department workers who is also a photographer, Carey, had one and highly recommended it. I took delivery of the camera along with a new Dell notebook only one week before going to the New Orleans Jazz Festival in 2003. This was a nightmare, a very fast learning curve by necessity.

Taking the actual pictures was the easy bit, getting to grips with the rest was horrendous. Downloading to the laptop, resizing JPEGs, enhancing colour correction, captioning, and finally writing to CD for back-up, took up an enormous amount of time. Of course I quickly became much more proficient, but it's still very time-consuming compared to processing and editing colour slides. I did one experiment on one artist, Gladys Knight, shooting her on

6 x 6 film

Gladys Knight: New Orleans, 2003 | 35mm film

Digital

digital, 35 mm film, and 6 x 6 film. I think you will see it's difficult to tell the difference on normal reproduction. But I have to say that digital photography is superior when it comes to working in low light conditions. I have found myself working in clubs that I'd given up some years ago because the lighting is so poor.

The equipment doesn't get any lighter, though, so for a number of years I have had an assistant whenever possible. Really good ones are hard to find - and it doesn't help them that I judge them against my young son, Mark, whose performance as an assistant was always excellent. He is now running a successful music magazine 'under the radar' with his girlfriend Wendy in LA.

For me, an assistant should be seen and not heard, know how to change and mark film quickly and intelligently, but more likely these days know how to manage all the digital paraphernalia that goes with taking pictures, above all pay constant attention, and not run around trying to take pictures.

All you need is talent – and experience, experience, experience • • • • • I don't think that photography as we knew it is dead. You can still buy film, and I think in spite of all the digital advances; in the black-and-white field there is still nothing to beat film and prints made from fibre paper. It's just becoming more marginalized in the mainstream of things but will I think grow in stature in the collector/art market.

I've been lucky over the years to have employed some very talented photographers, most of whom had had no formal training. Much more important is on-the-job experience. I'm a firm believer (at the risk of repeating myself) that you either have the eye for it, or you haven't: any number of years in college or university will not change that. Steve Morley, Tony Russell and Andrew Putler are all examples of that talent. Suzi Gibbons has that eye, and is now one of Britain's top garden photographers, whilst Tim Hall has definitely moved up the ladder. After working for me for some eighteen months, he has produced ten wonderful books in the last few years. The first was a rare look at Cambodia (he was the first photographer given free access for many years) followed by Vietnam, Burma, and China to name but a few. He has recently made a move into landscape photography. His success continues onwards and upwards. Mick Hutson did come to us straight from Salisbury College of Art and Design, and to my mind is one of the top live rock photographers in the world today. No doubt, though, many have slipped through the net. I did once turn down for a job Duncan Raban, who now has the very successful All Action digital agency.

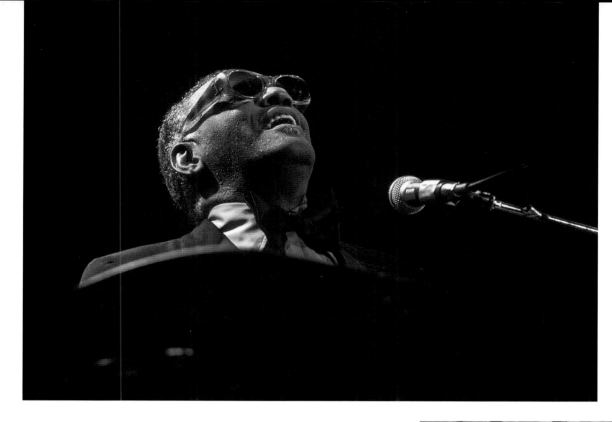

| **Ray Charles:**
Capital Jazz Festival, 1982
| **Ray Charles, Joe Adams:**
Newport Jazz Festival, 1968
| **Ray Charles:**
Newport New York, 1972

Nostalgia IS what it used to be! • • • • • One of the advantages of getting old (there are not too many), and being a photographer for a very long time, is that some of your pictures become quite valuable. It's a nice feeling to revisit the files after many years and re-experience the thrill of the times and the music. When Ray Charles died in May last year – followed by the release of the film 'Ray' this year, I was able to wallow in a great deal of nostalgia listening to new release CDs (a number with my picture on the cover), printing out some little-seen images, a great indulgence for me, but anything that takes me back to those wonderful concerts with Ray and the Rayletts in the sixties, I'll take it any time. The movie does just that.

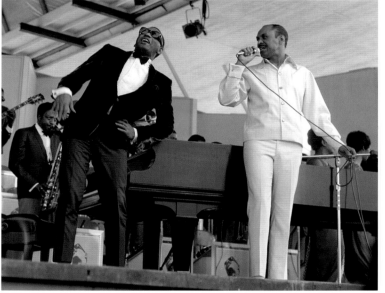

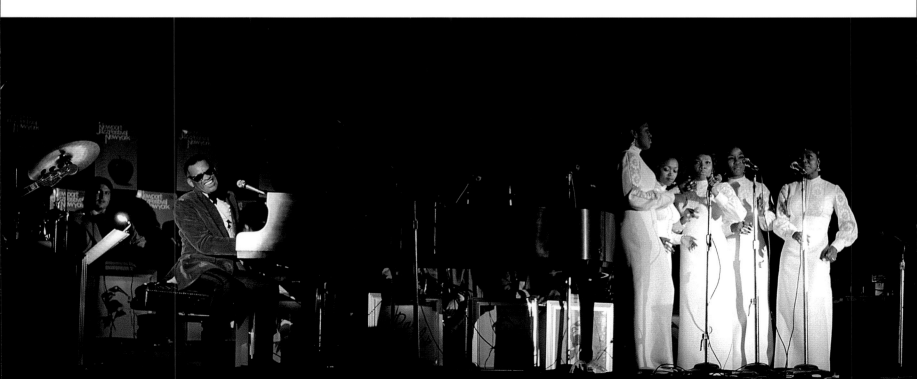

Ray Charles, Billy Eckstine:

Hollywood, 1974

Ray Charles:

Vaison La Romaine, 1980

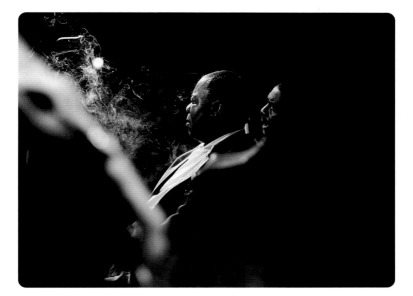

PAST

Louis Armstrong:
BBC TV London, 1964

———

Cootie Williams, Duke Ellington:
Royal Albert Hall London, 1964

The Past Rescuscitated • • • • Some pictures on the next few pages are those I really like, but for some reason or other didn't make it into the first edition of this book, or they appeared in 'David Redfern's Jazz Album', Eel Pie Books, 1979, (long since out of print) and now deserving a second showing.

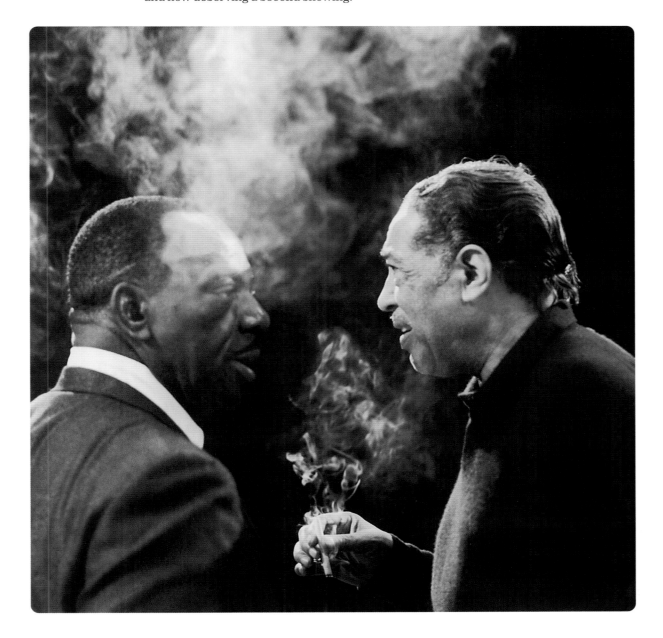

Stan Kenton: |

BBC Ealing Studios, 1976

Jimmy Smith: |

Comblain La Tour Jazz Festival, 1964

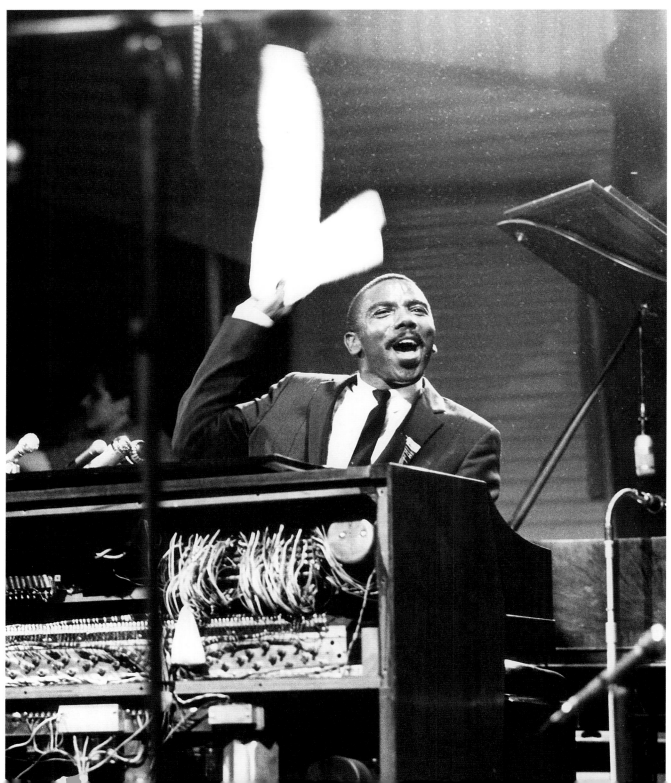

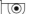

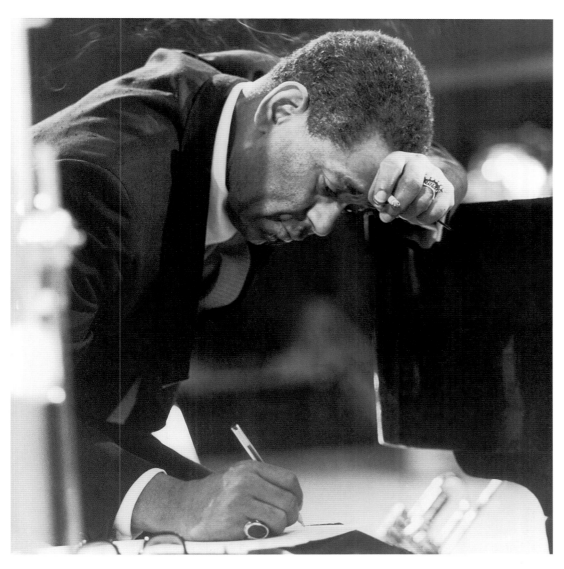

| **Dizzy Gillespie:**
Royal Festival Hall London, 1985

| **Oscar Peterson:**
Studio London, 1976

| **The Beatles:** London, 1964

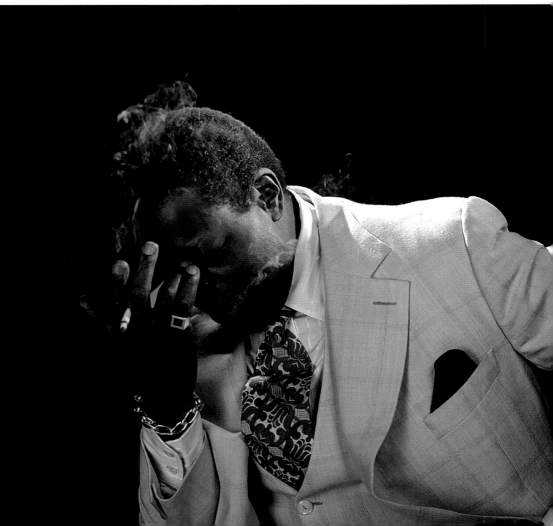

PRESENT

The Present – as was • • • • • What of today's stars and events? I have to admit that for a number of years my photography has been mainly restricted to music I really like (another indulgence of longevity in this business): that is jazz and blues with a mixture of soul and old fashioned R&B and a little gospel (especially on Sundays) sprinkled around.

That's why I still love the festivals, about the only places one is able to work still fairly uncontricted and more importantly - apart from Ronnie Scott's and a few other clubs and some concert sound checks in London - they are the only events where you can still meet the artist unencumbered.

One such event was the 2004 Newport 50th Anniversary Festival, pure jazz from start to finish, a wonderful setting and a very relaxed atmosphere.

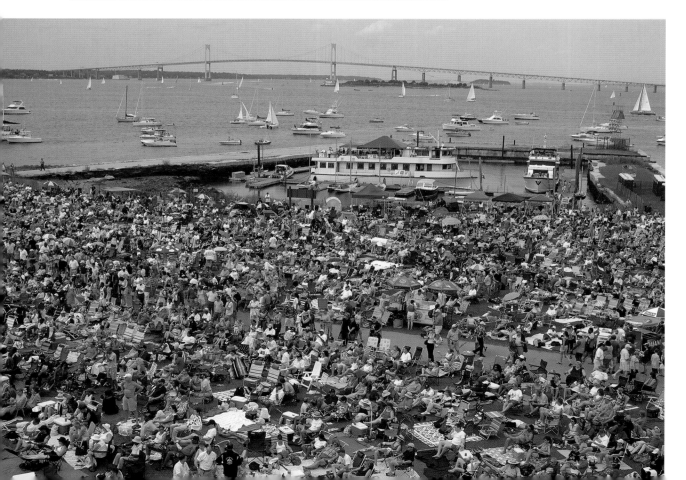

Newport Festival:

Jamie Cullum, 2004
Bill Cosby, 2002
Newport, 2002

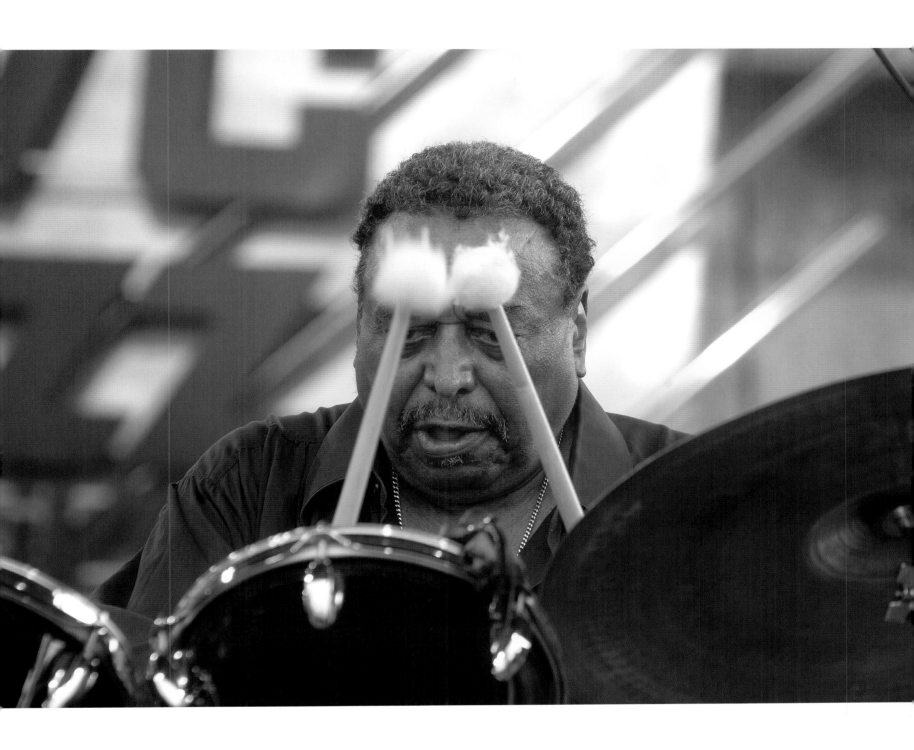

| Chico Hamilton: Newport, 2004

FUTURE

Elvis Costello: New Orleans, 2005 | **Roy Rodgers, Lil' Ed:** New Orleans, 2005

The event I've covered most consistently is the New Orleans Jazz And Heritage Festival.

In 2005 the weather was, as usual, good throughout, which was just as well, as I had the added problem of using a digital back, the V96 for the Hasselblad camera. What a challenge it was! I know it's no use harking back to the good old days of film, but it was so much easier in the field. The amount of equipment you really need to take is incredible: I needed four different sets of batteries to run both my digital outfits, not to mention chargers (that work in the USA), leads, laptop, and all the rest of the paraphernalia.

The Hasselblad back produces an amazing 47 Mb file for each shot, which was delivered direct to a hard drive I was wearing on my waist. I discovered the battery didn't last anywhere near the recommended time because I didn't turn the unit off after every series of shots, impossible in those conditions when the bright light and noise levels made it difficult to tell if the unit was on or off.

After a day's shoot it took approximately four hours of computer time to download, process, save, and back-up just one day's work. So for those who tell me digital photography is so easy, I have some news. Maybe it is for the amateur – but have you seen the quality...

You, too, can archive your memories · · · · ·
The whole question of archiving is another subject, which I don't think has been properly addressed. I'm sure most of us have a drawer or two of personal pictures taken over many years; I have under my bed, not to mention all those filing cabinets full of my professional pictures.

The vast majority of images taken today by digital means are never printed and are only accessible by computer, and I'll guarantee most of those will get deleted or vanish in cyberspace in the fullness of time. That's a lot of memories being lost forever.

I have to say I'm very happy with the results I achieved in New Orleans in spite of all the difficulties. I love and much prefer photography with the Hasselblad whenever I can. The vast majority of pictures in this book were taken with one, so it's fitting to be able to carry on using the same body and lenses with that special 'feel' I love so much, into the 21st century.

At the time of writing I hear that Leica are in trouble, but are introducing some form of digital back within the next few months. I really hope they succeed. Unfortunately in this photographic digital age, it's a matter of adapt or die!

Irvin Mayfield: Vienne, 2003 | **Michael Bublé:** Ronnie Scott's, 2003

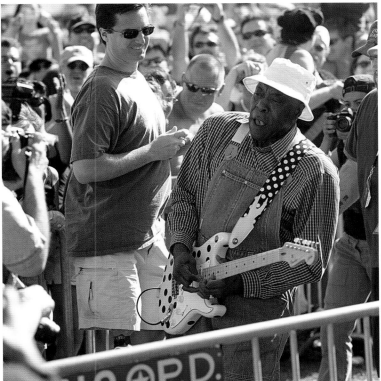

Style? Where? • • • • • I'm often asked to give a judgment on today's stars and personalities: do they have any (personality that is)? Where are today's characters? The music business is a very difficult and different animal to what it was in the sixties. I was fortunate enough to live and photograph through that special time. Nowadays one has to cut through so much hype and crap before one can even consider whether to photograph an event or concert. A typical example was last year when I went to photograph Katie Melua at the Royal Albert Hall. After Ruth at my office had made many phone calls I finally got the 'yes' two hours before the concert started. When I arrived I was sent from door-to-door trying to find my pass, only to be told that I'd have to sign a contract giving up most if not all of my rights to the pictures. I mentioned that I wanted to put one in my book, only to be told that I had to get special permission for that. Well, the lighting and the pictures (only to be taken during the first three songs) were pretty ordinary, so I didn't bother to ask for permission. That's one artist you won't see gracing these pages.

Buddy Guy: New Orleans, 2005 | **Creole Zydeco Farmers:** New Orleans, 2005

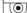

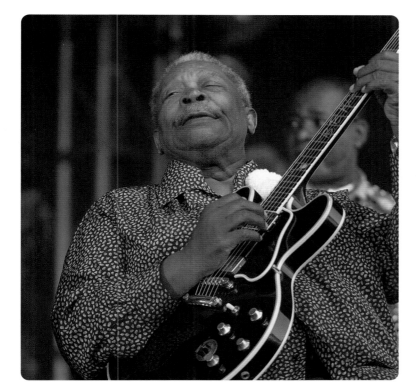

Style? Here! • • • • There are however lots of rising stars that are very accessible to my camera and that are a pleasure to listen to. Close your eyes and you wouldn't believe Joss Stone was only 17 when I shot her in New Orleans 2004: what is she going to be like in 20 or 30 years? Gwyneth Herbert certainly knows how to hold an audience and has her own distinctive style, but the real star female singer I've come across in the last few year's is Madeleine Peyroux, she has a fantastic voice and a great future. The best discovery for me in the last 12 months.

Without doubt, the UK success story in the jazz entertainment world is that of Jamie Cullum. The unpretentious and infective showman style that he brings to the music scene has won him thousands of fans on both sides of the Atlantic. It's always a breath of fresh air to see new talent like that sweeping aside some of the old fuddy-duddy traditions. Long may it continue!

There are dozens of musicians across the water who continue to delight me, one newish discovery is the fantastic New Orleans trumpet player Irvin Mayfield, who leads the Latin-jazz band Los Hombres Calientes.

Blues jam sessions always excite me, and the closing one at this year's New Orleans Jazz Festival was no exception. The main protagonists were the brilliant slide guitar players Roy Rogers and L'il Ed, both ably supported by an unbelievable rhythm section. The sounds are still ringing in my ears days - even weeks - later.

Madeleine Peyroux:
New Orleans, 2005

———

opposite:
Joss Stone:
New Orleans, 2004

And finally – a large cognac! • • • • • I was writing the end of the first edition of this book in Morocco in the summer of 1998 having spent a couple of days in Marrakesh staying at La Mamounia and during the evening we listened to the sounds of Holly Perry playing in the piano bar. The walls were beautifully decorated with jazz pictures and, yes, there were a couple of mine: giant back lit slides of Duke Ellington and Charlie Mingus. How did they get them? Who knows? Did they pay for them? Of course not. "San Fairy Ann – that's show business", I said and settled down to a large cognac while listening to Holly playing Erroll Garner's 'Misty' – for me.

Now some seven years on it's fair to say that copyright rip-offs don't get any less frequent. Late last year I discovered a French artist had taken and copied my famous Hendrix photo. He had given it the oil painting treatment, but with every detail exactly the same as on my picture: expensive lawyers' fees ensued, but with no satisfactory result.

But it's swings and roundabouts. In any event the internet makes sure we get our pictures seen by a lot more people, and I really don't think copyright piracy is on the increase, it's just become more visible.

In the vast scheme of this one life we have (it ain't no dress-rehearsal) it's pretty minor stuff. I'm still enjoying it to the full, working as hard as ever, sometimes more so now with the gallery. Yes, I am told I ought to slow down a bit and I said that by next year I would be working only four days a week!

I've always said that my 70th birthday party will be held in our house in France, so my next project is to secure one - hopefully in the Ardeche, where I'll be able to continue some of my work, while sitting in the sun, thanks to all the technological wonders we have these days.

In September 2003 I was coming out of a building in City Road in London when by pure chance I ran into Susan, walking up the street. We had met twenty one years ago when I chatted her up. She was the makeup artist during a band photo shoot. I'm the first to admit that I didn't have total recall during that chance meeting; but, fate or not, she's now very much part of my life. As we ride off into the sunset, I'll quote the song from the late great Louis Armstrong 'It's a wonderful world'

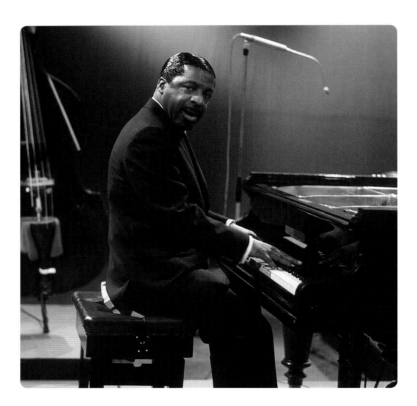

| **Erroll Garner:** BBC TV, 1964

SOME TECHNICAL NOTES

Cameras I Once Owned · · · · ·

Kodak Folding Brownie, 120 film: late 1940s

Voigtlander Bessa 66, 120: 1953-1956

Voigtlander Vitessa 35mm, 2.8 Color Skopar lens:1956-1959

Rolleiflex 2.8.E with a Planar 2.8 lens: 1959-1966

Hasselblad 500C with a 150 mm f4 Sonnar lens: 1964-

Olympus OM1/2, 55mm 1.4, 28mm 2.8, 135mm 2.8 , 180 2.8 lenses

Cameras I Now Use · · · · ·

Hasselblad 500CM, Hasselblad 503CW body, Hasselblad Winder CW, Distagon 50mm f 4 lens, Planar 80mm 2.8 lens, Sonnar 180mm f4 lens, Teletessar 350mm 5.6 lens, 120/220 magazines.

Nikon F4 body, AF 50mm 1.5 lens, AF Nikkor 35-70mm 2.8 zoom lens, AF Nikkor 80-200mm 2.8 zoom lens, AF Nikkor 300mm 2.8 lens.

Contax TVS camera

Fuji FinePix S2 Pro (uses all the Nikon lenses)

Meters · · · · ·

Weston Master 2: 1960s
Gossen Lunasix meter: 1970s onwards
Pentax Digital Spotmeter: 1980s

I hardly ever use the meters built into cameras. I found that they were useless for most concert situations, particularly where there is a lot of back-lighting, or where fine spotlights are used. They are also unreliable at outdoor festivals where the performer is under cover.

I now use a **Gossen** Spot-Master 2. Its one degree angle and internal digital reading make it an ideal tool for my sort of photography. But of course that changes somewhat with digital photography when the results are instantly visible, it's possible to work without any sort of meter.

FLASH · · · · ·

It's well known that I rarely use flash. But the first flash gun I ever used extensively gave me excellent results. It was a **Braun** Hobby 55 with one of those large mottled reflectors that yield a wonderful soft light.

FILM · · · · ·

Black & white:

In the Fifties I tried all varieties of film. **Addox** 100 (German) was very good for all those army flash shots. I also tried **Agfa, Kodak, Lumiere** and **Perutz** to name most of those available then. Towards the end of the decade I settled on **Ilford**, mainly the fast 400ASA HP type, and I have used nothing else ever since.

I started with HP3, quickly moving to HP4 between 1960 and 1976. This was a wonderful fast soft film It was HP5 from 1976-1989; and now I use HP5 plus. All of the HP films were, and are now, rated at a minimum of 800ASA as they are deep-tank processed in Microphen.

Colour:

Tungsten

The first colour film I used was **Ansco**'s Super Anscochrome T 120 – 100ASA, which I rated at 200ASA. Then in 1963 **Kodak** introduced EHB 120 125ASA, a new Ektachrome E4 film. Pushed one stop it was an excellent film for TV work, although with some studio spot lamps the colours tended to green up a bit, so I used a Hasselblad 20R filter which did the trick.

With the advent of E6 in 1976 Kodak replaced EHB with EPT 160ASA: still the fastest 120 tungsten film around.

In 1993 Kodak introduced EPJ 320T, a T grain emulsion. Without doubt this was a great improvement. I regularly push it two half stops with good results, but sadly it's only available in 35mm.

Daylight

I started with **Kodak** Ektachrome 50ASA moving on to Ektachrome X 64ASA and have used mainly Ektachrome slow films ever since. For high speed requirements I tend to use **Fuji** Provia 400 which is generally pushed one or two stops. For the outdoor festivals I like to use a 200ASA film in either 120 or 220 format. I like the **Agfa** RSX 200, and the new **Kodak** E200 pushes extremely well. Both are relatively grain free.

DATES · · · · ·

This book is written and illustrated in chronological order, but some of the pictures are inevitably out of sequence. The reason will usually be obvious. However, I apologise in advance if it turns out that I have got some of the dates wrong. It just didn't occur to me all those years ago to date my pictures. I was, after all, just taking them for the present. I had no idea that they would become the backbone of our picture library as it is today. So, instead of guessing I have sometimes given an approximation, and a couple of times given a general date in the text. These are for the two important pop TV programmes I worked on so much – *Ready, Steady, Go* (August 1963 to December 1966) and *Thank Your Lucky Stars* (1961 to 1966). What I am certain of in virtually every case is where the picture was taken. That side of my photographic memory hasn't faded one bit.

THANKS · · · · · To all those involved in the production of the first edition of this book: the wonderful design team led by Storm Thorgerson, Peter Curzon and not forgetting Sam; additional thanks to Storm for dreaming up the title; brother Paul for his careful editing of my words and thinking up all the witty story headings; and Penny, Eddy, Michelle, Jeff and all at Sanctuary for the freedom to do this book my way!

To Paul and Peter for their continuing work on this edition; and to Kevin Goodall, student extraordinaire.

To the team at Redferns: Dede, Jon and the rest of the crew who have been magnificent in indulging me while I prepared this book, especial thanks to Carey for his superb black-and-white printing.

I couldn't have done this book – lived this lifestyle – without the help I've received from countless people in and out of the music business: so thanks to my ex-wives Kate Redfern and Mary Moore Mason for putting up with me all those years. And thanks to the producers, promoters, venue managers and countless other people who helped me along the way, especially to the following people and organisations who helped well beyond the call of duty: Festival Productions Inc – George Wein, Charlie Bourgeois, Bob Jones; New Orleans Jazz And Heritage Festival – Quint Davis, Louis Edwards, Matthew Goldman, David Foster; Harold Davison, Jack Higgins, Liz Pretty; Pete King and all the crew at Ronnie Scott's; BPR – Brian Theobald, Ina Dittke; Serious Productions; Richard Wootton; Jazz à Vienne – Jacques Launay, Pierre Budmir; Jazz à Juan – Béatrice Di Vita; BBC Television – Terry Henebury, Anne Rosenberg; Air – Marc Conner, Sheela Bates; all those who worked on Thank Your Lucky Stars (especially Jimmy Bake) and Ready, Steady, Go. My apologies to all those I have missed or who are not mentioned in the text – you'll all be in the next one!

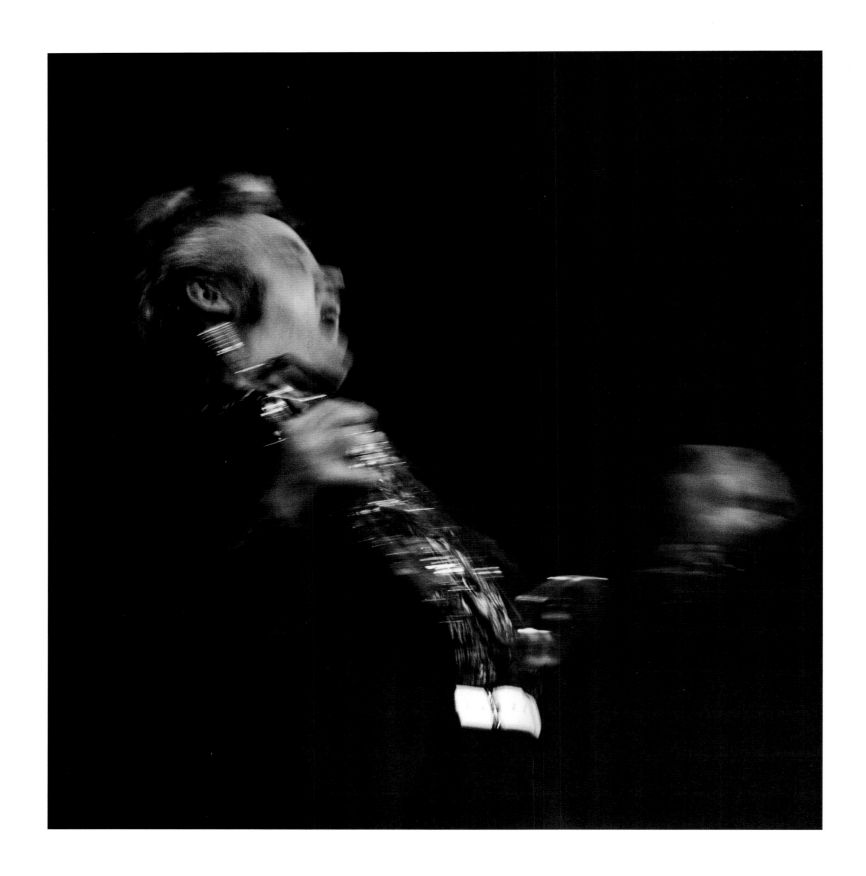

Maynard Ferguson: Oxford, 1975